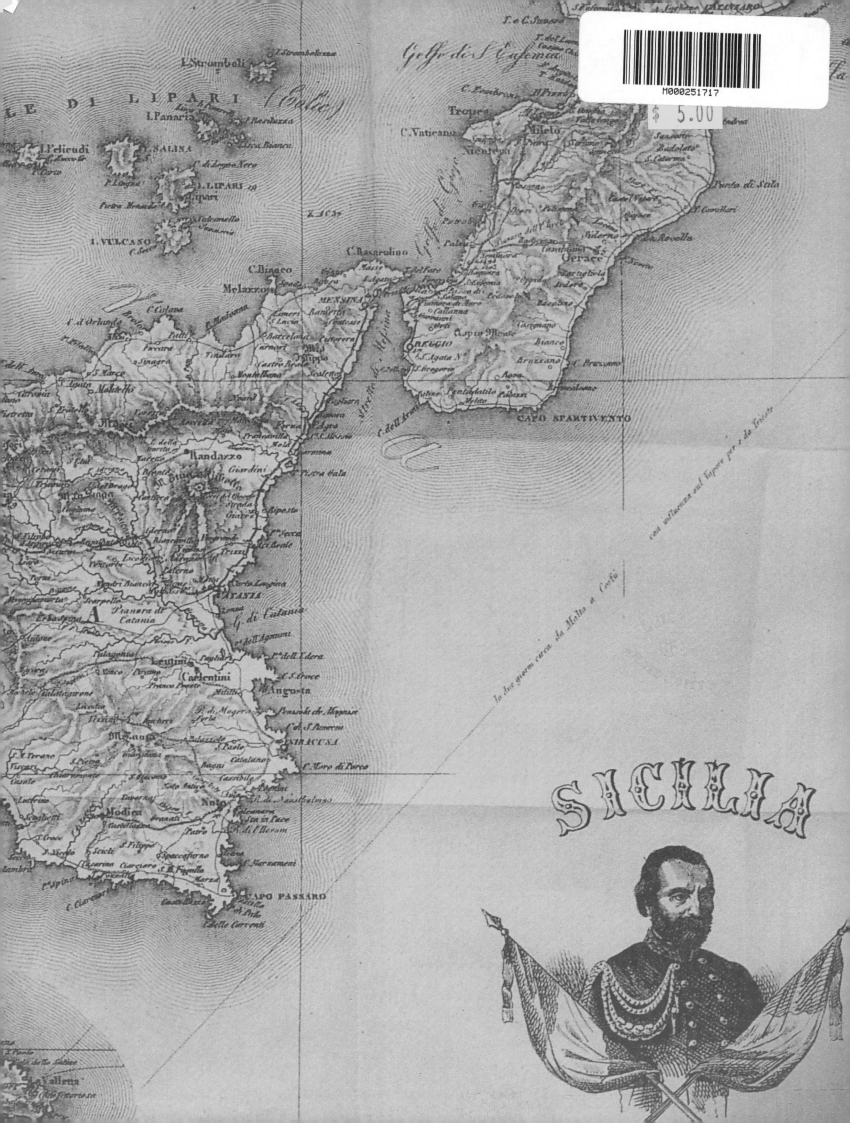

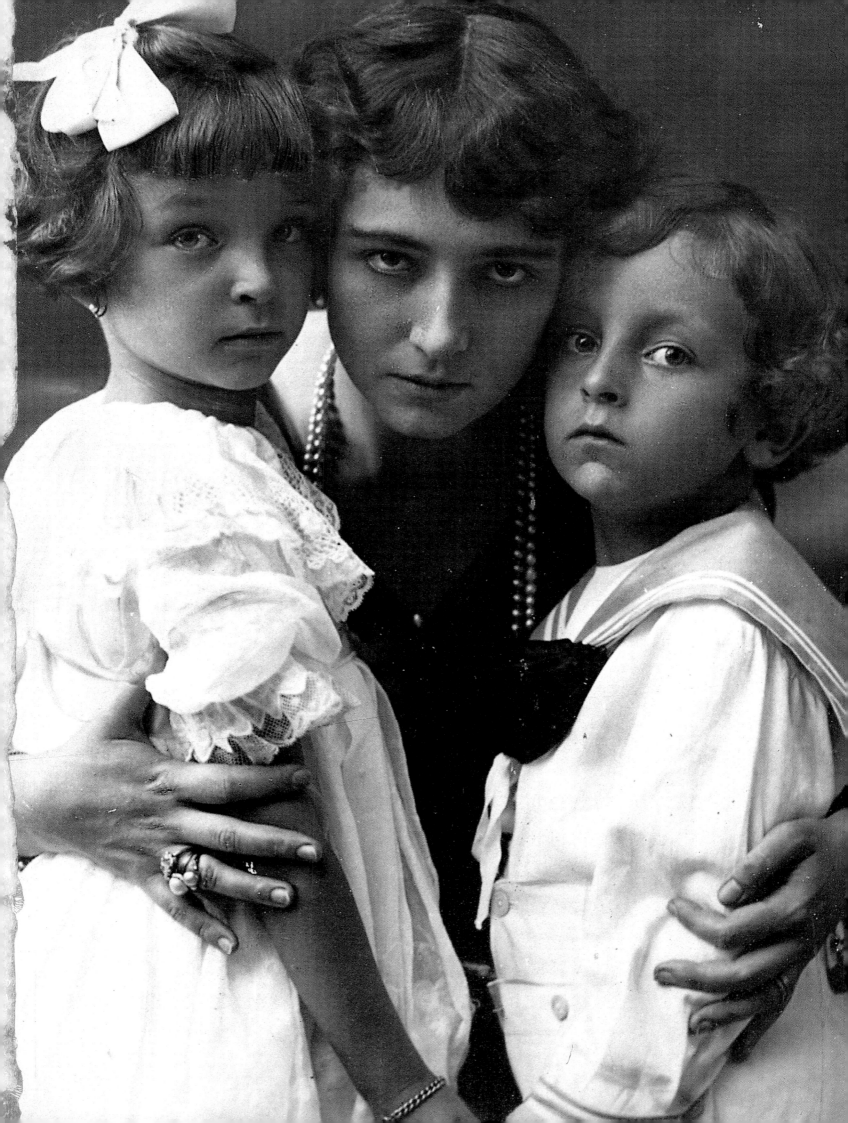

PHOTOGRAPHS BY
Jean-Bernard Naudin

TEXT BY
Gérard Gefen

STYLISME
Lydia Fasoli

WHITH THE COLLABORATION
Fanny Calefati di Canalotti

Sicilian Twilight
The last Leopards

Based on the idea of Lydia Fasoli

The Vendome Press

Design : Marc Walter

First published in the Unites States in 2000 by
The Vendome Press
1370 Avenue of Americas
New York, NY 10019

ISBN: 0-86565-221-X

Table of Contents

pp. 1. Princess Giulia de Gangi, her daughter Stefania and her son Benedetto, around 1920.
pp. 3. Princess Gangi's lace ballgown, embroidered with pearls.
pp. 4. Fresco from the Beneventano del Bosco palace in Siracusa. This 15th century construction was totally transformed in 1774 by the architect Luciano Ali.

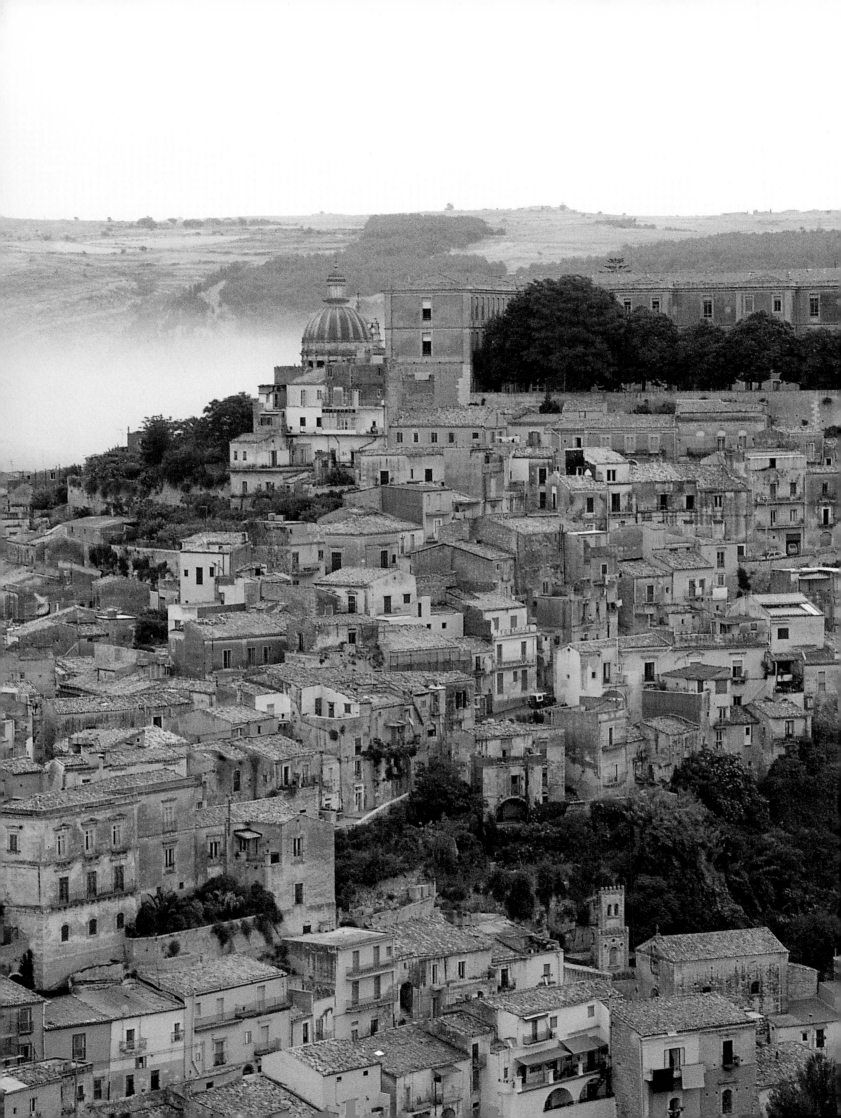

Palazzo Gangi:
this bas-relief adorns
the façade overlooking
the terrace.

A brief history
of the Leopards

The few cable lengths that separate Scylla from Charybdis would never have been enough to make an island out of Sicily if the Sicilians had not got involved. Civilized by the Greeks, under the domination of the Romans, invaded by the Barbarians, occupied by the Normans, the Angevins and the Swabians, handed over to the Spaniards, then the Bourbons of Naples, before being united into the Kingdom of Italy in 1860, the Sicilians inherited a variety of traditions and mannerisms that were more difficult to get through than the Straits of Messina were to get across. So much history might have altered their character but they were, on the contrary, hardened to the point of acquiring what the Sicilian writer Gesualdo Bufalino called "an excess of identity". Whoever is born in Sicily, Bufalino added, "has the joy of feeling at the very center of the world, yet being unable to get through the thousand windings of his inheritance, of finding the line of his proper destiny".

A British officer, Edward Baynes, affirmed in the *Metropolitan Magazine* in 1834 that Sicily was "an absolutely eccentric country, a stranger to any law and terribly capricious". This was an opinion shared by many travelers who had been there or were to go. Baynes added that in this land of "ferocious customs" one could also find "a few individuals who, thanks to their distinction of spirit and their manners, were equal in every way to the people the most elegant and accomplished royal courts in Europe had turned out". He went on to say that "Nearly always, a nuance of extravagance, imagination and fantasy accompanied their elegance and good taste". The chronicles of this Sicilian nobility, the literature they inspired, the art they gave rise to all bear out the observations of this British officer.

The upper village of Ragusa,
built after the 1693 earthquake
which nearly totally destroyed
Ibla, the lower village.

In the 1790s, a German traveler, Friedrich Münter, counted up two hundred and twenty-eight aristocratic families (58 princes, 27 dukes, 37 marquis, 26 counts, a viscount and 79 barons). The official Golden Book of the Sicilian nobility, which ceased in 1926, had a few more: two hundred and forty-five in total – to which it added about two hundred families "not yet recognized, a certain number of which are probably extinct". Certain modern authors came up with even more: 142 princes, 95 dukes, 788 marquises, 59 counts, 1,274 barons. But these statistics relate to titles, of which many families had several, in fact a real collection either all belonging to the head of the family or spread over its younger members. Thus the Lanzas had nearly fifty, the Alliatas around forty, and so on.

During Münter's time, an erudite forger for a short time succeeded in making certain grand Palermo families believe that their titles, earned in battles fought by their ancestors at the side of Guiscard and his friend Roger the First, dated back to the middle of the 11th century (at least). In reality, it was Frederick II of Hohenstaufen who had conferred on his barons the more ancient title of count. The marquesses created by Alfonso of Aragon appeared in 1440; in 1544, Charles V created his first duke and in 1563 Philip II made the first prince. As to scions of noble families without a title, it was general practice to give them the title of *nobile* or baron.

But the Sicilian aristocracy, of Angevin, Spanish or Italian origin, remained so powerful until the end of the 18th century that another traveler, the Frenchman Jean-Marie Roland de la Platière, could write "The nobility possesses everything; it nearly governs: the people are at its beck and call". In addition to their extravagant imagination, which so struck Edward Baynes, Sicilian society had very particular characteristics. At the beginning of the 19th century, the feudal structure inherited from Norman kings, and confirmed by the Aragons and Spaniards, was still intact. The great families had conserved the ownership, or at least the sovereignty, over nearly all the land on the island. Notwithstanding, with few exceptions they did not directly exploit their land, which was rented out to entrepreneurs who, in general, sublet it to the peasantry on usurious terms. The middle classes, clergy and merchants enjoyed a very secondary role and were far inferior in number and economic importance to their European counterparts. The three *bracci*, or arms, of the Sicilian parliament, while quite similar to the French *États*, or States, were made up entirely of the nobility. The governors came from the nobility, as did "captains of justice", senate members in large towns and members of the *Sindaco* of Palermo, a sort of plebeian tribune who spoke on behalf of the people in case of confrontations with those in power!

Theoretically, Sicily was an independent kingdom, whose monarch (simultaneously King of Naples) was represented in Palermo by a Viceroy. But for a long time the local barons had been troublesome to their sovereign. Opposition to the King of Naples reached its apogee in 1781 with the nomination of Domenico Caracciolo, a Neapolitan aristocrat, as Viceroy. Caracciolo had been living in Paris for nearly ten years, where he was close to the Encyclopaedists, and came to Palermo with the firm intention of reforming the government and society. But it was not his liberalism which aroused the resistance of the Sicilian nobility;

The coats of arms of aristocratic families proudly dominate walls and pediments.

rather, the nobles pursued a feudal war against the central power, something that their English and French counterparts – who set the tone in Palermo – hadn't done for ages. In any case, many noble families had arrived in Sicily well after the end of the Arab conquest; The Lampedusas, for example, who had come from Capua in the 16th century, claimed Byzantine origins.

The French Revolution, or rather the wars that came in its wake, precipitated things. Ferdinand III of Sicily (King of Naples as Ferdinand IV), the weak husband of the intransigent Marie Caroline, Marie Antoinette's sister, had reigned since 1759. On December 26, 1798, when General Championnet left Naples after declaring it a Parthenopaean republic, Ferdinand sought refuge in Naples. Under the protection of the British army and navy – this was the time Admiral Nelson was living there in the company of the beautiful Lady Hamilton – the king and his court led a brilliant and spendthrift existence. A year

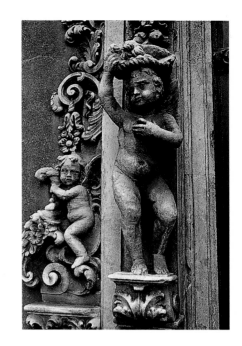

later the military situation allowed Ferdinand to return to Naples, but in January 1806 the king had to flee to Sicily once again. The presence of a 17,000 member British expeditionary force stimulated the economic development of the island, attracted several entrepreneurs from London, and contributed to the beginnings of a Sicilian middle class. But in 1811, Ferdinand imposed a tax of one per cent on all transactions, an action violently fought by the aristocracy. After a few intrigues of a Sicilian-Neapolitan nature, Lord William Bentinck, commander-in-chief and ambassador of His Gracious Majesty, obliged Ferdinand to rescind the tax and then, in 1812, imposed a British style constitution on Sicily.

When he returned to Naples in 1815, Ferdinand abolished this constitution, dissolved the Naples Parliament, suppressed the Sicilian flag, reunited the Neapolitan and Sicilian crowns, and took the title Ferdinand I, King of the Two Sicilies – undoubtedly a unique case of a monarch having reigned under the same name in three different periods. These measures were to burden and complicate Sicilian politics for the rest of the century while the application in Sicily of Neapolitan laws, particularly those making up part of a civil code inspired by that of Napoleon, profoundly upset society. In general, the great families displayed sufficient cohesion to overturn the measures abolishing primogeniture. On the other hand, the suppression of certain privileges brought serious consequences for many of them, particularly those whose age old debts had been aggravated by the cost of making up part of the court in Palermo. While the creditors had once been satisfied with the interest from mortgaged properties, now they were forced to seize the land and sell it at auction. As the new middle class arose, it threatened the superiority of the aristocracy, whose capitals and incomes were decreasing while their expenses mounted. As for the common people, their condition certainly didn't improve; it only got worse.

Revolts against the Bourbons in 1821 and 1848 were boldly crushed. The aristocracy was both confounded and divided: they were not unpleased by the autonomous sentiments of the rebels, but they feared their liberalism. It was the same on May 11, 1860 when Garibaldi and his Red Shirts disembarked at Marsala. But, little by little, with the annexation of Sicily from the Kingdom of Savoy (on the map Turin is further from Palermo than it is from Copenhagen), with the confiscation of church property (from which younger

Palazzo Biscari in Catania:
sculpted putti ornament the
window frames of this palace
built out of lava.

members of aristocratic families destined for the clergy had profited), with the triumph of lawyers and merchants (previously considered as only slightly superior to servants), the nobility resigned itself to the loss of its spiritual and temporal power.

It did not, however, give up its ceremonies or habits. It is this twilight, that lasted until the apocalypse of the First World War, that Giuseppe Tomasi, Duke of Palma, Prince of Lampedusa, Baron of Montechiaro and Toretta describes in his renowned novel *The Leopard*, which appeared in November 1958, a year after the author had died on July 23, 1957. To tell the truth, Giuseppe Tomasi was not the first to put the drama of the Sicilian aristocracy on the literary stage. In 1894 Federico De Roberto had painted in magnificent colors the violent story of one of these families in his book *The Viceroy*. A friend of Verga, a journalist at Corriere della Sera, De Roberto belonged to the naturalist school more attached to social reality than subtle psychology. Another Sicilian, Luigi Pirandello, had described the dramas and misfortunes of Prince Laurentano and his family in his great *verismo* novel *The Old and the Young* which first appeared in 1909 and was revised in 1931.

Giuseppe Tomasi, a man of letters and cousin of the excellent poet Lucio Piccolo, certainly knew one or the other of these works.His own success was far greater. This Prince of Lampedusa knew how to give his characters humanity, weaknesses, contrasts and contradictions that reflected the truth of nature. Also, as a 'Leopard' himself, the author knew better than anyone the customs, people, décor, pleasures and daily lives of the class he was describing. Two autobiographical texts succeeded the novel, making the Leopard a historic and literary prototype. The first, *Places of my Early Childhood*, also by Giuseppe Tomasi de Lampedusa, was published in 1961 in *The Siren and selected writings*. The second was the memoirs of Fulco di Santostefano della Cerda, the Duke of Verdura and Marquis Murta La Cerda, written in English, rewritten by the author in his mother tongue as *A Sicilian Childhood*, then translated and adapted by Edmonde Charles-Roux under the title *Une enfance sicilienne*.

There is certainly a resemblance between the Leopards of Sicily and other aristocracies. The near obssesive refinement they displayed during their last flowering is a classic phenomenon. There are traits of "Little Lord Fauntleroy" in Fulco di Verdura, and echoes of Chateaubriand in Lampedusa. But the Sicilian nobility was by far the last feudal phenomenon in Western Europe, a strange survivor during the age of railroads and triumphant science. Above all it was marked by a particular extravagance that inspires Fabrizio Salina, Lampedusa's hero whose coat of arms bears a dancing leopard: "All Sicilian manifestations are dreamlike, even the most violent: our sensuality is a desire to forget; our bullets and knife wounds express a longing for death; our laziness is the desire for voluptuous immobility, another form of a death wish, like our cinnamon and black salsify sherbets."

Above. *Detail of an armrest of a Baroque style bench in the ballroom of the Palazzo Gangi.*

Opposite. *The terrace of the villa built by Prince Palagonia in 1797. In the following century, it passed into the hands of another great family, the* Notabartolos of Sciara. It was built on the site of an isolated farm, in a place known as Mezzomonreale, on the south-east edge of Palermo.

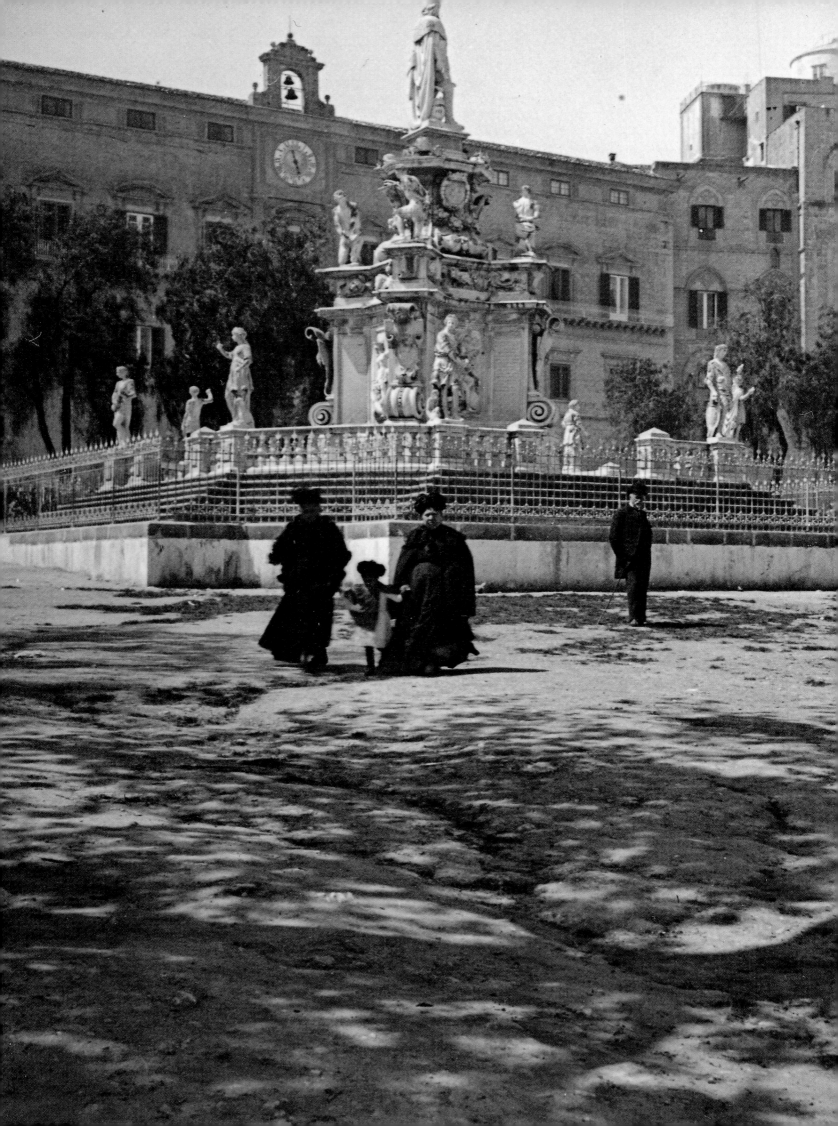

In town

Opposite. *A monument
dedicated to Philippe V of
Bourbon (Philippe d'Anjou,
grandson of Louis XIV, 1683-
1746). Behind is the Norman
Palace, the former royal
palace.*

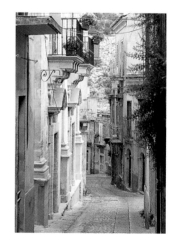

Thanks to the large incomes they had enjoyed over past centuries and the institution of primogeniture which avoided the dissolution of their fortunes, Sicily's great families had several residences: one in town, another a short distance away, and one or several estates. Lampedusa had at least six: the town house in Palermo, the villa at Bagheria, a palace at Toretta about twenty kilometers from Palermo, a country house at Reitano halfway between Palermo and Messina, the great castle of Santa Margherita de Belice as well as two others "where we never went", a house and castle at Palma de Montechiaro.

When speaking of town, it was naturally Palermo. At the beginning of the 18th century, Palermo and Messina were of nearly equal importance, and the Viceroy spent six months in each city. But the plague in 1743, a great earthquake in 1783, the ferocious bombing of the town by the Neapolitans during the repression of 1848 had all considerably reduced the importance of Messina. Catania, a town in full expansion, had only 70,000 inhabitants in 1870 – in contrast to Palermo with 200,000 – and although Federico De Roberto set a good part of the saga of the princes of Francalanza there, it was above all a middle-class town. As far as Siracusa and Agrigento (then called Girgenti) were concerned, these vener-

able cities of antiquity had less than 20,000 inhabitants. Finally, what Lampedusa described as "the aversion of the Sicilian for the countryside", as well as the attraction of the Bourbon court when it resided in Palermo, precipitated a change noted by travelers since the previous century. In 1786, Heinrich Bartels wrote: "Now that the most favored part of the aristocracy is coming to Palermo to spend its money and direct the affairs of state... Sicily is emptying out and Palermo is over-filled. In short, a well-born Sicilian had to be a misanthrope, seriously penniless, or pursued by justice if he wasn't seen in Palermo at least a few times a year".

In 1877 A.J. du Pays described Palermo at the time of the Leopards in his book *A Guide to Italy and Sicily* as follows: "The town is in the form of an elongated quadrilateral, one of whose sides runs along the sea. Its circuit is around 22 kilometers, and includes 15 city gates. There are narrow and tortuous streets; two are broad and regular, cutting in at right angles and creating a sense of order. These divide the city into four districts of equivalent size; the *Loggia*, the *Kalsa*, the *Albergaria* and *Siracaldi*, commonly known as *Capo*. Their point of intersection is the Piazza Vigliena, also known as Quattro Cantoni, from whence one can see the four principal gates of the city. This section is small, circular, and filled with statues, among them effigies of Charles V, Philip II, Philip III and Philip IV of Spain. Via Toledo, one of these streets leading to the sea, is a mile in length and known today as the Corso Vittorio Emmanuele. The section that stretches between the central square and the sea is known as the Cassaro (Al Kasar); the other is the Via Maqueda or Strada Nuova. It continues at the O., outside the city walls, by streets known as Ruggiero Settimo and Strada della Liberta".

By the 19th century, the city had already started developing towards the north but essentially its configuration hadn't changed since the first half of the 17th century. Palermo, in fact, found itself relatively spared from the natural cataclysms, earthquakes, or volcanic eruptions which had ravaged Messina, Catania, Ragusa, Noto and so many other Sicilian cities. This fact also explains that, contrary to what one sees in these cities, which have been completely rebuilt since the last catastrophe, civil architecture – as far as the exterior is concerned – presents a great many styles. Baroque certainly in the Villafranca, Gangi, Ugo or Belmonte Russo palaces, but the Marchesi or Aiutamicristo palaces date back to the 15th century, the Abatellis palace to the century before, and that of the Prince of San Cataldo is Gothic-Mauresque, from the recently fashionable "Troubadour Style". Many of the rest, such as that of Lampedusa,

The Corvaia palace in Taormina. Built in the 13th century and remodeled at the beginning of the 14th, this was the seat of Parliament in 1410 before passing to the Corvaia family in the 16th century.

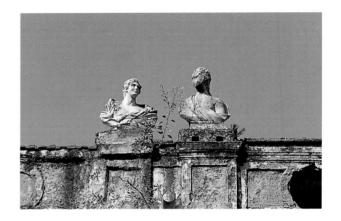

Stone portrait busts crown a wall in the district known as Del Pigno.

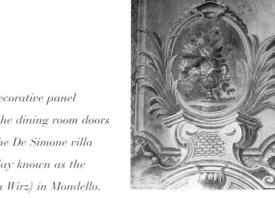

A decorative panel on the dining room doors of the De Simone villa (today known as the Villa Wirz) in Mondello.

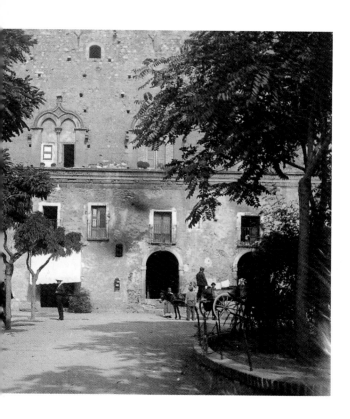

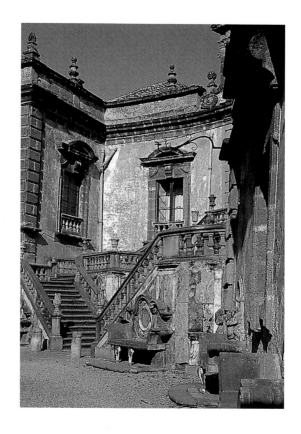

A tochetto, *an upstairs gallery that is accessible from a double staircase.*

had no façade of note. In fact, the siting of a great many palaces has nothing to do with the power or prestige of the family involved; one could find grand bourgeois on Via Maqueda or Piazza Marina. On the other hand, the Via Lampedusa, where the writer's palace was at number 17, was hardly even "decent", and the Via Montevergine, where Fulco di Verdura lived, was "narrow, sloped, slippery and without a sidewalk", according to the description of this memoir writer. The age of a family could be often deduced, as was the case of the Verduras, by the accretions brought over the centuries to the original building which, as Fulco wrote, "tolerated each other, were juxtaposed like patches added over the centuries to an old ball gown". But, whatever their age or location, the palaces of the Leopards could be distinguished by enormous doors for carriages, a reminder of a Sicilian passion for horse-drawn vehicles which always struck foreign visitors.

One would stop an instant before going through the gate. Here, we must settle a little problem of vocabulary as in Sicily, more than elsewhere, the nature of things counts more that their appellation. No Leopard would have used the term Palazzo, or palace, to designate his dwelling. He would have left that expression to the lower classes, accountants, lawyers, tradesmen, or servants, while he would speak of his Casa, or house, with a capital C when writing, but never when speaking. In fact, in Italian the word "palazzo" designates any large building, noble or ignoble, of which those that house a state organization are to be absolutely avoided.

One would enter a large courtyard (space was needed to permit the coachmen to maneuver, unless there were two coach gates). At the end could be found a double flight of stairs on the façade leading to a superior gallery, the *tochetto*, and always inside the great staircase of honor, embellished by majestic statues and exotic plants. But, before allowing the visitor access to the *piano nobile*, where the reception rooms were located, the porter would perform a little bell ringing ceremony to warn the servants. At the Verduras there was one ring for a single man, two for a couple or a lady, three for family members, four for the master or mistress of the house. For a priest, the ring was the same as for a single man, plus a lighter note. The Lampedusas greeted a princess with four rings, a duchess with three, and more common visitors with just one. It was at the Leopard's house that the term "concert" took on a real meaning: if a princess, duchess and a friend of each of these ladies arrived on a single car, the porter rang ten times, first four, then three two and one. The ceremony was particularly impressive for somebody like Don Gesualdo, one

of Verga's characters, who was merely a *parvenu* who had married his daughter to a Duke.

The large amount of visitors was a surprise to people from abroad. In Sicily, a land of cheap and abundant workers, servants represented a quarter of the population even after the advent of electricity, that is to say a larger percentage than in Paris at the time of Louis XIV. A rigorous and complicated hierarchy regulated this army which, as in the 17th century, wore sumptuous and anachronistic livery. At the top of the pyramid was the major-domo and chief governess, the *padrona di casa*, whose powers were near to that of the owners, the *maestro* and *maestra di casa*, who depended on them totally. Below these, were a lot of lesser people such as grooms, cleaners, laundresses and kitchen maids often brought in from the county estates. In addition there were two personalities whose titles display their importance; the head of the kitchen known as *monsu*, a Sicilian deformation of the French *monsieur* and the coachman who was addressed by his first name preceded by *gnuri*, a contraction of *signuri*. To this could be added secretaries, accountants, archivists, librarians, who always wore black livery and who were granted the title of "don", as were chaplains. All these were rounded out by a few people of either sex, old cousins and distant relatives who had fallen on bad times, and were given odd jobs to do. At the beginning of the 20th century, the relationship of Sicilian aristocrats with their houses echœd with medieval feudalism. The *Ave Maria*, for example, was said together every evening, mixing sexes, ages and social conditions.

But let us continue our visit. We might come upon an interior garden; some were sumptuous, others minuscule as in the Gangi palace, where the vestibule had been transformed into a small hothouse. Then there would be a seemingly endless suite of small and grand salons, severe or Baroque, sometimes empty (according to an ancient custom by which furniture was moved around as needed), sometimes filled with furniture of all periods and bric-à-brac collected over the centuries which, due to indulgence or familial piety (often two synonymous notions in Sicily), had never changed place and was rarely dusted: 18th century Chinoiserie, snuff boxes or Capodimonte biscuit porcelain with light-hearted subjects. As should be in a grand house, ancestral portraits fought for the eye against scantily dressed nymphs. But on the walls were two particularly Sicilian specialties. The first, paintings with the family coat of arms – a curious example of a literally abstract art – that bore witness to the family's power (quite often illusory). The other, scenes like those that haunted the childhood of Fulco di Verdura, reminds us of the fascination

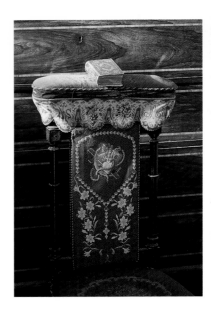

A petit point prie-dieu
in the private chapel of the
Gangi princes in Palermo.

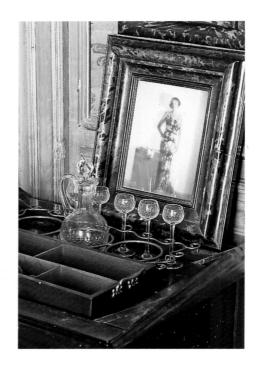

A photograph of Stefania
Mantegna de Gangi
in a tortoiseshell frame.

The gardens of the Villa Igiea in Mondello. Built in 1908 for the Florio family, the Villa Igiea is the masterpiece of Ernesto Basile, and the best example of the Liberty style in Palermo.

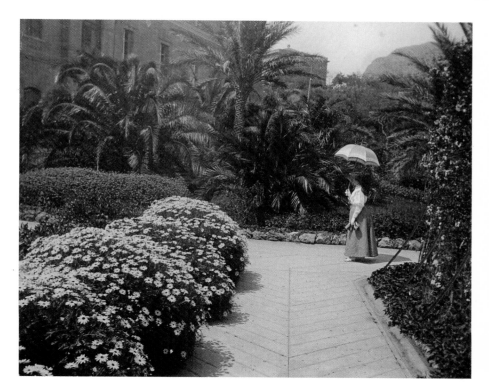

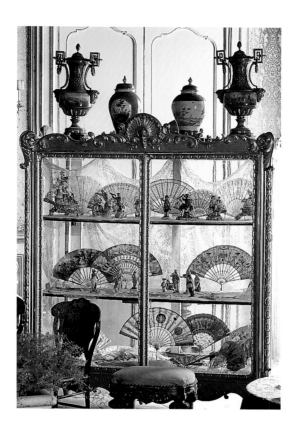

Collection of fans of the 17th and 18th centuries in the palace of the Gangi princes in Palermo. On the top are Sèvres and Chinese vases.

Dora di Rudini, cousin of Baroness Caterina Beneventano.

that death had always held for Sicilians: "We only saw martyrs showing to the people the instruments of their agony… or other bleeding ascetics, always in rags or naked, and distressingly emaciated, their eyes riveted towards the sky while they gave themselves dreadful *mea culpas* with the help of whips or large stones laid out on their chests".

In the daytime, the salons were plunged into darkness. At the appropriate time, they were lit by the large Murano chandeliers favored by Sicilians over the last three centuries. In the 1860s, when Antonio Salviati revived the Venetian glass industry that had died with the fall of the Serenissima Republic in 1797, Palermo's palaces were finally refurbished with the colorful glass.

At the center of this complicated layout of salons was what the Duke of Verdura called the *galleria*, the large living room which was only opened on such exceptional occasions as marriages, balls, receptions and days of mourning. A visit to the palace would always stop at the bedrooms of the master and mistress of the house. Today we would be surprised by the austerity of the former. A simple iron or copper bed, a prayer chair and a few absolutely indispensable pieces of furniture. It was in the bedroom that sin was fought – one might say the same of the bathroom. Such was the Anglomania at the end of the century that the Liberty style was immediately taken up, but the Leopards were never convinced to give their bedrooms the same importance or comfort that prevailed across the English channel.

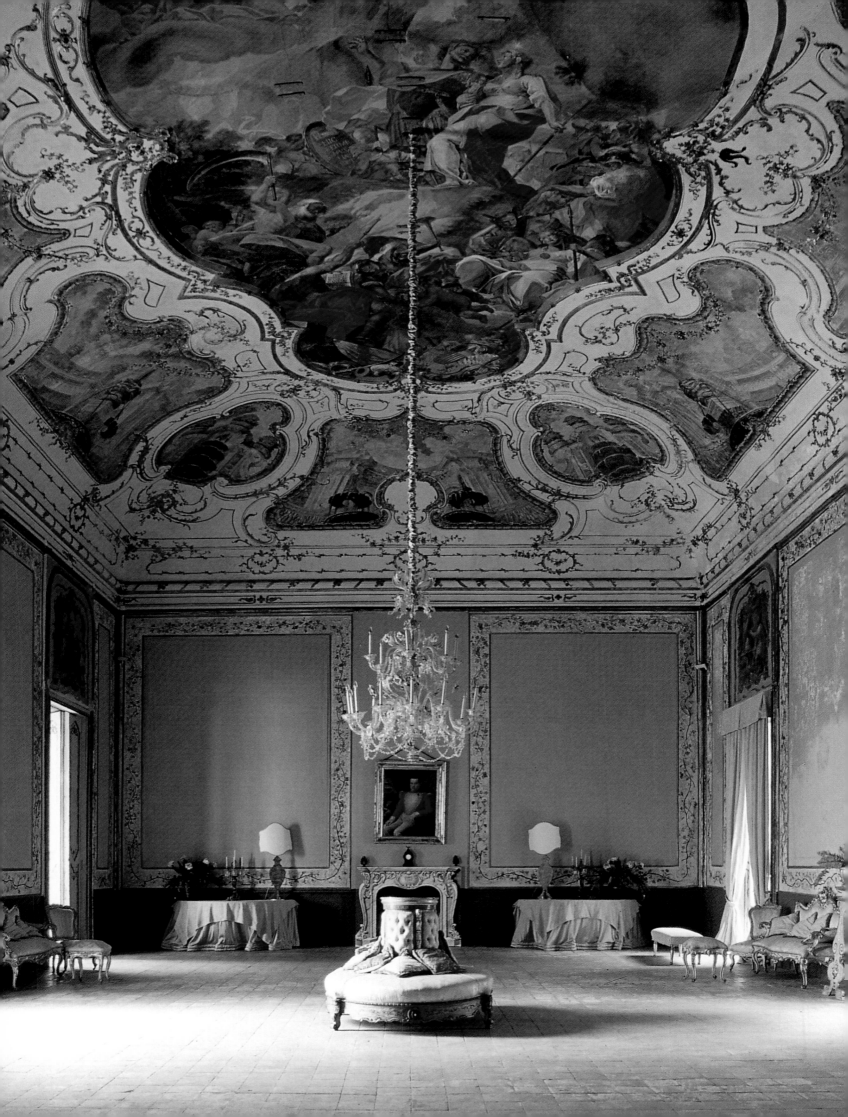

The foot of a Napoleon III ebony and bronze candlestick wrapped in passementerie *at the Aiutamicristo palace.*

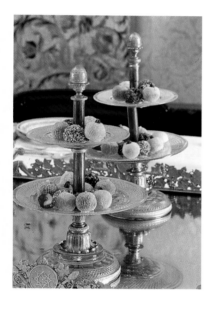

Sicilian pastries with pignoli *and nuts.*
Opposite. *the ballroom in the Aiutamicristo palace in Palermo, property of the Calefati di Canalotti family from Messina. It was built by Andrea Gigante in 1763 and the frescoes are by Giuseppe Cristadoro (1711-1808).*

Eighteenth century porcelain in the Gangi palace.

Table settings in the dining room of these aristocrats were on the other hand, the epitome of luxurious homeliness. The table was decorated with a luxury worthy of the Kingdom of the two Sicilies; solid silver, superb and varied plates, very fine table linen, and the prince himself served the soup to his children, to the governesses and tutors. A little later, Fulco di Verdura bore witness to the ravages caused to the local aristocratic diet by Anglomania; steak and kidney pie, Yorkshire pudding or mince pie (locally transposed to *mezzosposo* or "half husband"). If tea time was a must, the British style did not succeed in chasing away the alcoholised chocolates, nor such local refreshments as *gelú i mulinu*, a concoction based on watermelon juice, jasmine water, vanilla, chocolate and other ingredients, nor the multiflavored ices known as *granite*.

But apart from parties, formal dinners or receptions, there were often guests at the Leopards' tables. Thanks to an oriental sense of hospitality, an understandable curiosity of a people distant from the great European capitals, the age-old Sicilian custom of *commendatizie*, or letters of introduction, opened up the most closed doors for their bearers and the local aristocracy literally fought over entertaining visiting foreigners. This tradition remained intact until the second half of the 19th century to such an extent that foreigners were abducted from their hotels to live in local palaces and villas. During the visit of Richard Wagner to Sicily from November 5 through April 13, 1882, even his wife Cosima (though ill at ease with these meridional Catholics, whose palaces she described as being "richly decorated but of a childish and picturesque taste") recognized that Sicilian hospitality was "extremely kind and natural".

Everywhere there were carpets and curtains, so many that you didn't know where to step until arriving at the great marble staircase where you encountered the porter, a real character with a great beard and extravagant livery, who examined you from head to foot with a wrathful look and if, by any misfortune, he didn't like the look of you, he would cry out from his large cage, "There is a mat to wipe your feet". An army of good for nothings was there, lackeys and valets, who were sweeping without opening their mouths and trod lightly and served you without saying a word or taking an extra step, with such condescension that any desire you had would pass. All this was regulated by the ringing of a bell with the ceremonial of the high mass – just to get a glass of water or enter into the apartments of his daughter. Giovanni Verga, *Mastro-Don Gesualdo*

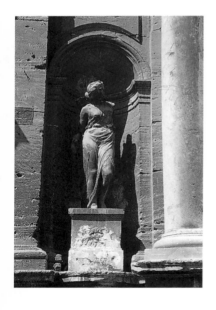

It was Prince Gangi who brought Wagner to Palermo in 1881. There the composer conducted Siegfried's Idyll, *finished the orchestration for* Parsifal *and arranged the marriage of Blandine, the daughter of von Bülow and Cosima, granddaughter of Franz Liszt, to a Sicilian prince.*

Left. *A balcony overlooking the courtyard of the Gangi palace in Palermo.* Opposite. *The Gangi palace.* Overleaf. *The entrance to the Biscari palace, built by Antonio Amato, and one of the masterpieces of Sicilian Baroque architecture of the 18th century.*

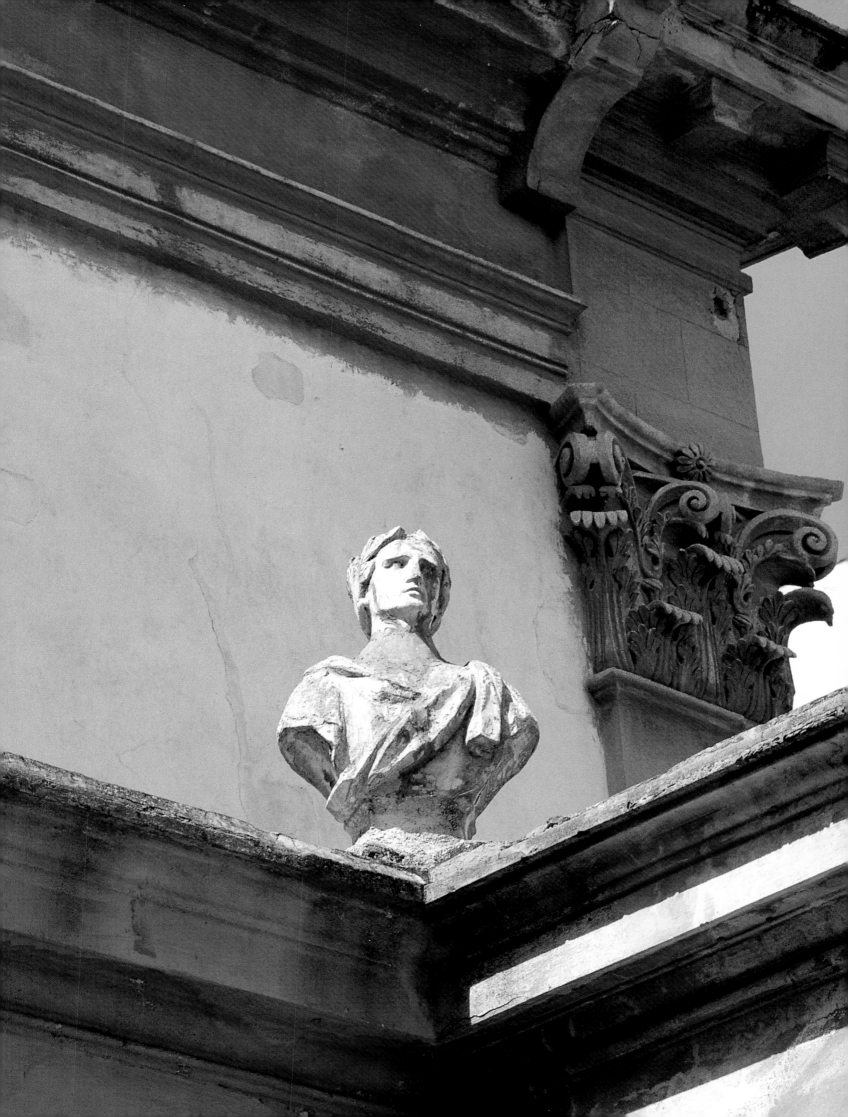

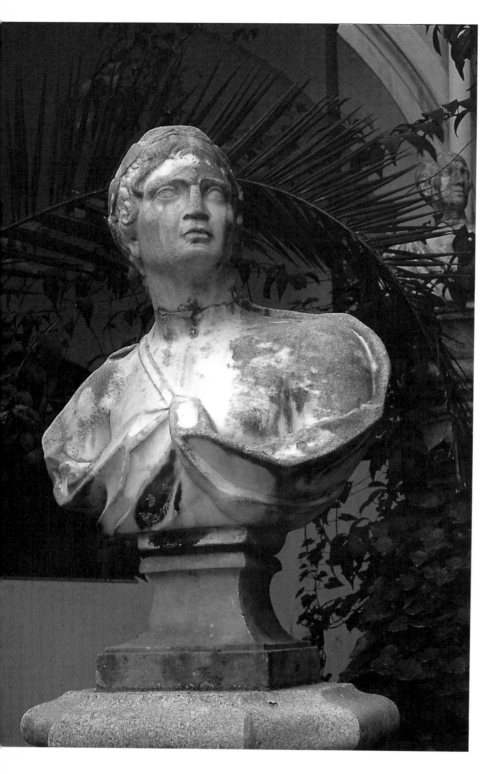

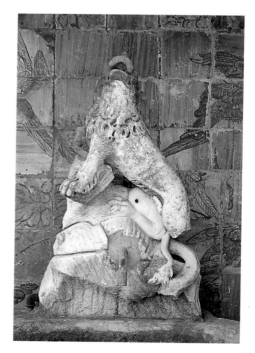

Opposite. Below right. *Detail of a staircase in wrought iron and stucco in the Biscari palace.* Above left. *A caryatid holding up a balcony of the upper floor in the Ugo palace.* Overleaf below. *Detail of the balustrade of the monumental salon of the Beneventano palace in Siracusa.* Overleaf above. *Majolica tiles of the 18th century which were taken out of the ruins of the Gangi palace and reinstalled on the terrace of the Lanzi Tomasi palace in Palermo.* Page 27. *Donna Franca Florio.*

Above. *A Sicilian marble head in the Palazzo Gangi.* Right. *A fountain statue of a leopard or a lion.*

Opposite. Above right and below left. *Sicily is extremely rich from a botanical point of view, as can be seen in these plants (*Aeonium hawortii *and* Setcreasia purpurea*) in the Lanza Tomasi palace.*

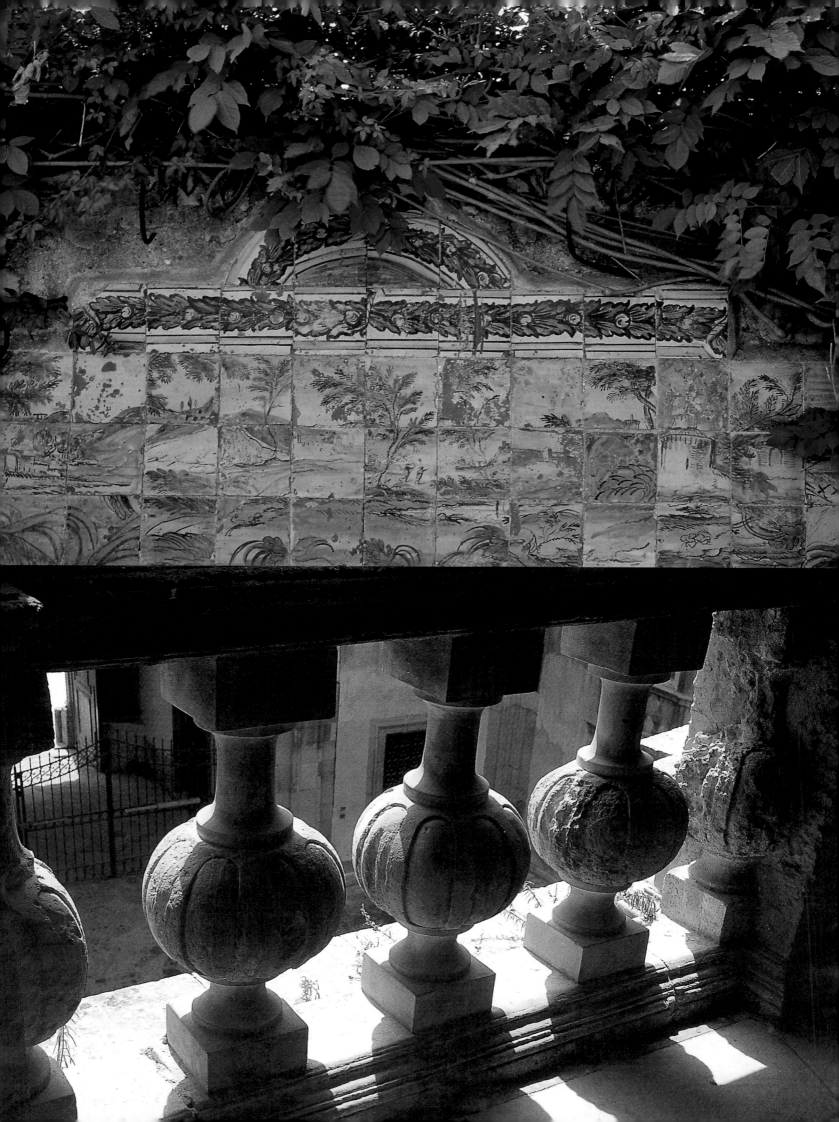

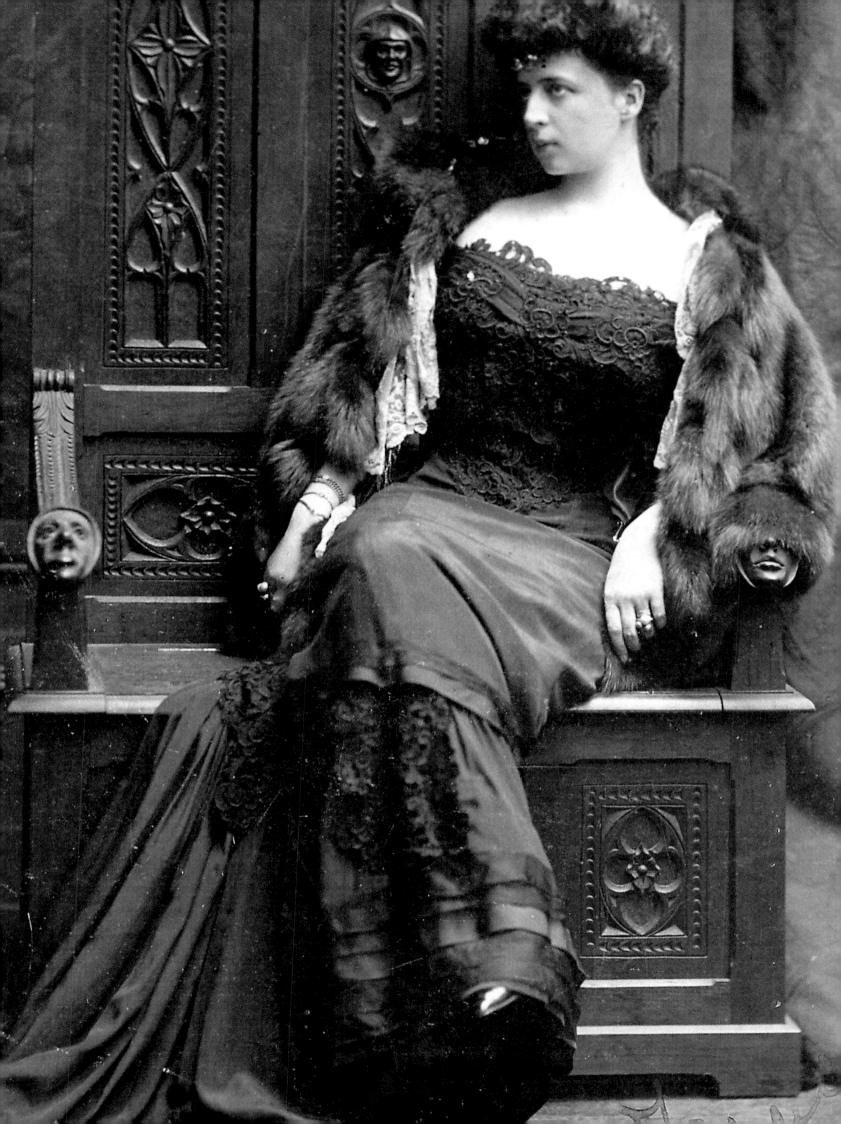

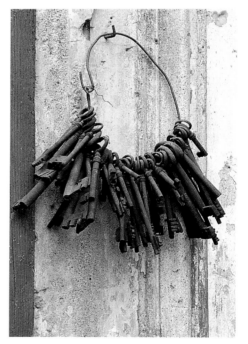

The set of keys that opened all the doors was often in the care of a member of the family. *Opposite. Interior staircase of a neo-classical palace of the second half of the 18th century, which has not abandoned itself to Baroque folly. Here we may be seeing the influence of a family from the Lombard nobility who came to Sicily in the 17th century. Overleaf. The ceremonial staircase of the Gangi palace in Palermo, ornamented by statues of the seasons by Marabitti.*

In The Leopard, *Tomasi de Lampedusa wrote as follows about the Gangi Palace. "Tancredi wanted Angelica to know the whole palace, with its inextricable series of rooms for guests, its salons for receptions, its kitchens, chapels, terraces, passages, staircases, porticos, and above all the neglected and abandoned apartments which made up a complicated and mysterious labyrinth".*

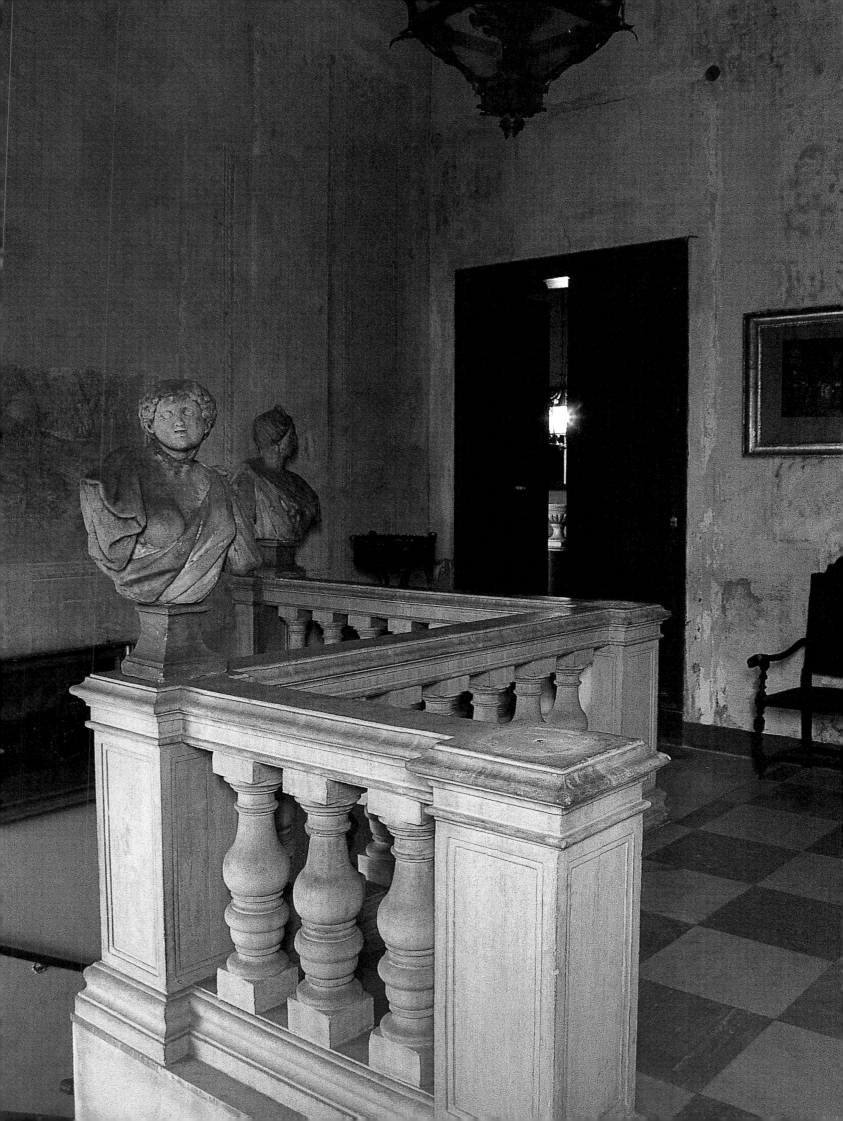

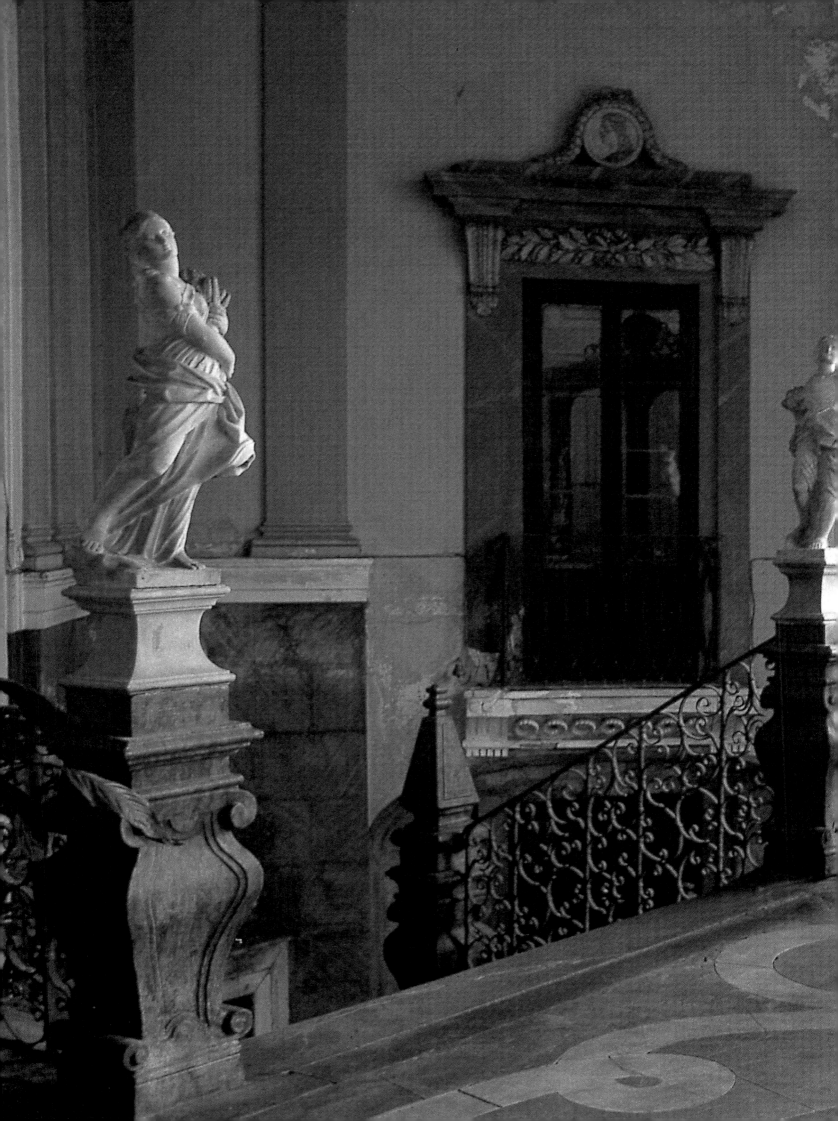

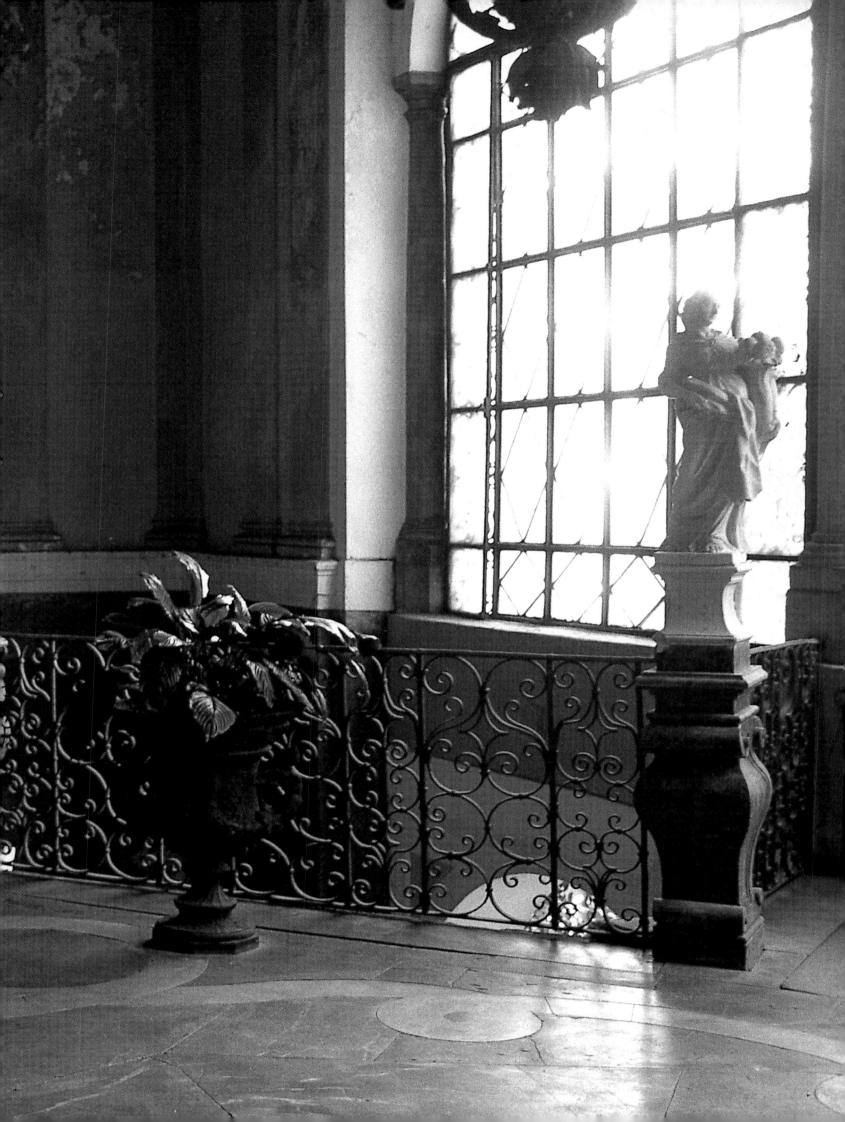

A door in green material led to the antechamber whose walls were covered in green silk on which hung several paintings; six ancestral portals crowned the balcony and the two doors. From here one could look at the row of salons located on the front of the house. For me, that is where the magic of light started, always so full of atmosphere, so varied whether in the heart of the narrowest streets, or in a sun-filled city like Palermo. Light was sometimes tempered by the silk curtains of the French windows, or, on the contrary, reflected off a gilt frame or the yellow damask of an armchair. In the summer, on occasion the salons were plunged into shadow, but one could still perceive through the closed shutters the powerful clarity that reigned outside. Or perhaps there was, according to the hour, a single shooting ray, like that on Mount Sinai, crawling with innumerable grains of dust which caused vibrations in the tonalities of the uniformly ruby red rugs. The magic and varied assortment of incandescence and color never failed to bewitch me. Lampedusa, *The Siren*.

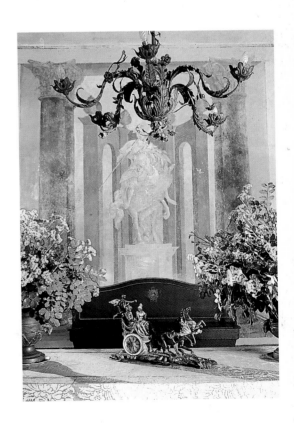

Above. *Salvatore Cecala, cousin of Baron Francesco De Simone Achates.* Right. *A wooden clock, carved in the form of an Auriga.*

Left and overleaf. *Antechamber of the Beneventano palace in Siracusa. The walls are covered by frescos in the Pompeian taste.*

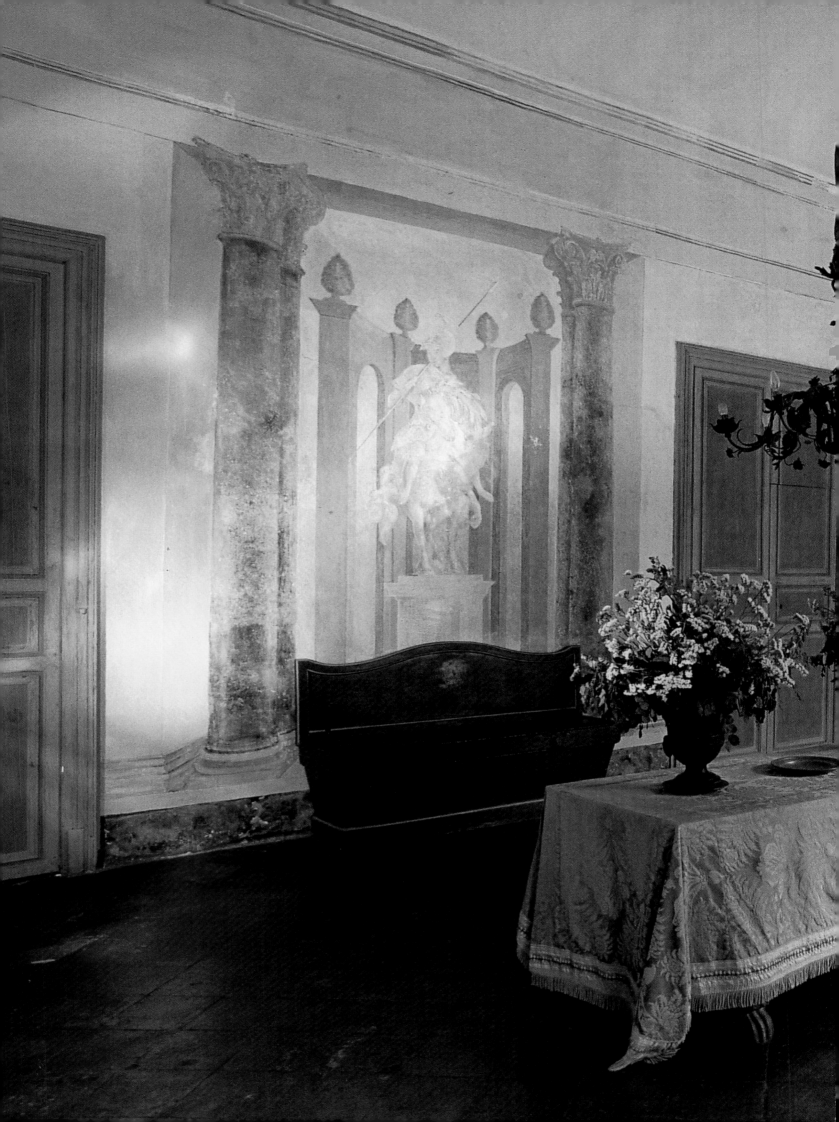

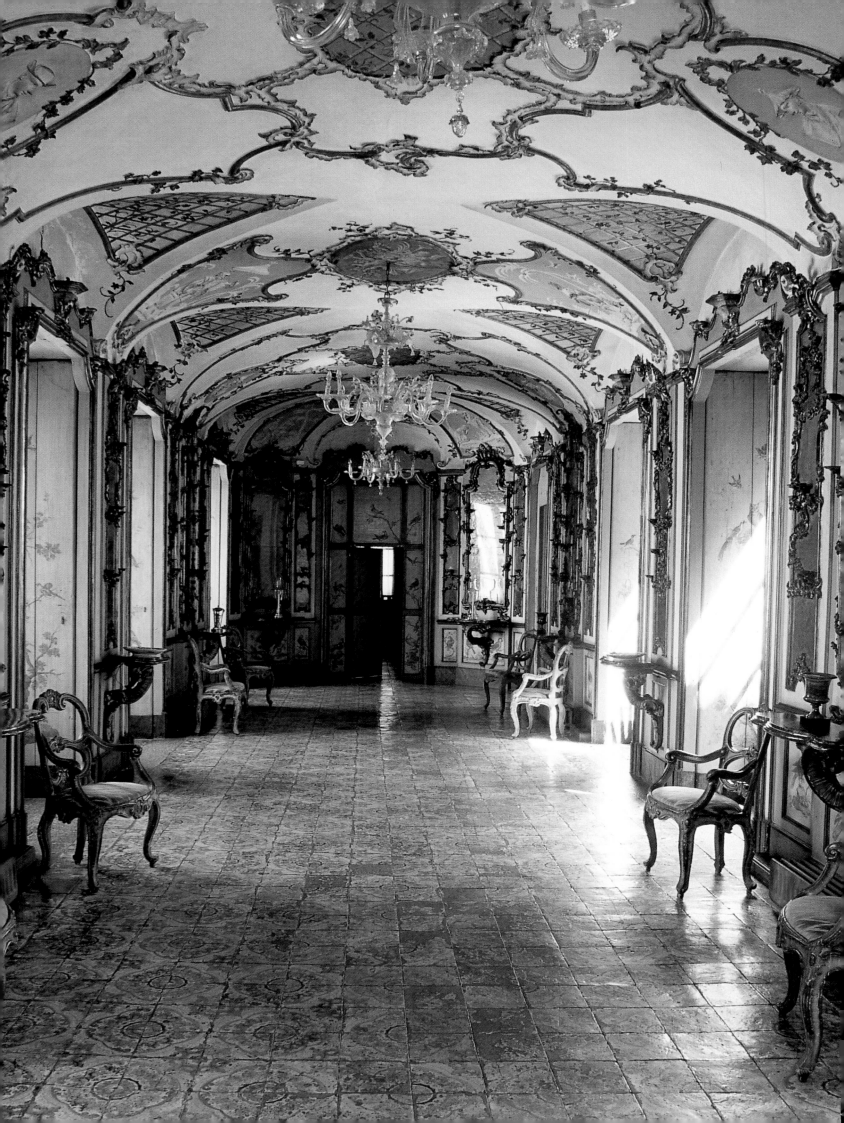

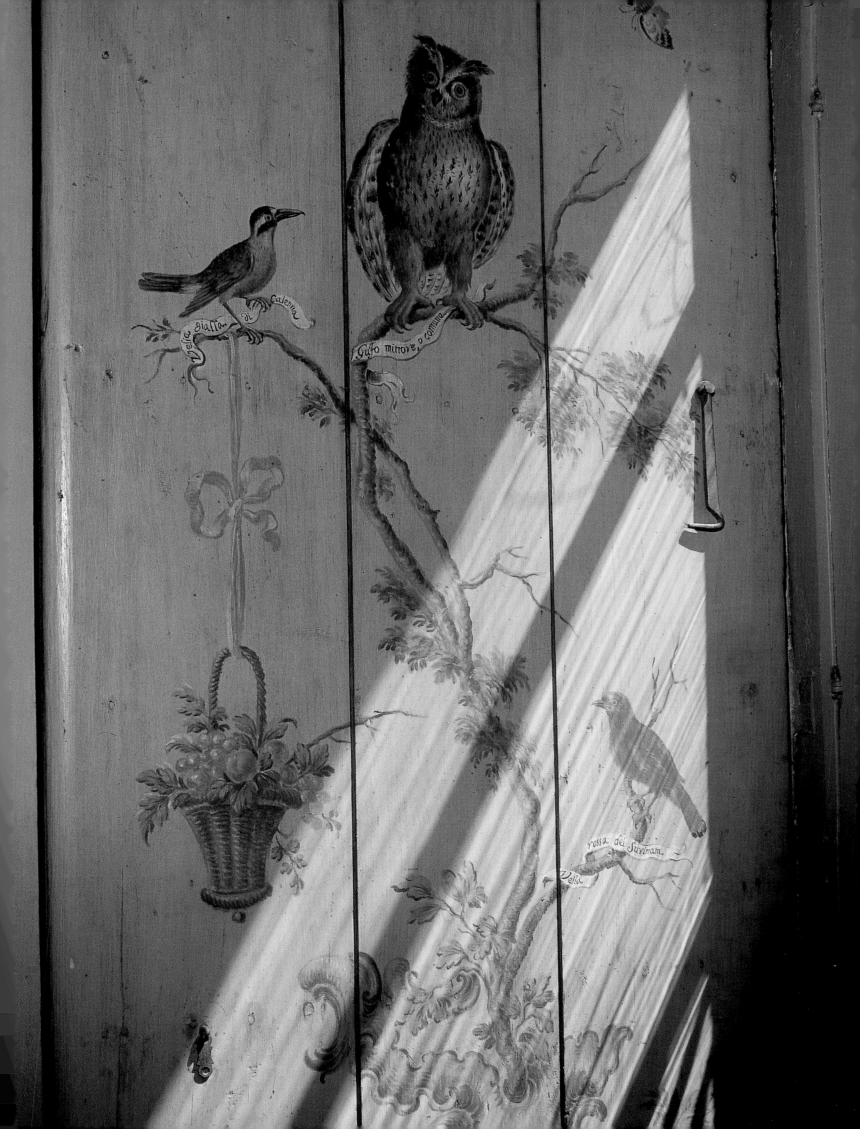

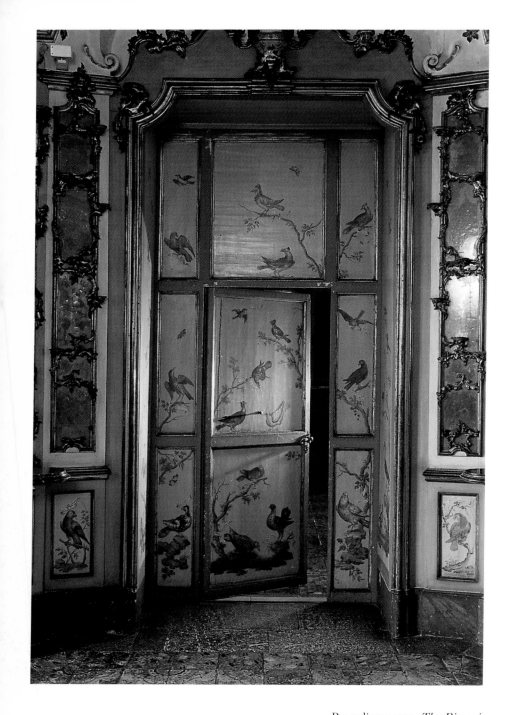

Left. *On consoles placed between the mirrors are Meissen porcelain birds, similar to those painted on the paneling. The terracotta floors (detail opposite) are from Caltagirone, and seem to be a setting for the Sicilian light. Goethe, who lived in the Biscari palace in 1787, was particularly fond of this part of the house. Below. Caterina Ugo, the Marchesa Delle Favare.*

Preceding pages. *The Biscari palace in Catania. In 1695 Prince Vincenzo Paternò Castello commissioned local artisans to decorate this gallery with birds inspired by Buffon's* Natural History. *The paneling and stucco are in the Venetian 18th century style.*

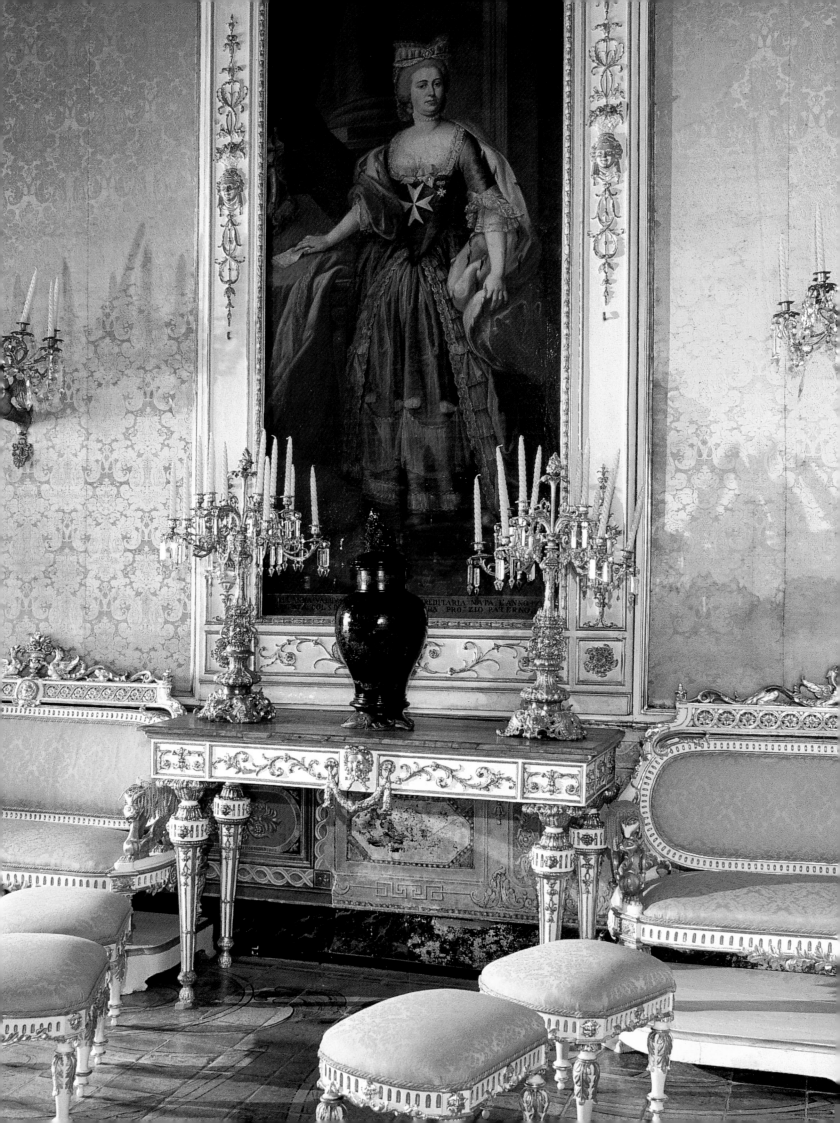

Overleaf. *The "grotesques salon", transformed in 1749, decorated with frescoes in the Pompeian style. The furniture is 19th century, but in the 18th century style, and the ebony Chinoiserie chairs are highlighted in gold. The ceramic tile floors are from Caltagirone.*

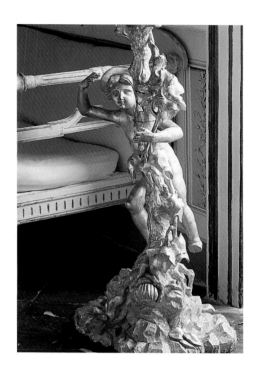

Left. *Portrait of Marianna Valguarnera who, in 1750, undertook the transformation of the Gangi palace, thus making her contribution to its splendor. The Sicilian Baroque-style furniture was commissioned from local artisans by the princess.* Above. *A 17th century gilt* jardinière *from the Beneventano palace in Siracusa.* Opposite. *A corner console holding a bronze gilt and porcelain candelabrum.*

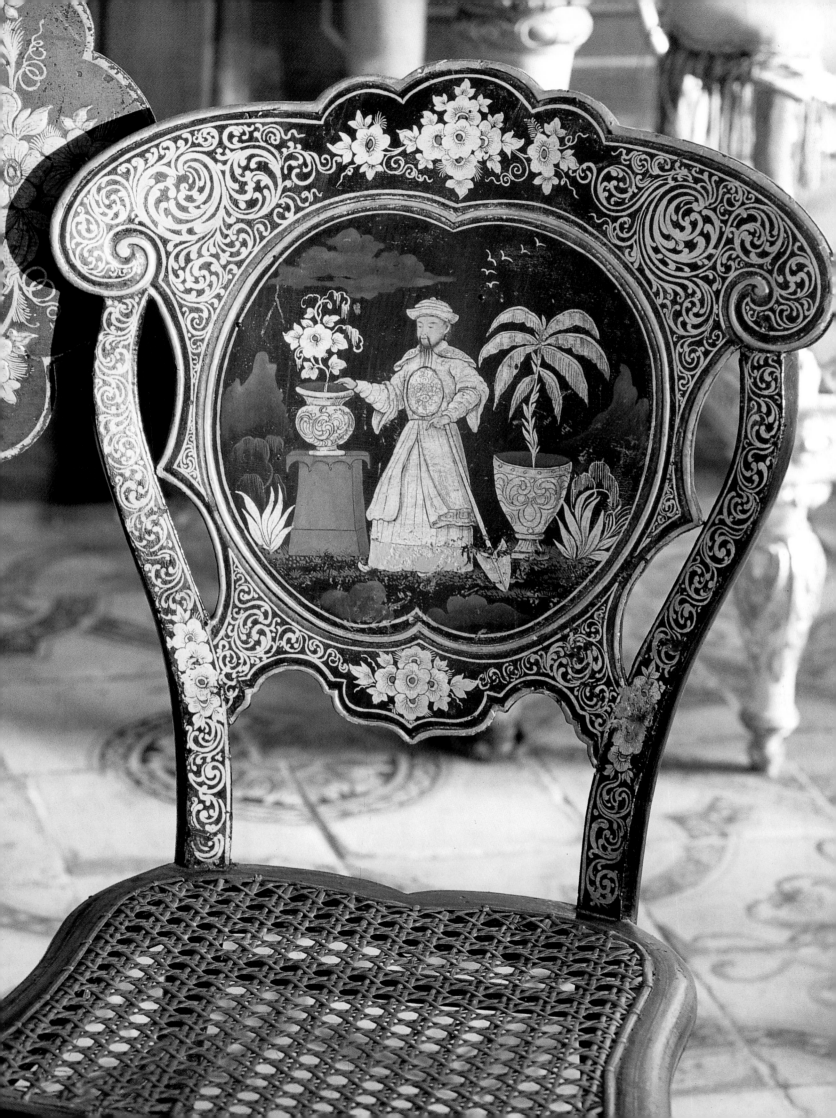

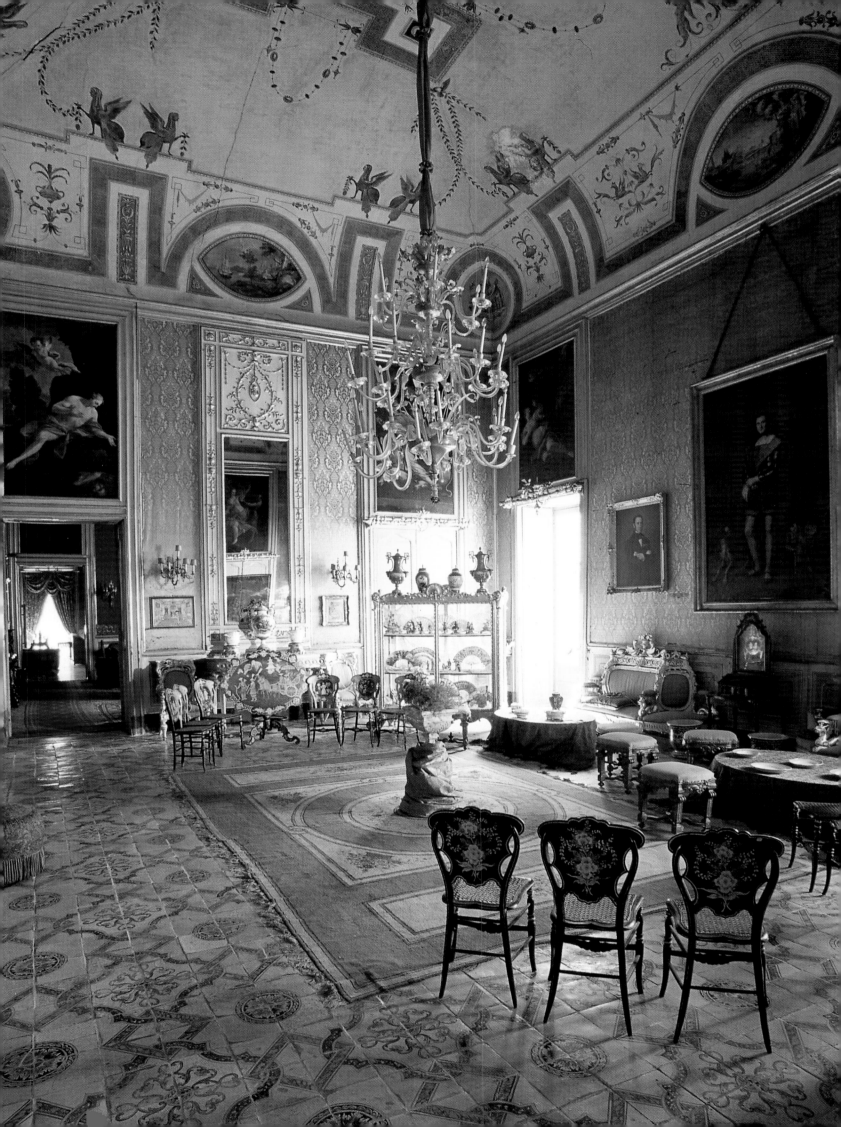

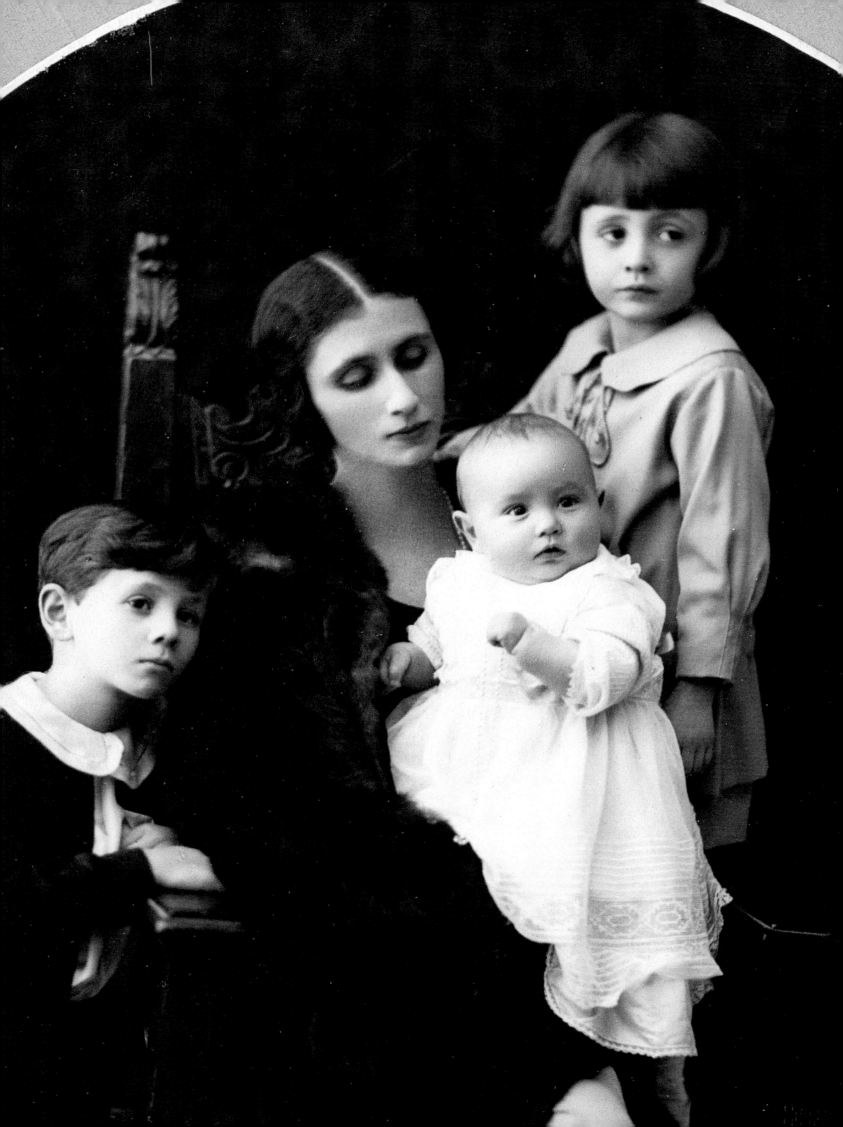

The character
of a Leopard

When discussing this subject, we must limit ourselves to "Character" in the sense of de la Bruyère, for the Leopard is more of a social than a human phenomenon. In this respect, Lampedusa's hero, Fabrizio Salina, who was lucid, subtle, detached and scholarly, is hardly the prototype. Still, Lampedusa had chosen to illustrate the elder son; the worries of a second son would have been very different and varied. In fact, like the right of primogeniture that had been abolished by law, the fate of the less fortunate younger members depended on the importance of their families. Sometimes the family fortune was large enough to assure an honorable, even brilliant existence for younger members of an aristocratic family; otherwise, they had to live off the pickings of their elder brother, go into debt, enter the orders or find a rich wife. But in Sicily, the chasm that separated the middle classes from the aristocracy severely limited the sort of fortune hunting that the French dandy Boni de Castellane pursued by marrying the extremely rich daughter of the American railroad tycoon Jay Gould. A girl needed the backing of the Florio family, the richest in Sicily, to enable her to marry Pietro Lanza de Trabia, the scion of Sicily's most aristocratic family, in 1885. In Federico de Roberto's novel, which takes place a few years later, Lucrezia de Francalanza wants to marry

– for love – the well-endowed Don Lorenzo Francalanza, of the nobility of the robe. She was told quite emphatically "Only asses believe that the nobility of the robe is equal to that of the sword…And at present, what is happening?…Every notary takes himself for a prince…At one time there were barons with ten quarters of nobility. Today, they have ten shillings instead".

Although the leopard has no feminine counterpart in heraldry or zoology, we must speak of mothers, daughters and sisters. The fact is that the greatest common feature between the most noble Sicilian aristocrat and his meanest peasant was the joy brought by the birth of a son and the distress at the appearance of a daughter! What misfortune was brought to somebody like the Marquis of Villabianca who had one son and six daughters. At the end of the 19th century, when the assets of such families had been considerably diminished, the dowry, without which a daughter could not be married off, was a considerable financial sacrifice. And that wasn't all! To the dowry a parent had to add the considerable, even ruinous, expenses caused by the extravagant festivities one had to give to celebrate a marriage. When Donnafugata, Lampedusa's hero, first heard the bell toll, his first thought about the man who had just died was, "How lucky he is. He no longer has to give a damn about the dowries of his daughters". The obvious solution was to put as many daughters as possible into convents – the Marquis de Villabianca did this with all his daughters – but even that entailed expenses; the obligatory party given when a girl took the veil was not much less expensive than a marriage, and a parent had to pay for the quite onerous maintenance of the new nun. If morality was strict, the sisters hardly lived less luxuriously, eating such delicious pastries as those made of almond paste at the monastery of Martorana, observing the carriages go by from the windows, or participating in Palermo's favorite exercise, scandalmongering. A good number of convents looked directly out at the Corso Vittorio Emmanuele (ex Via Toledo), the great artery that led to the Piazza Marina, where all the fine life met up. In other convents, the curiosity of the boarders could be satisfied thanks to a special arrangement described by Alexandre Dumas who, like all foreign visitors, was quite astonished by the custom. "The first thing that struck my eyes when I looked out at the street was the third floor of a house opposite us which had an enormous, cage-like balcony running the entire width of the house; it had a rounded shape, rather like the belly of an old secretary, and the grille work that covered it was so closely knit that one could not see through it. I asked the

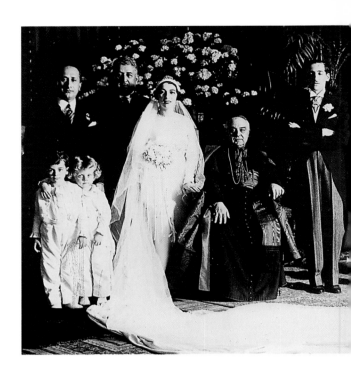

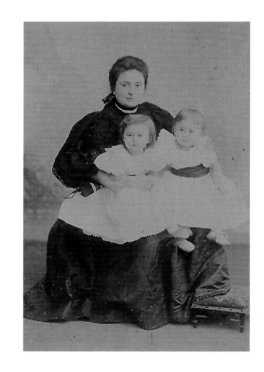

The Marchesa Silvia Paternò di Spedalotto, with her twins Achille and Ettore in 1895.

The marriage of Prince Raimondo Valguarnera in June 1932. As was usually the case, the priest who celebrated the marriage poses between the bride and groom for the family photograph.

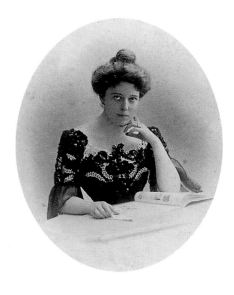

A young woman at the beginning of the 20th century is seen wearing a St. Gallen lace corsage.

master of the house the meaning of this odd machine that I had seen on several houses, and was told that it was a balcony for nuns. In the environs of Palermo, as in Palermo itself, there are around twenty convents for the daughters of the nobility. In Sicily, as elsewhere, nuns are supposed to have no relationship with the outside world, but as Sicily is the most indulgent of countries, they are allowed to look at the forbidden fruit but not touch it. Thus, on holidays, they can take their places, in but not on these balconies to which they come, even from far away, by means of underground passages and hidden staircases. I was assured that, during the revolution of 1820, some nuns who were greater patriots than others, were carried away by their nationalistic enthusiasm to the point that they threw boiling water on the Neapolitan soldiers below. Hardly had this explanation been given to us than the cage was filled with invisible birds, who started cackling in competition with each other. As far as I could judge by the noise, the balcony must have held at least a hundred nuns".

The education of girls differed little from that of boys, in both cases relying on principles that went back to the 17th century; reading, writing, a little Latin and music (piano for the girls, violin for the boys), horseback riding and fencing for the boys or, for the girls, "darning socks, sewing in the French manner, – exercises no doubt destined for future charitable works – embroidering with white, gold or silver thread". For both there were, with the governess, French and English lessons which were so basic and useless that Lampedusa complained of the "general absence of foreign languages in Sicily". These lessons sufficed for a social class that was separated from any useful social activ-

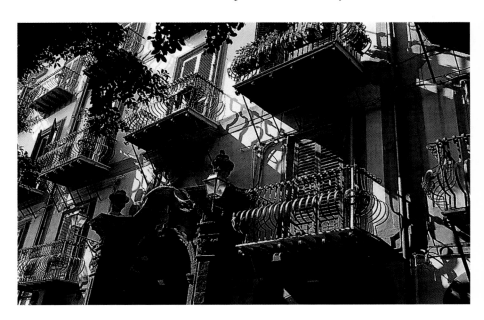

A characteristic example of wrought iron balconies in Sicily.

ity, including taking care of their own affairs. This education was often dispensed at home by ecclesiastical teachers; otherwise it took place in two large educational institutions, the Real Collegio Ferdinando for boys and the Real Educandario Carolino for girls, admission for both requiring at least a hundred years worth of proven nobiliy.

As far as the intellectual preoccupations of the Leopards were concerned, whatever their education, witnesses of the times differ in their opinions. Lampedusa wrote, "Sicilians knew nothing of the existence of Dickens, Eliot, George Sand, Flaubert, even of Dumas". He attributes this ignorance to the "traditional insular impermeability for anything new" (except England and Japan) and to the "vexations of Bourbon censorship" (although these disappeared in 1860). Fifteen years later, Verdura describes the family library as a never visited shambles where old books on parchment, portfolios of engravings, and political posters, gazettes dating back to the 18th century were piled up along with collections of the two magazines most famous for their social news and literary content: *The Illustrated London News* and *La Vie Parisienne*.

And yet elsewhere the same authors describe these matters differently. At the same time as Verdura, Lampedusa discovered in the family library at Santa Margherita Belice *Diderot's Encyclopedia*, Fontenelle, Helvetius, Voltaire, all of Zola, "new novels of low quality", and the *Malaviglia* of Verga with a dedication of the great Sicilian writer. As far as Fulco di Verdura's mother was concerned, Caroline Valguarnera di Niscemi read Thackeray, Dickens, Fogazzaro, Paul Bourget, Henry Bordeaux, Marcel Prevost and, of course, D'Annunzio.

The real truth lies somewhere between these two extremes. Just like economic wealth, intellectual life in this period was in a state of stagnation compared with the 18th century, a period during which foreign visitors praised the erudition of both the men and women of the Sicilian aristocracy. Of course, the Via Maqueda of Fabrizio Salina was not the Faubourg Saint Germain of Proust's Swann. But neither Dumas nor Maupassant, to mention two exemplars of France's literary life, kept any recollection of their dealings with the Sicilian aristocracy. The reception that these people gave to Richard Wagner in 1881-82, although at that time none of his works had been performed in Sicily, as well as to Renoir who had come to Palermo to paint the portrait of the master of Bayreuth, demonstrates that they by no means rejected the art or music of the future.

We have already mentioned the political sentiments of the Leopards or, rather, the rich variety of their opinions. By no means indulgent of

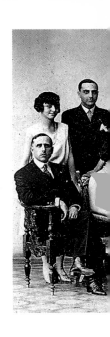

A family photograph taken on the day of the celebration of the golden wedding anniversary of Marchese Giuseppe Salvo di Pietragnanzilli and Marchesa Caterina Ugo delle Favore in 1928.

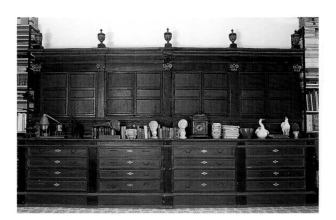

The Lanza Tomasi palace: the late 17th century sacristy cupboard is today used to store the family archives.

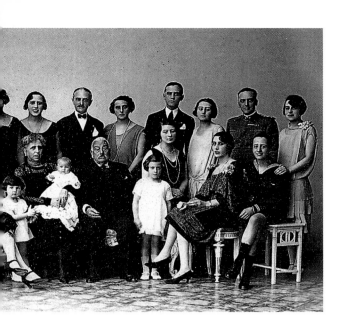

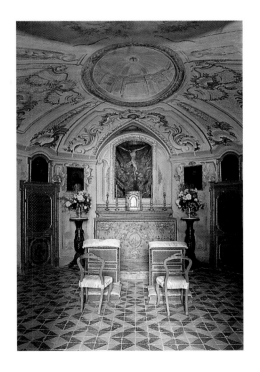

Private chapel of the Wirz villa in Mondello. 18th century Sicilian Baroque style.

the Naples Bourbons, distrustful of the Piedmont Savoias, fearful of social evolution, which, in fact, had just arrived in Sicily, conscious of their decadence but unable to reform it, they were condemned to inefficiency, even indifference. To the messenger who encourages him to become a senator of the new Italy, the Leopard replies "I am sorry, but I won't lift my little finger in the political world. Somebody would surely bite it".

On the other hand, religious convictions were strong and universally shared. To tell the truth, if a few aristocrats had been marked by the Enlightenment – and that seems the case with Lampedusa's hero – few differed from the mass of the Sicilian population who were profoundly attached to the Church, its saints and rites. But the manifestations and practices of the island faith were – and perhaps still are – so special that we can speak occasionally of a "Sicilian religion". We also must not forget that the Tribunal of the Inquisition was not suppressed in Sicily until 1782, and that at the time of the Leopards there were more than 50,000 priests, monks and nuns in Sicily, of which there were over 10,000 in Palermo alone, which is 150% more than in all of contemporary France! This omnipresent, ardent and savage faith was often more directed to the saints than to God himself. Sicilians used to say that "God and the Virgin must think of everybody, the saints only of us".

In 1642 Palermo had dismissed Saint Christine for her inefficiency, and had replaced her with a local aristocrat, Saint Rosalie, who died in 1166 and was interred in a grotto on Mount Pellegrino which, as a result, had become a major pilgrimage site. Linked with the cult of saints was a true passion for the relics that were conserved in churches, or the collections of private chapels. We must remember the Cardinal of Palermo's inspection of the private chapel of the Leopards which is described in the last chapter of Lampedusa's book. The great vicar counted at least 74 relics, carefully numbered, catalogued, and richly framed, that the daughters of Prince Salina had procured from "an old fat lady, half nun, who had close relations in the churches, convents and religious associations of Palermo and its environs". The examiner authenticated five and threw the rest into the dustbin. Princess Salina then exclaims, "For me, this Pope is a Turk". She was speaking, however, of Pope Pius X who was by no means disliked by the most conservative Catholics.

The cult of relics was surely related to another characteristic of Sicilian religion, the familiarity with – if not to say the taste for – death. The funeral of a Leopard was, if one dares to say so, one of the

great moments of his life, and the luxury he had enjoyed in this life was to lead him into the next. Thus at the funeral of Princess Francalanza described in Federico Di Roberto's novel, the Prince de Roccasciano cries out, "What a funeral, gentlemen! And what an expense!... They must have spent eleven *onces* (the *once*, later replaced by the lira, was worth about $60 in today's money) on wax alone! And the ceremony! A sung mass! I can assure you that I spent 100 *onces* on the funeral of my father, and what did I get for that? Nothing at all. This time I can tell you that they spent that on torches alone".

If the scene described by Di Roberto had taken place in Palermo before 1881, the cadaver of the princess would surely have been embalmed, then exhibited in a fancy coiffure, powdered and made up, dressed in her finest frock, and placed in the famous Capucin catacombs where, from the 17th century, 8,000 mummies had been piled up, many belonging to the best civil and ecclesiastical classes. The preoccupation with death even affected the sheltered life of children who received their presents (from the dead) on November 2, All Saints Day, rather than at Christmas as was the custom elsewhere. At the end of the 18th century the intervention of the Archbishop of Palermo was needed so that these presents would not always take the form of skeletons or skulls.

If these religious practices found their origins more in the Middle Ages than in paganism, they included a multitude of general or local superstitions: explanations of omens or dreams, propitiatory gestures, magical conduct. There was barely a Sicilian, rich or poor, who didn't wear a small coral branch to chase away the evil eye, or who didn't know the formula for combating the actions of a *iettatore*, somebody bearing the Evil Eye.

In this area, we must repeat, the only difference between a poor devil and the shining Leopard was that the latter always possessed his private chapel, a private confessor and social as well as family connections among Sicily's great clergymen as well as at the Roman Curia.

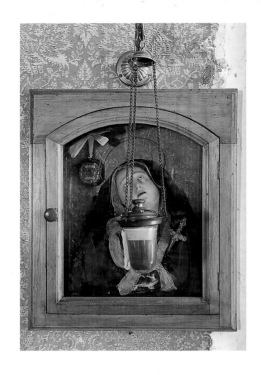

Opposite. *The Capucin catacombs in Palermo. "The mummies are set out sometimes on two, sometimes on three levels, aligned next to each other, on projecting boards, so that those on the first level serve as caryatids for the second level, the second level for the third, and so on. On occasion, there are visits from heirs of those who are consuming the fortunes left behind; they see their uncle, grandfather, or wife, who comfort them with a grimace. Among the dead are counts and marquises... In addition to these niches shared by martyrs, beyond the receptacles reserved for the aristocracy, there is still one arm of an enormous funerary cross that serves as a special receptacle for the bones of the aristocratic ladies of Palermo". Alexandre Dumas, The Speronare.*

Above. *The Virgin in agony, executed in wax, presently at the Gangi palace.* Right. *A wax image of the Christ child in a glass case.*

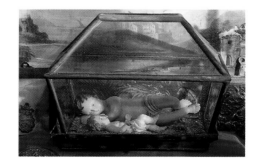

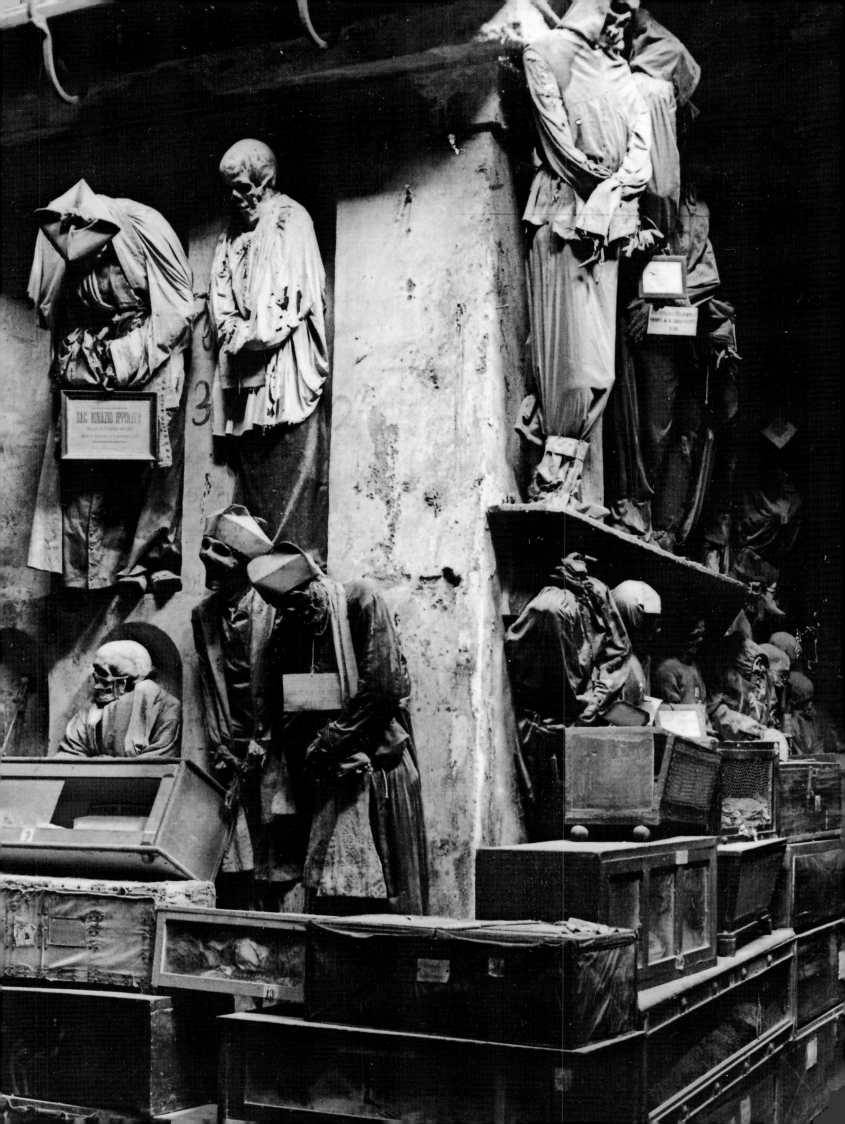

The abolition of feudalism didn't take the titles of the Sicilian nobility with it. A vestige of past merits, nobility bears witness to the original

gratitude of the State and encourages its members to preserve their moral prestige. Along with that of the nation and religion, the cult of the family makes up one of the three supports of the Holy Doctrine which protects us from social subversion. It maintains and fortifies a core of respectable personalities who set an example for others and who give pride to the society of mankind. Francesco Palazzolo Drago, preface to *Noble Sicilian Families* of 1927.

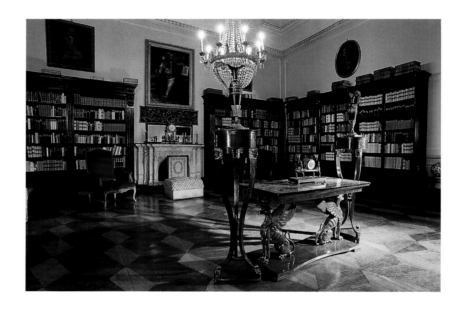

Above. *Agécilas Greco, the Italian fencing champion, around 1900.* Right. *The library of the Lanza Tomasi palace.*

The Tomasis, who counted the author of The Leopard, the Prince of Lampedusa, as a family member, are from Capua in Campania. They moved to Sicily in the 17th century, and their heraldic motto is "Spes mea in Deo est".

Opposite. *Two sicilian gentlemen.*
Overleaf. *The library of the Gangi palace. Above the Empire sofa is an embroidery in gold and silver thread. The bookcase is inlaid with tortoiseshell.*

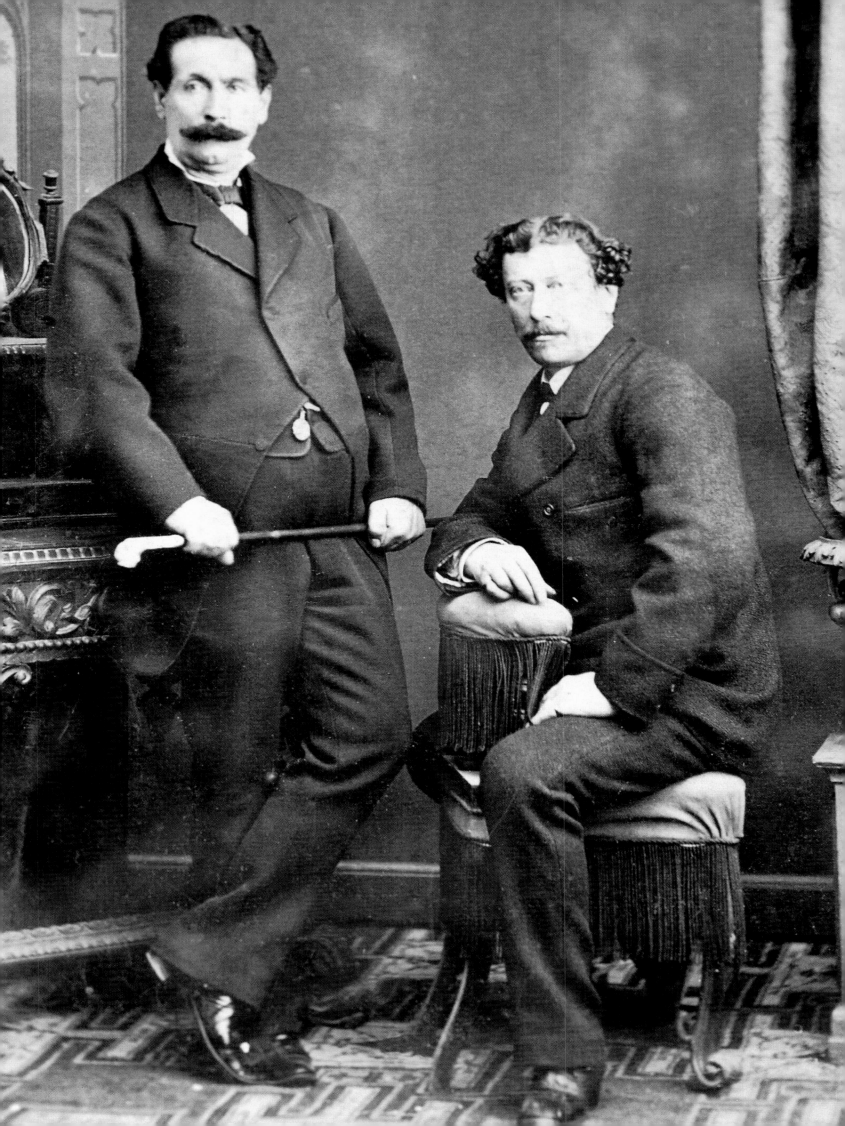

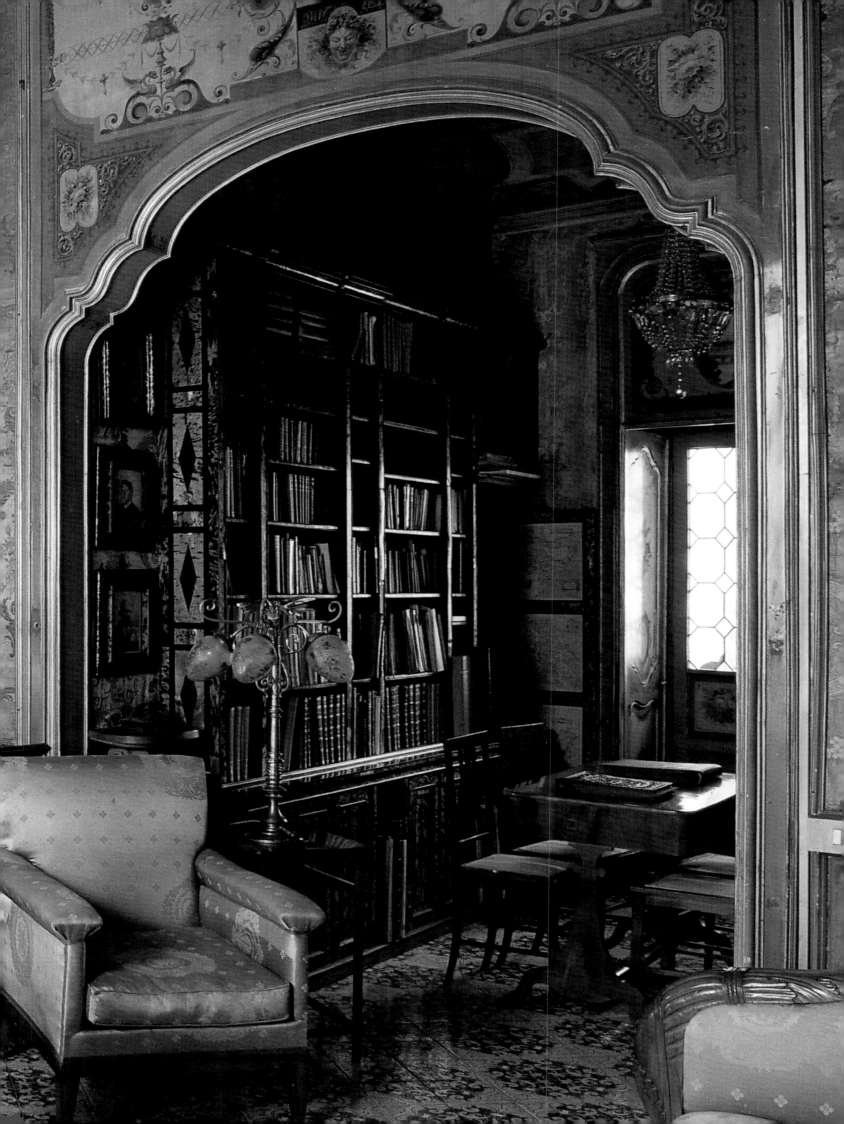

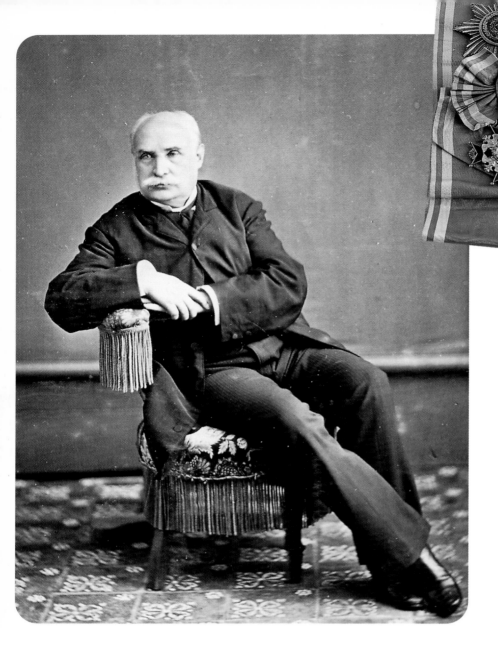

Authors even affirmed that this dazzling social whirl helped ruin certain grand families. Four years later, Garibaldi entered Palermo and put an end to Bourbon rule.

Above. *The Marchese Achille Paternò di Spedalotto in 1875. Overlaid on his photograph is the Order of Saint Nicholas of Poland, given to the Marchese Vincenzo Paternò. In 1845 Tsar Nicolas I, his empress and part of the Imperial Russian court disembarked in Palermo. The empress only left in the spring of 1846 and, during this period, social life was particularly brilliant.*

Above. *Baron Giuseppe Sgadari. Left. Alfio Barbera, cousin of Baron Francesco Achates, in 1850. Opposite. The billiard room of the Beneventano palace in Siracusa.*

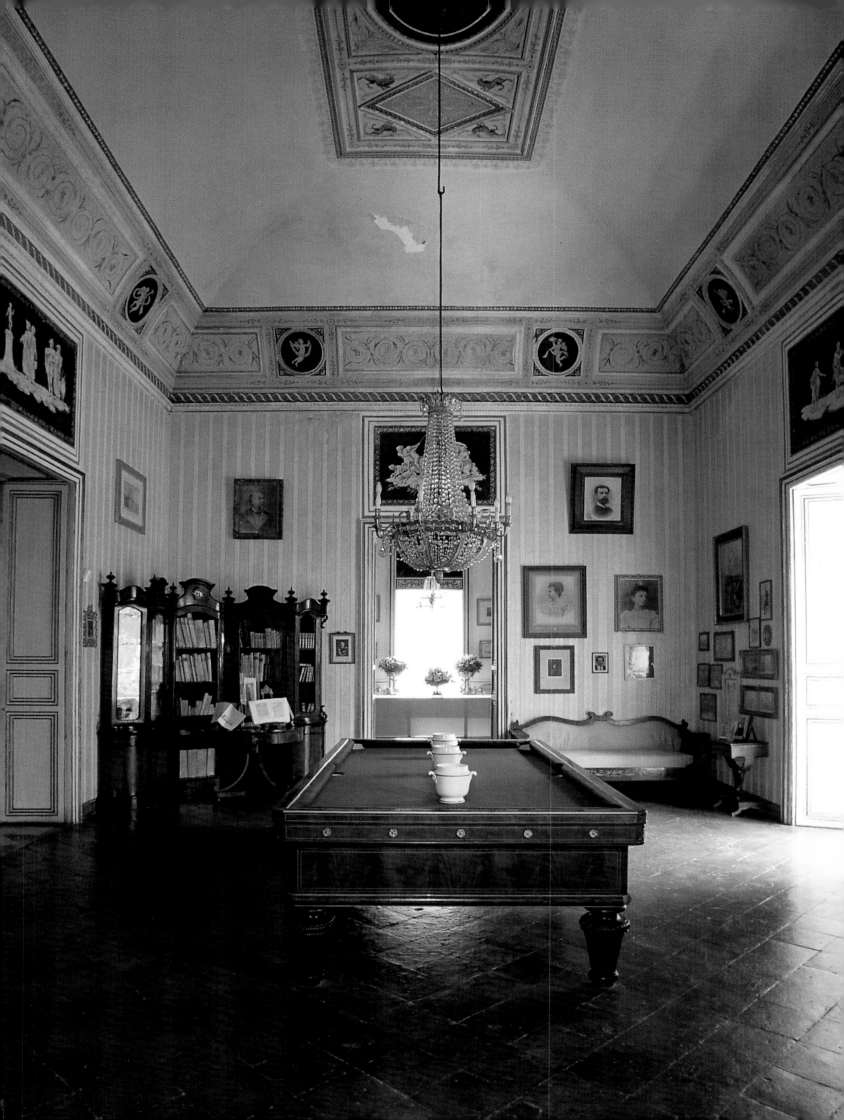

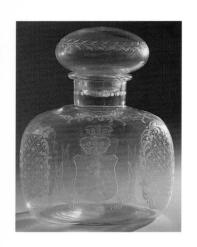

A woman – a Sicilian woman, Donna Franca – passes under the Procuraties, tall, slender, supple, rippling, marching at a cadence the Venetians correctly call "a hare's pace". And suddenly, in my imagination, I summon up a courtesan of the glorious days: Veronica Franca. She was brown, suntanned, indolent and had an eagle's eye. A voluptuous essence, volatile and penetrating, emanated from her royal body. She was nonchalant yet ardent with a look that both promised and deceived. It was nature, not her will, that made her so dominating. In her golden hands, she held "all that is good or evil". Gabrielle d'Annunzio. *Notebooks.*

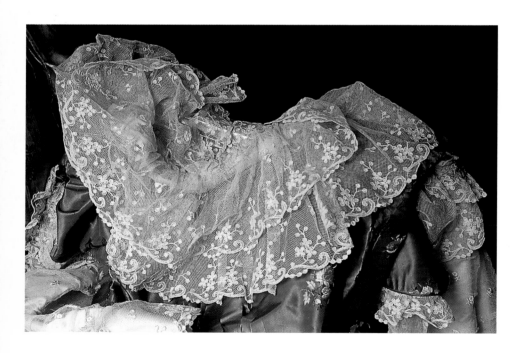

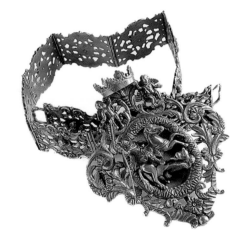

Above. *A silver marriage belt of local character from Piana degli Albanesi.* Left. *Detail of a taffeta, embroidery and lace dress worn at a costume ball given at the Palazzo Gangi.* Opposite. *Portrait of Giulia Alliata di Monreale, Princess Gangi, in 1922.*

Top. *A Venetian glass marriage flagon, engraved with the arms of the Tomasi di Lampedusa family.*

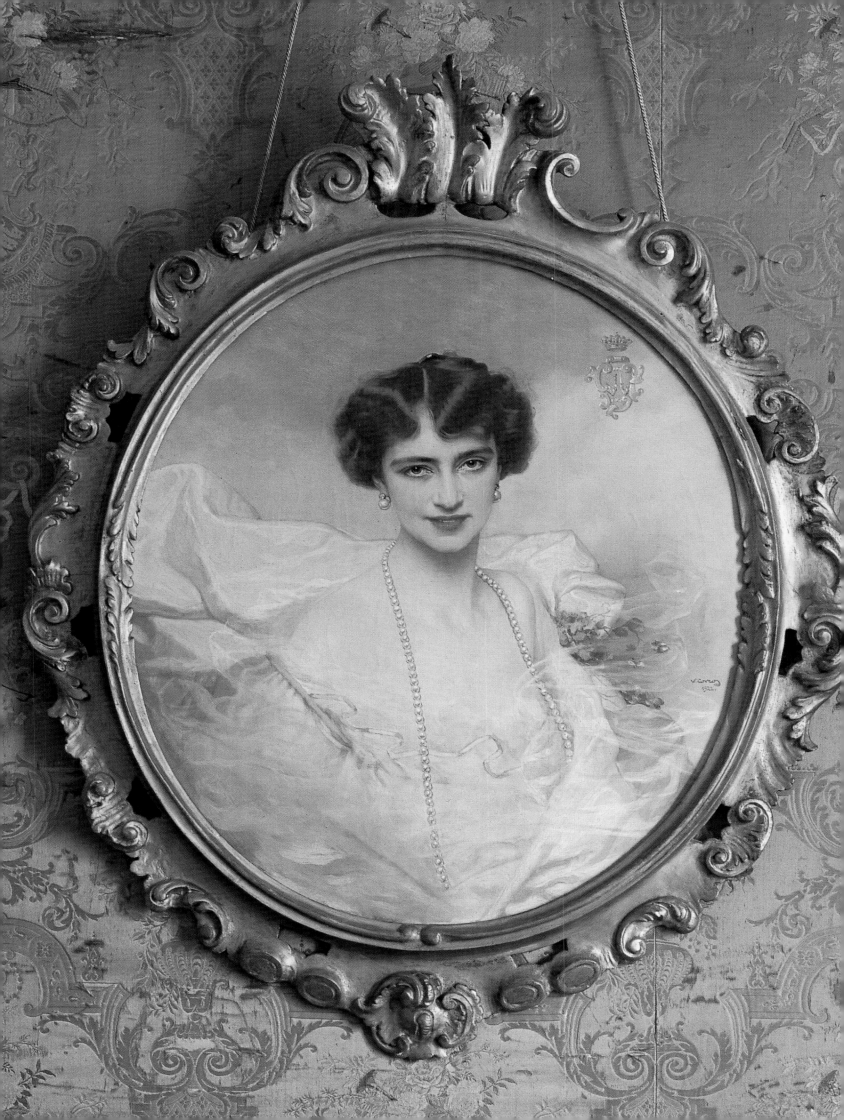

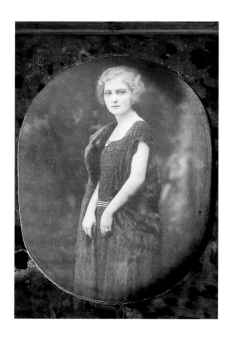

A blown glass flagon,
highlighted in gold, was
once used for holy water.

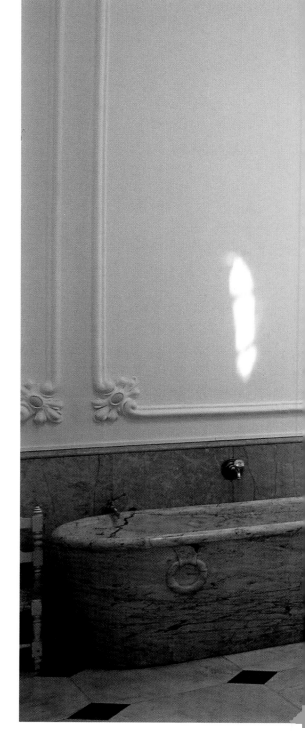

Above. *The Marchesa Giulia
Paternò di Spedalotto in
1920. In the ladies'
bathroom of the house in
which she lived (right), a
damask embroidered robe,
made by the sisters of a
convent in Sciacca, is
thrown over a velvet* chaise-
longue.

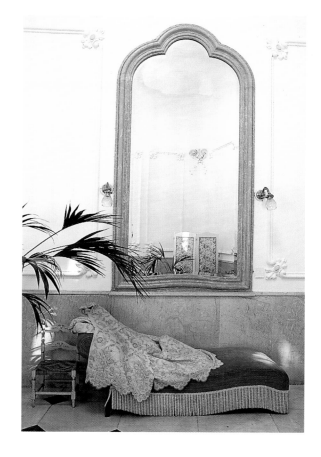

*Malvagna palace, Palermo.
With its beautiful Roman tub, this
bathroom demonstrates the
evolution of lifestyle from the rather
rustic facilities prevalent in the
middle of the 19th century at the
palace in Donnafugata described
by the author of "The Leopard".*

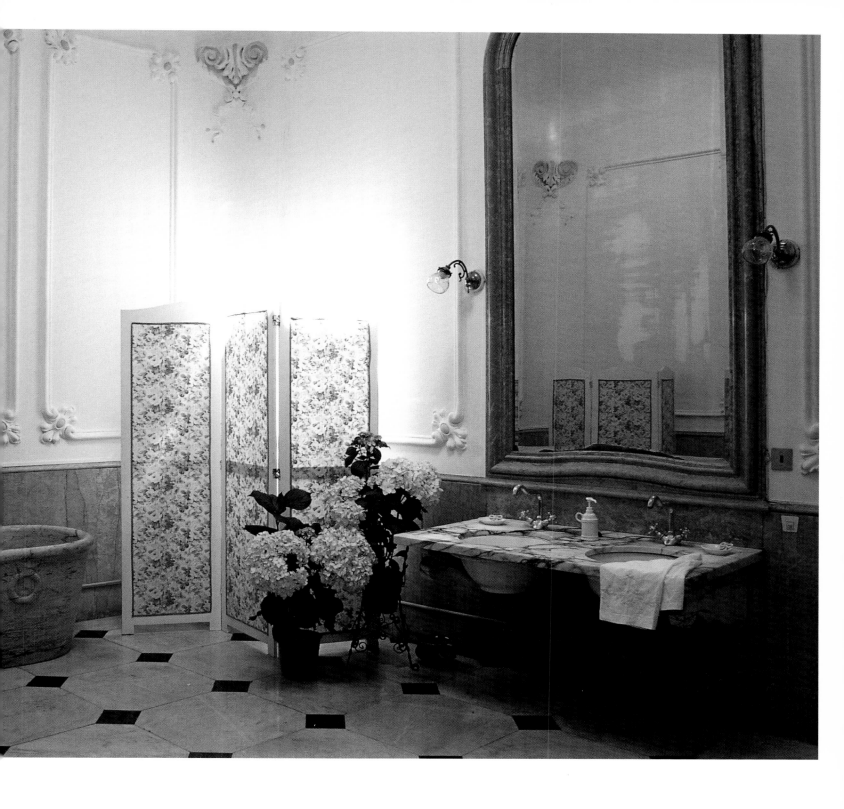

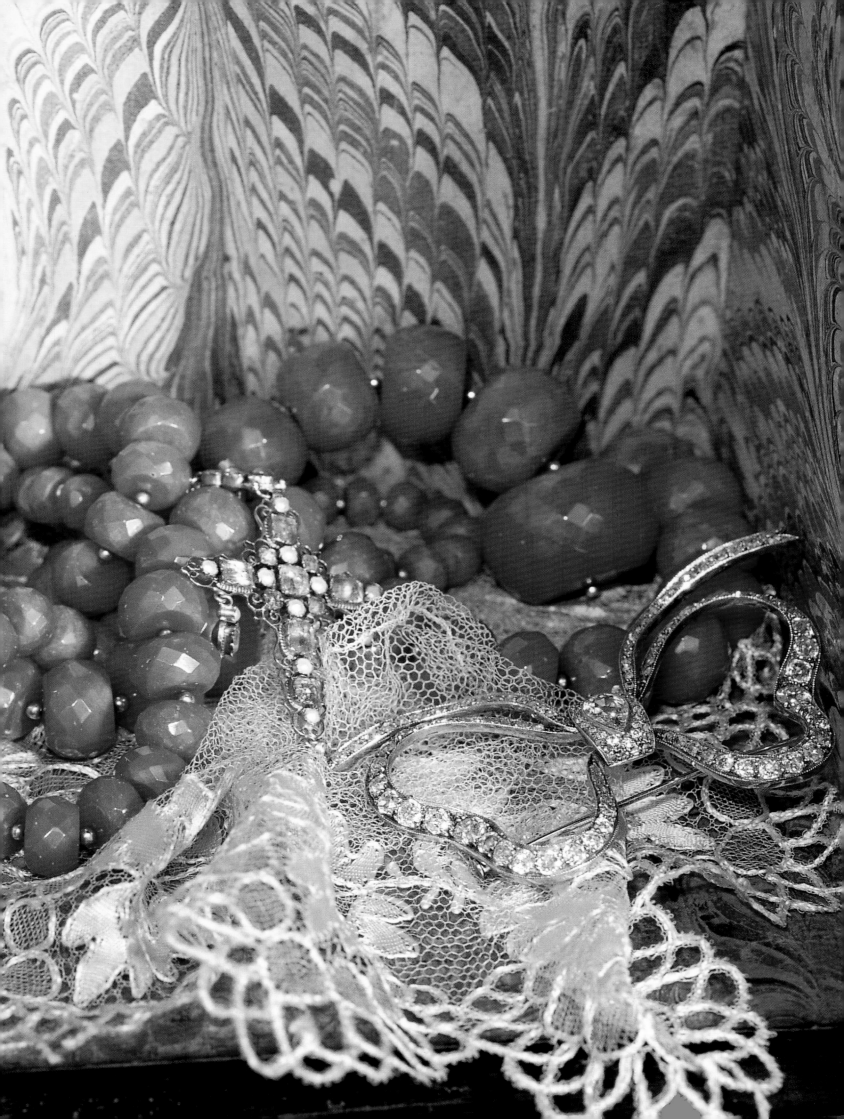

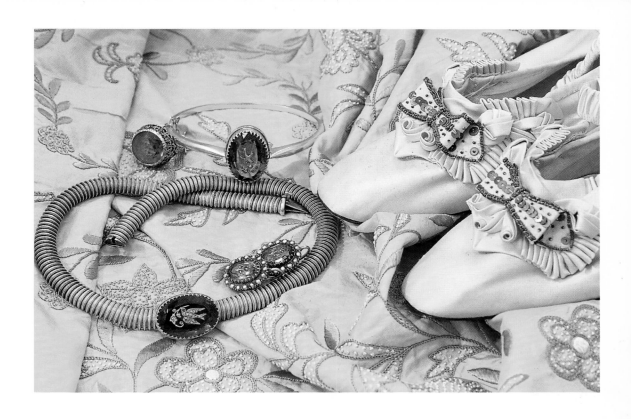

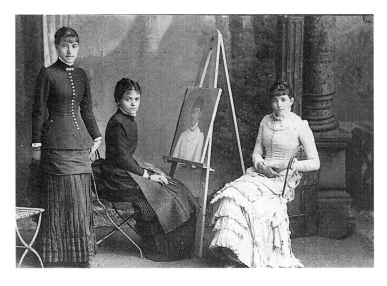

di Monreale, Princess Gangi, in 1910. *Right. Perfume bottles, a Spanish tortoiseshell mantilla holder, and a powder case imitating a guilloché enamel pocket watch, and a neck collar made up of gold thread and pearls.*

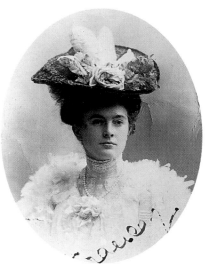

Left. *Coral jewels. Coral from Trapani, a glowing red color, was very fashionable in the 17th and 18th centuries for both jewelry and religious art. Above. Amethysts mounted in the Empire style and shoes from the beginning of the 18th century are displayed on a yellow, embroidered Spanish shawl in the Gangi palace.*

Overleaf. Left. *Giulia Alliata*

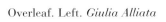

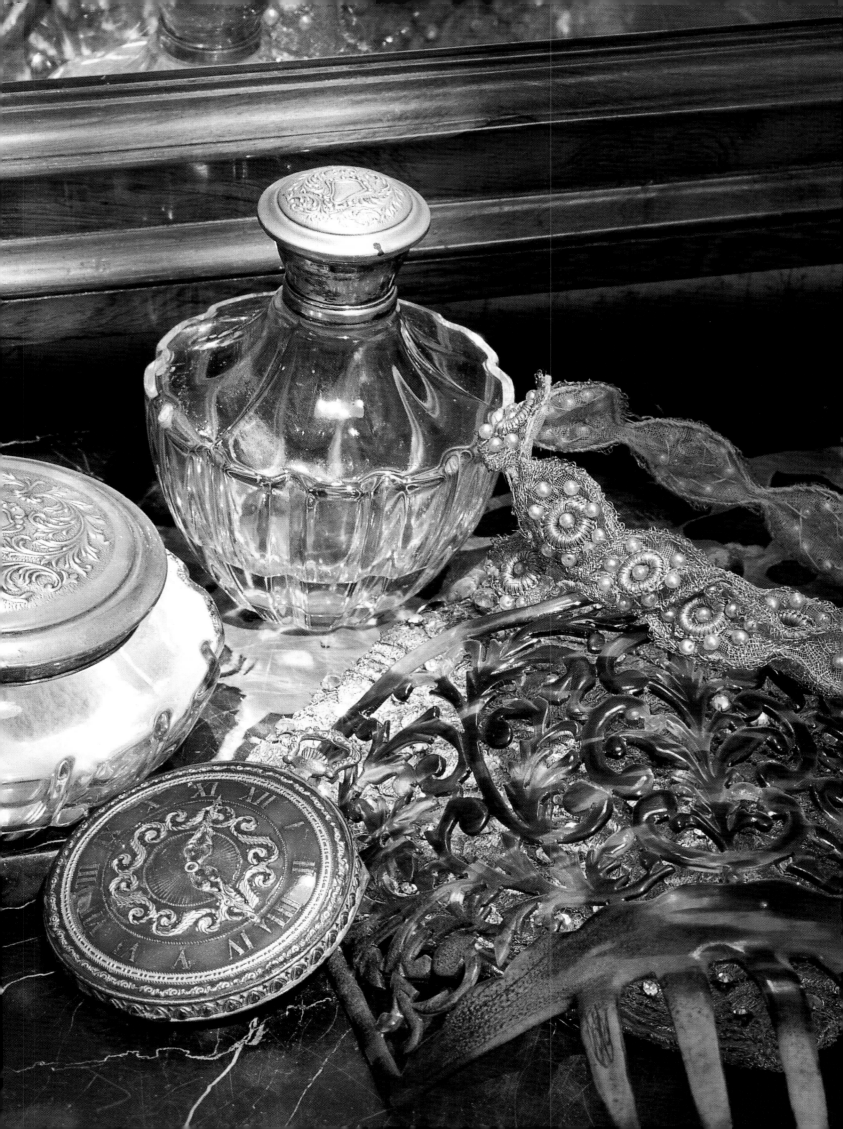

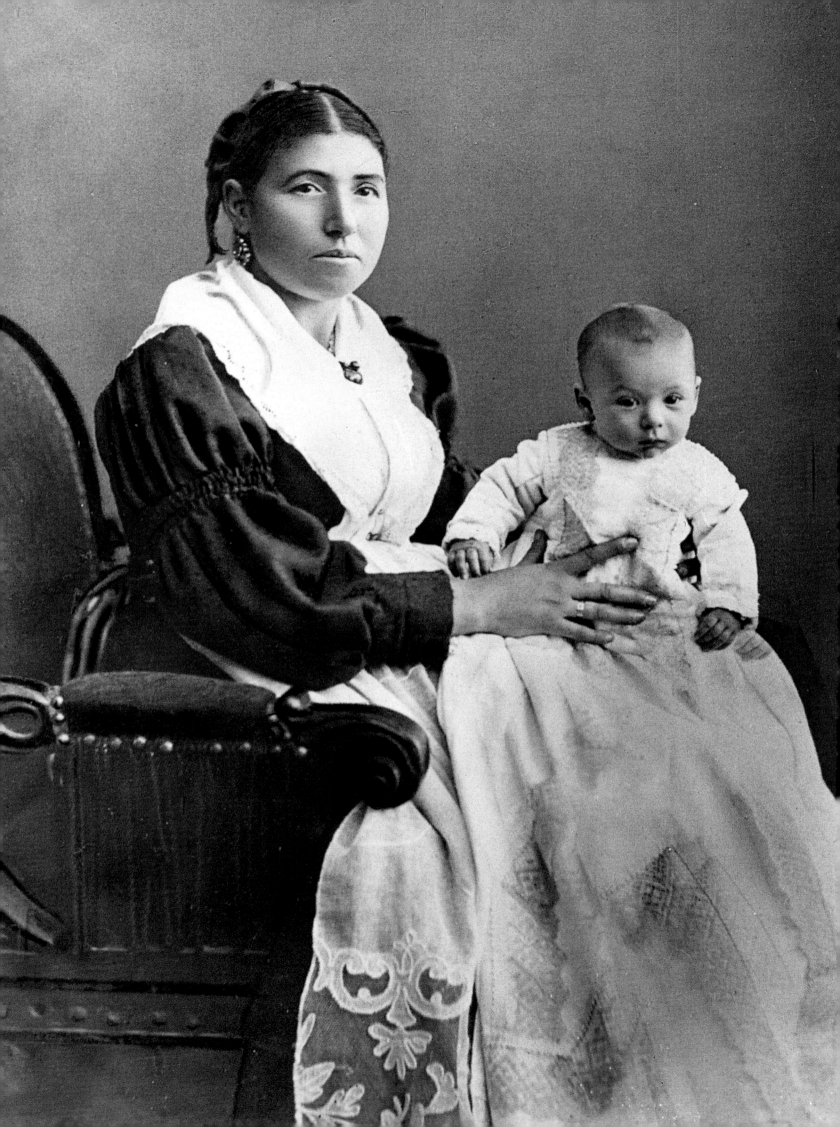

Despite English nurses, obligatory tea, and useless attempts to make me swallow porridge, it would be vain to consider that I received a British education. Many things in Sicily were against it, above all one's house. In the place of a nursery, we used a large room, abutting my mother's rooms, a storage area for clothes really, in which a quantity of enormous wardrobes stretched

along the walls. These contained sheets, blankets, house linen, a mass of shawls, coats, furs, all the clothes of my mother and myself. A whole wardrobe was reserved for storing our toys which, in theory, had to be put away once used, in case my grandmother took it into her mind to cross our playroom. But this law was rarely observed.

Fulco di Verdura. *A Sicilian Childhood.*

Opposite. *The engineer Giuseppe Vitale on the lap of his wet nurse in 1890.*
Above. *Dolls and other playthings from the Gangi palace.*
Left. *A photograph of Rosalia and Silvia Paternò di Spedalotto in a silver and ivory frame from the beginning of the century, embellished by equine attributes.*

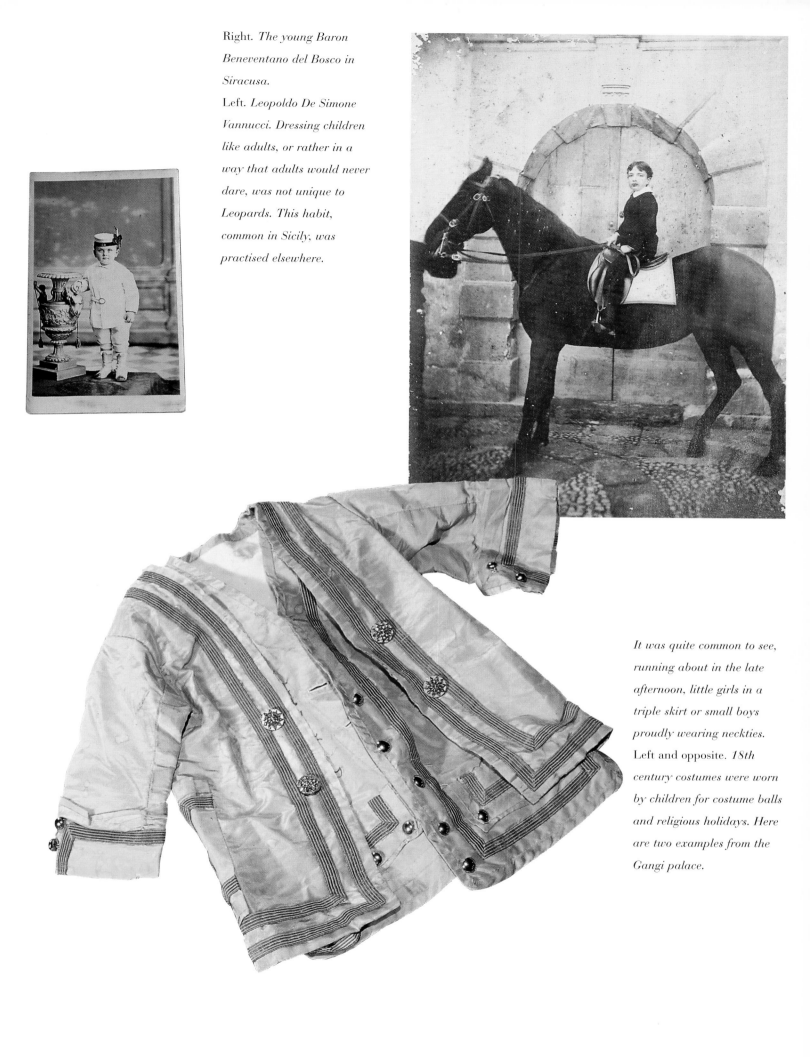

Right. *The young Baron Beneventano del Bosco in Siracusa.*

Left. *Leopoldo De Simone Vannucci. Dressing children like adults, or rather in a way that adults would never dare, was not unique to Leopards. This habit, common in Sicily, was practised elsewhere.*

It was quite common to see, running about in the late afternoon, little girls in a triple skirt or small boys proudly wearing neckties. Left and opposite. *18th century costumes were worn by children for costume balls and religious holidays. Here are two examples from the Gangi palace.*

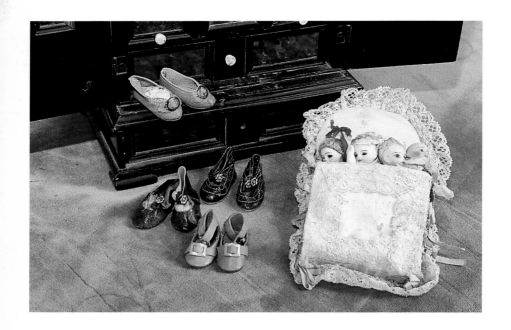

Above. *A Louis XVI style miniature commode, made in Sicily around 1885, presently in the Beneventano collection.* Opposite. *On a piece of black velvet embroidered in silver thread, is a page's cap, like the blue velvet cape part of children's costumes, better seen on the wigged infant. Dressing for first communion was equally extravagant.*

Like these Liberty-style glasses for children in the Gangi palace, a fashion for doll's furniture reminds us of the British influence on the lifestyle of the Sicilian nobility. Above left. *Miniature porcelain dolls of the 18th century from a collection in the Alliata Pietratagliata villa.*

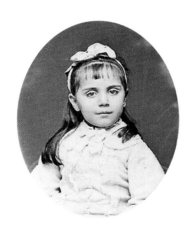

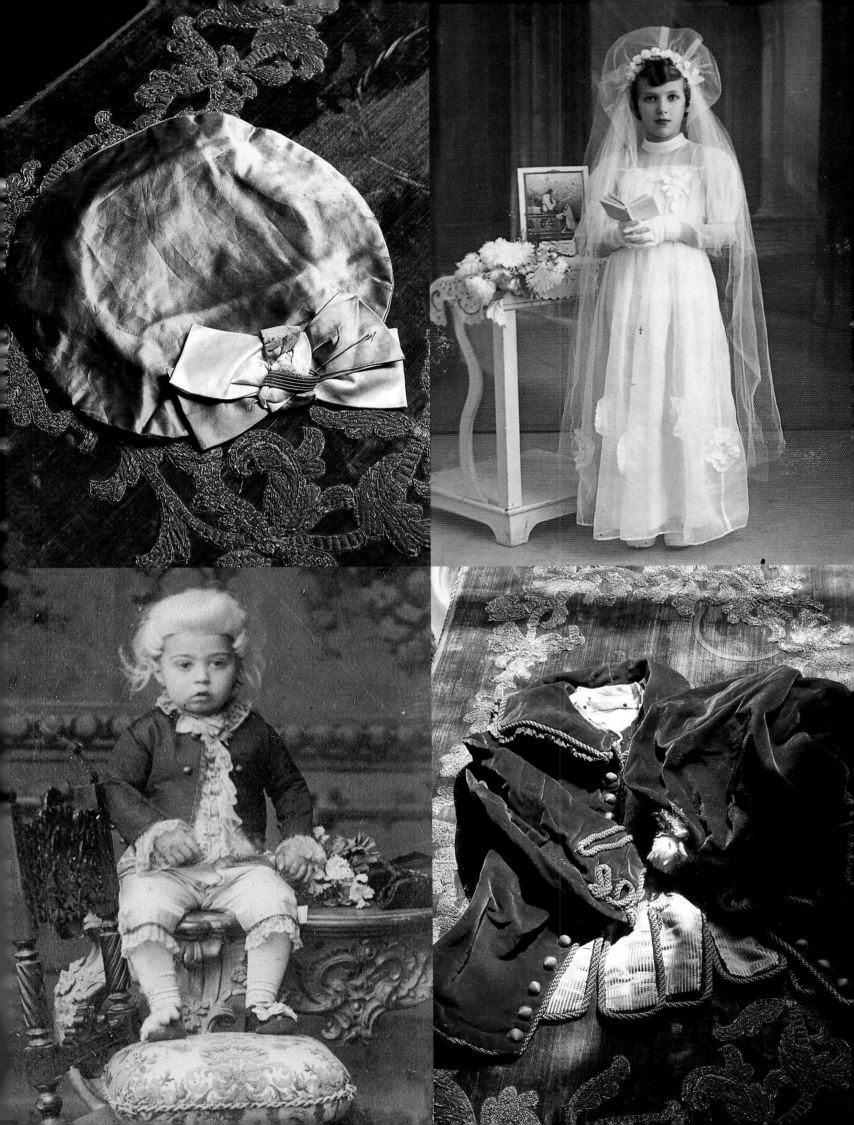

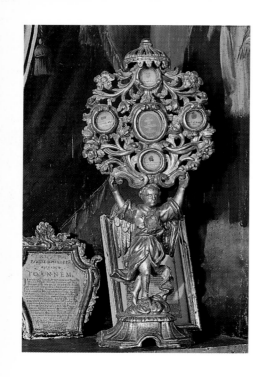

Confession could still be taken at home, and the scruples of penitents obliged that the rite take place quite often. To the team of confessors, one had to add the chaplain who came every morning to celebrate mass in the private chapel, the Jesuit who assumed the spiritual guidance of the entire house, the priests and monks who came to ask alms for one or another parish or religious association. The to and fro of religious people hardly ever ceased; the antechamber of the Salina villa often resembled one of those shops for the clergy near the Piazza Minerva, which displayed every possible ecclesiastical head covering possible, from the flamboyant headdress of cardinals to the colored berettas reserved for country priests.

Lampedusa, *The Leopard.*

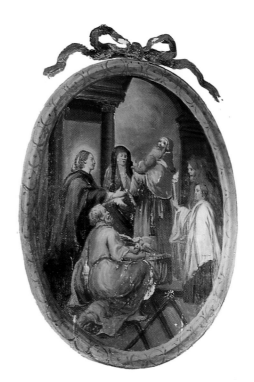

Above. *A reliquary from the Alliata di Pietratagliata palace.*
Opposite. *The private chapel of the Gangi palace; the confessional is on the left.*
Overleaf. Left. *Detail of motifs decorating the doors of the chapel and a silver ex voto.* Right. *Sicilian pious ladies in lace dresses and mantillas.*

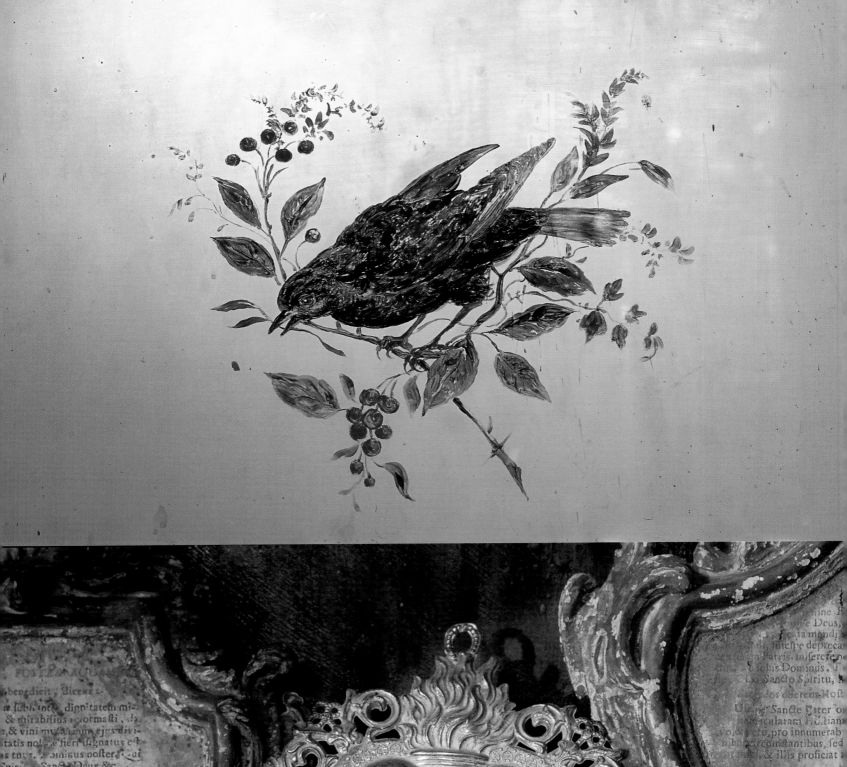

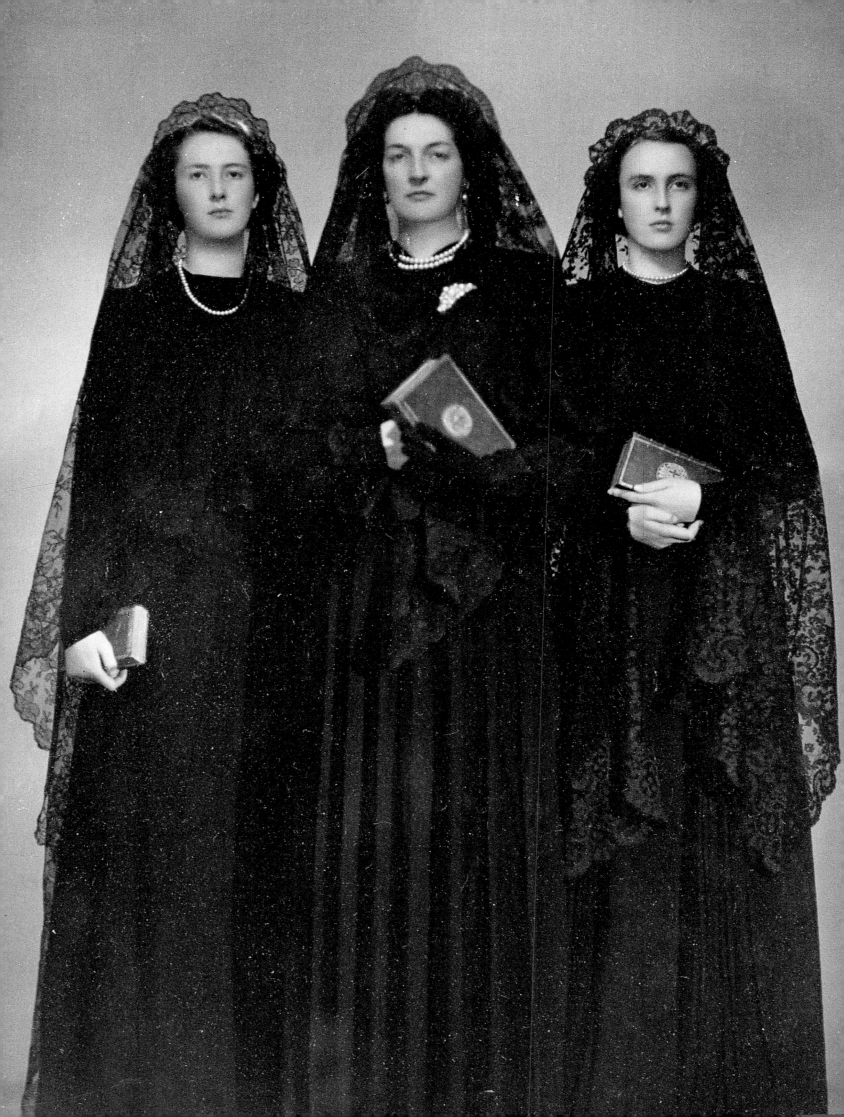

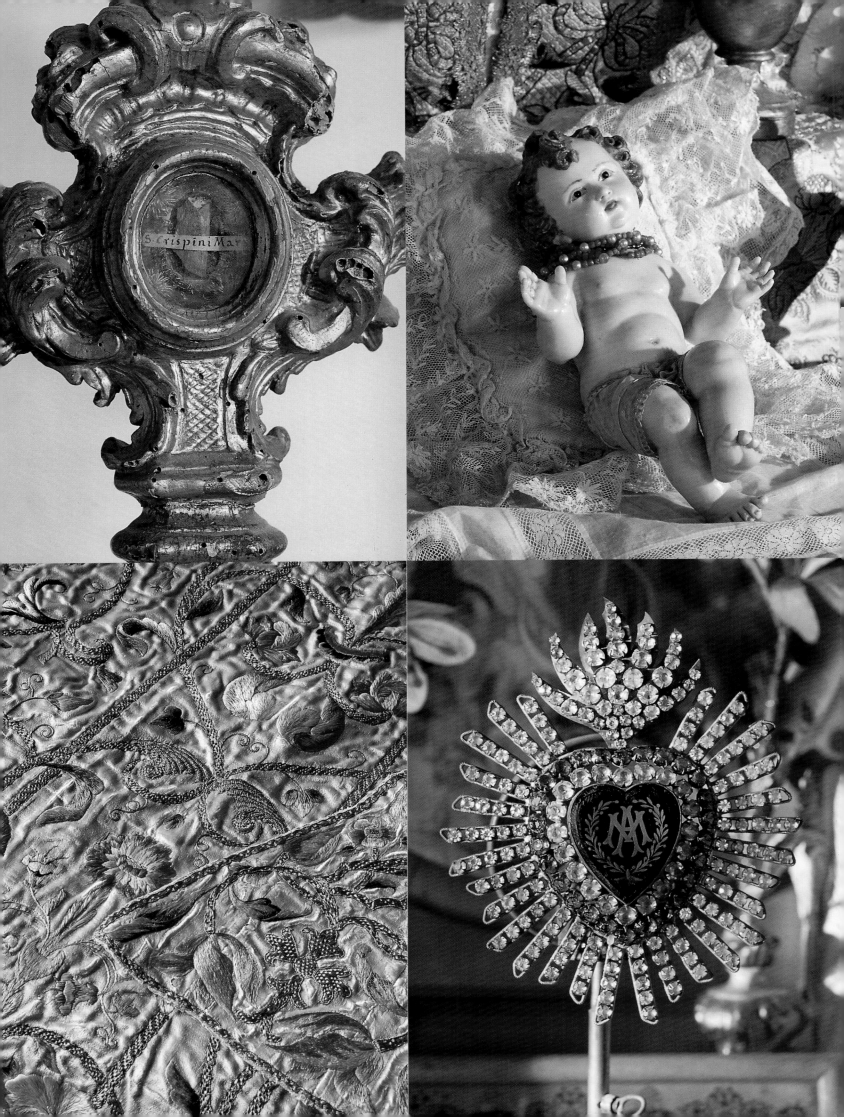

Wonderfully colorful objects
represent not only the
richness of Sicilian artifacts,
but also the Baroque
atmosphere that dominated
the celebration of the mass.

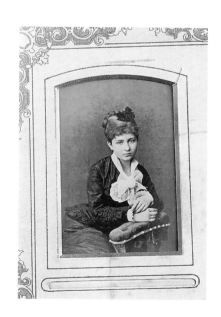

Overleaf. Flagons of holy oil
are set before photographs
of Sicilians who died during
the war.

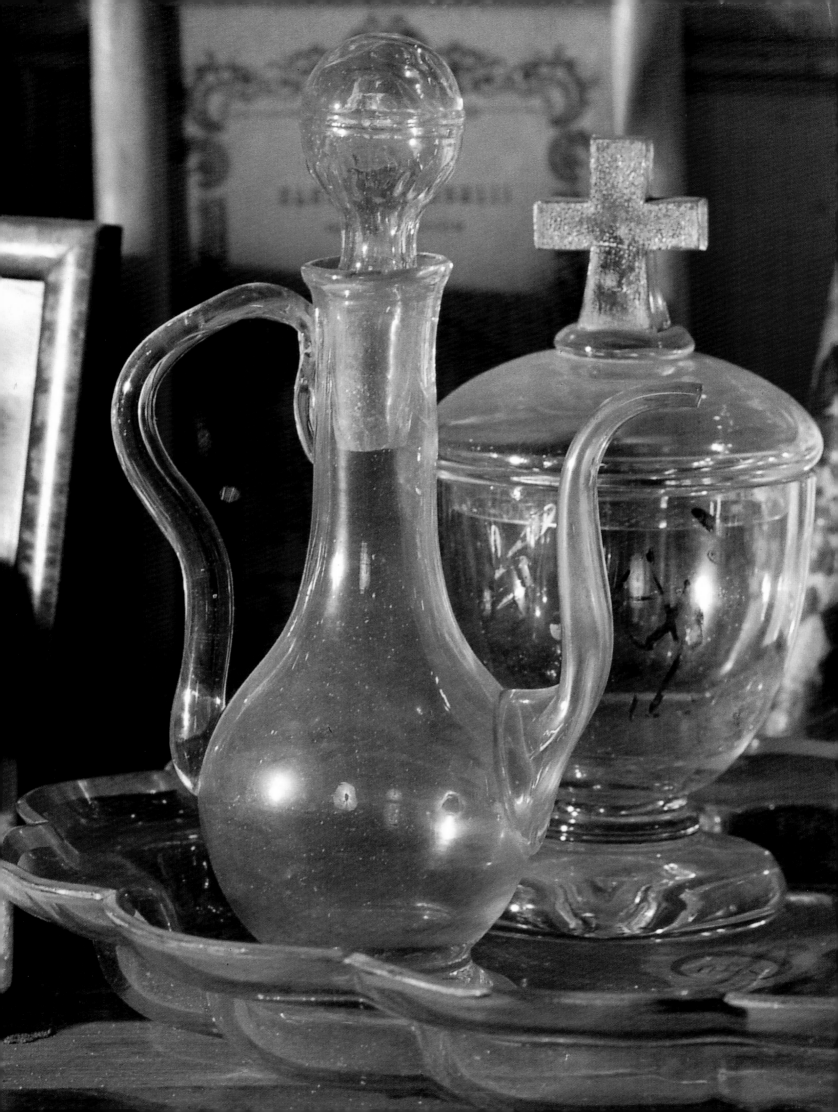

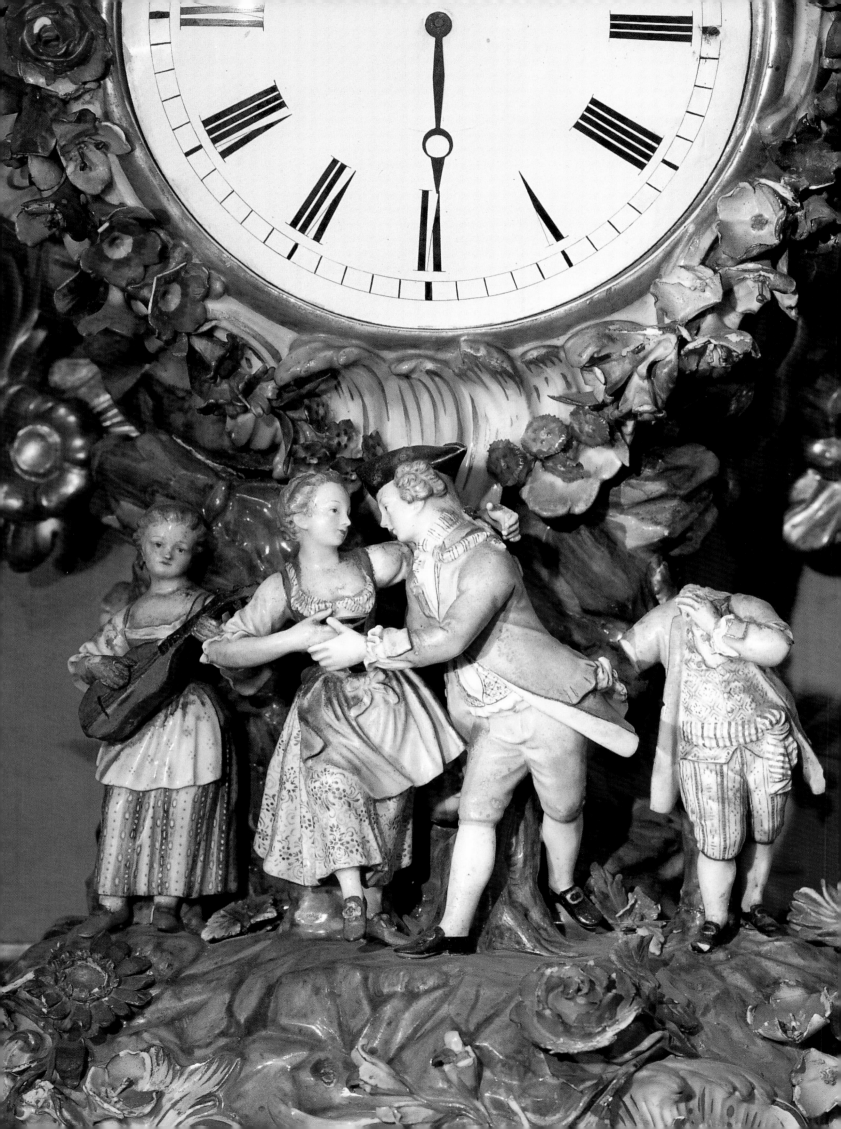

A day in the life of the Leopard

Opposite. *An 18th century porcelain clock from the Gangi palace. Porcelain in Sicily, like that in the rest of Europe, rendered homage to a courtly and aristocratic lifestyle. Dalliances and flirtation were favorite subjects, as were harlequins, jesters, beggars, exotic birds and other animals. The principal porcelain manufacturers were German, and thus such pieces as this clock reflect the princely life of German courts.*

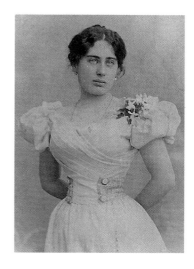

The Leopard, in general, woke up late. Possibly he would accompany his wife to the mass she heard every day in a neighboring church – private chapels had the drawback that one couldn't be seen or have one's piety admired or, for that matter, one's dress. In fact, the day only started towards noon. If there were no holidays or feasts days to celebrate, no baptism, marriage, burial, visiting dignitary nor a great trial, one would first pay a few visits to intimate friends or take a *cassariata*, that is a two-way trip along the Via Vittorio Emmanuele (ex Cassaro) to meet up with other friends at the Bellini Club, also known as the Casino of the Nobility. This club, founded in 1769 with the very specific appellation "Great Conversation of the Nobility of Palermo", was even more exclusive than its English equivalents. In 1854 it had only 700 members of which many (such as Lampedusa, who wrote part of *The Leopard* in the library) belonged by hereditary right. Women were admitted, balls were given, and both friends and foreign visitors could be received at the club. As in the convents, the peddling of gossipy tidbits was one of two principal activities. The second, and more expensive, was gambling, another passion shared by the aristocracy and the common Sicilian. During the Bourbon reign, the viceroys had attempted to curb the vice, which

Below. *A young Sicilian lady prepares to go to her first ball, where romance may be in the air.*

caused the ruin of many a patrician family. But taxes, restrictions and prohibition were absolutely useless; there were still wild games of *basetta*, *trente et quarante*, *carretta*, *scassaquindici* and a few other dangerous distractions, including billiards.

The Leopard had lunch at three o'clock. After a short siesta, a few visits and another *cassariata*, it was soon evening. Some went to the theater, which began at "una della notte", that is to say one hour after sunset; others returned to the Casino of the Nobility. And, of course, aristocrats and their spouses went, separately or together, to perform an unchanging rite of Palermo society – a promenade, either on foot, in a carriage, or on horse to the Piazza della Marina. During lovely summer nights people would come home to go to bed only at dawn (alone or separately), sometimes after yet another *cassariata*. This ritual dated back to the 18th century and every traveler, if we read their accounts, was enchanted by this way of life. Alexandre Dumas wrote about it enthusiastically: "It is the promenade of riders and horses, as the Flora is that of pedestrians. Everybody who has a horse and buggy simply has to come there to make a tour between six and seven o'clock every evening: it's quite a sweet obligation; nothing is as enchanting as this marine promenade along a line of palaces, the lovely gulf stretching out on one side into the open sea beyond and a belt of mountains on the other which both envelops and protects it. Then, that is to say as of six in the evening until two in the morning the *Greco* blows, a fresh north-east breeze that replaces the ground wind and gives energy to an entire population whose destiny seems to be sleep in the daytime and awaken at night. This is the time when Palermo wakes up, breathes and smiles. Gathered up on this beautiful quay with only the light of the stars to embrace the carriages, riders and walkers, everybody seems to be talking, babbling, singing like joyous birds, exchanging flowers, making appointments, blowing kisses. They all seem eager to get somewhere, some to lovemaking, others to pleasure; everybody seems to be drinking the cup of life to the full, little preoccupied with the half of Europe that envies them, the other half who have pity.

In 1770 an English traveler, Patrick Brydone, was surprised to notice that, "in order to favor pleasure and intrigue, the custom seems to be that nobody carries a light". And he concluded that the customs of the aristocracy were less rigorous than those of their dependents and that they were less sensitive to that great Sicilian jealousy that was the cause of the famous *delitto d'amore*. This opinion was shared by Vivant Denon, later to become Napoleon's art expert, who, at the same time, wrote of the upper class that "famous jealousy was among the things one spoke

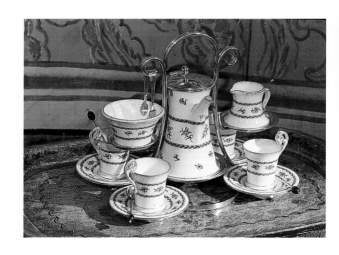

A porcelain coffee service from the Coalport manufactory in Britain. The coffee pot is in a silver container. This set is in the Empire style and was used in the Gangi palace.

The Teatro Bellini in Catania was inaugurated in 1890 with Norma, *one of the masterpieces of the Sicilian composer Vincenzo Bellini (1801-1835), after whom the theater was named.*

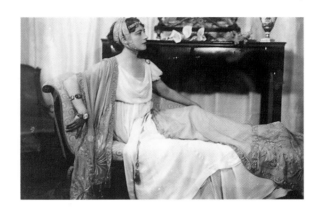

Giulia Mantegna de Gangi in an Empire dress. She is posed on her day bed rather like Madame Récamier.

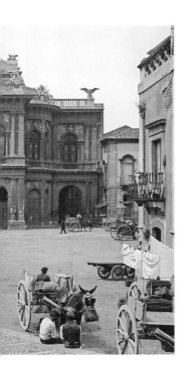

about two centuries after people had died". We might surmise that the end of the 19th century was more "Victorian" in this respect. But if we follow the peregrinations of the Leopard who searches out his mistress, Mariannina, we can find him on the way to Saint Maria della Catena, two steps away from the Piazza Marina.

Lampedusa wrote that "the people of Palermo are, after all, only Italians". From this, we can deduce that Leopards shared the passion of a nation that had created the *commedia dell'arte*, grand opera and *bel canto*, along with their story lines–theater quite correctly described as Italianate. The taste for this in Palermo was perhaps less excessive than it was in Catania, the land of the Bellini musical dynasty, but in the middle of the 19th century there were at least ten theaters, the most ancient being the Santa Cecilia, founded in 1693, the most prestigious the Royal Carolino Theater where Gaetano Donizetti conducted during the 1825-26 season.

But neither the stage of the Carolina nor the Santa Cecilia was well enough equipped to put on the new Romantic war-horses. At the time *Aïda*, *Tannhäuser* and *La Gioconda* were being written, a decision was taken to build an adequate setting for these large scale works. In fact two were to be built, one for the nobility and the upper middle class, the other for the people, one conservative the other liberal, one Catholic the other anti-clerical. The first was called the Teatro Massimo, the second – quite justly – the Politeama Garibaldi. In fact, this division was to keep conversation going at the Casino of the Nobility until the last quarter of the 19th century. Started in 1866, the Politeama was to be finished (except for a roof) in 1874, and finally capped in 1877. The competition for the Massimo, sponsored by the Leopards, was launched in 1864, the first stone laid in 1875, and *Falstaff* was given in the yet uncompleted theater in 1897. Ever since it was invented, the row of boxes that was such an essential element of Italian theaters constituted a space that both united and separated the different social classes. But in Palermo, if we are to believe Fulco di Verdura, "the boxes were distributed according to a mystical system inspired by the most intense snobbism". In the first balcony were the "officials": officers, functionaries, local politicians. The aristocracy alone occupied the second balcony. The prefect had the box abutting the stage on the right. The box on the opposite side and the three boxes next to it were for the members of the Circolo Bellini, "an aristocratic refuge for Palermo's big hitters", the equivalent of the elegant dandies of the Paris Jockey Club. The third balcony should not concern us here, as it was for the upper bourgeoisie, the truly rich who

enjoyed power outside the theater, but were put in their proper place in its gilded setting. And we shouldn't even speak of the fourth parterre, or the orchestra seats, literally unspeakable for Anglophile Palermitans. On the other hand, the fifth and highest balcony was a very special place, a sort of limbo in the world of the Leopards. Here, Fulco di Verdura assures us, were the families in mourning who could hardly appear in their usual box, oddly dressed youngsters from good families, young girls who still had to make their début into society, and ruined princes or marquises too poor to afford a box in the second balcony and too proud to sit anywhere else. Do we need to add that the public that attended the Massimo, all categories included, was considered one of the most excitable and difficult in all of Italy?

While careful to mark out their territory at the theater or in other places in which they gathered, the Leopards nevertheless mixed together with the Sicilian people in the festivities that animated the Sicilian calendar. On the cathedral square in Palermo, "princes and artisans, princesses and merchants" met quite casually during the fair of Saint Christine. The same could be said of other religious occasions, particularly of the five days that made up the feast of Saint Rosalie, from July 11 to 15. These feasts were true institutions, and were the most striking events of the year in Palermo. In 1783 the reformer-viceroy Carraciolo wanted to reduce these feast days from five to three, in the interests of economy and as a matter of general principle. He met severe opposition both from the nobility and the people, who were defiant on the matter. On all the walls of Palermo one read the inscription "O festa, o testa" (either the feast or his head). Finally, the Palermitans had both, as the feast remained unchanged and the Viceroy was called back to Naples. The centerpiece of the feast was a gigantic float known as the *festinu*, which was carried from the Marina to the royal palace. In the 19th century, despite attempted penny-pinching (the apparatus cost nearly $150,000 in today's terms), this was an impressive spectacle, here described by Alexandre Dumas. "We soon started to see it at the very end of the Rue del Casero [*sic*], standing, as we were, around a third of the way down it. It advanced slowly and majestically, pulled by fifty white oxen with gilded horns. It was as high as the tallest houses and was covered with painted or sculpted figures in cardboard or wax. On its different levels and on a sort of prow of this vessel-like construction were between 140 and 150 people, some playing instruments, others singing, and finally some throwing flowers. Although this enormous mass was really made up of rags and glitter, it was extremely impressive. Our host

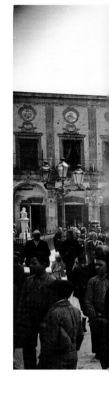

A religious procession in Monreale. People are often surprised by the extravagant, nearly oriental religious manifestations of Sicily, but this has no bearing on the deep and sincere religious beliefs of the people. Religion is ingrained into every facet of daily life, but a Baroque element is omnipresent in the many feast days that are spread throughout the year, and are celebrated with parades, elaborate floats, presentation of relics and great feasting.

Detail of a table ornament in Palermo's Ugo palace.

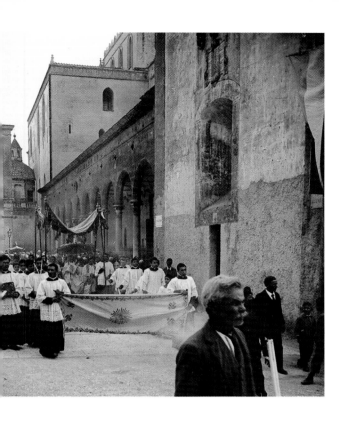

Detail of an 18th century fan in the Alliata di Pietratagliata palace in Palermo. In the hot Sicilian climate no lady would go out without a fan, and these were often very elaborate and beautiful.

quickly noticed the favorable effect this giant machine produced on us but, shaking his head with displeasure rather than encouraging our admiration, he bitterly complained of the decreasing faith and growing niggardliness of his compatriots. In fact, the carriage which was now about as tall as the roofs of the palaces, had once been taller than the church towers. It was so heavy that it needed one hundred rather than fifty oxen to pull it, and it was so charged with ornamentation that it usually broke about twenty windows during the procession. Finally, it was accompanied by such a large crowd that it was quite unusual if a certain number of people weren't crushed by the time it arrived at the Piazza Marina. All that, as we can well understand, gave the feasts of Saint Rosalie in the past a far greater reputation than they enjoyed today, and flattered the pride of the old Palermitans…

"Immediately following the float were the remains of Saint Rosalie enclosed in a silver reliquary and placed upon a sort of catafalque carried by a dozen people, who worked in relays and walked in a waddling manner, rather like geese. I asked the meaning of this strange movement and was told that Saint Rosalie had a slight physical defect. Behind this reliquary, a far more strange and inexplicable spectacle awaited us; this consisted of the relics of Saint James and Saint Philip carried, I believe, by about forty men who were constantly out of breath and had to stop short. This interruption caused a space of about a hundred steps to appear between them and the relics of Saint Rosalie; as soon as this happened, they started running and didn't stop until they had caught up; then they would stop once more, wait for a new space to open up and, as a result, the procession of these relics proceeded by fits and starts from the moment of departure until the instant of arrival…

"After the relics of Saints James and Philip came those of Saint Nicholas, carried by ten dancing and waltzing men. This way of rendering homage to a saint seemed most odd to us, so we asked for an explanation. We were told that during his lifetime Saint Nicholas was rather jolly and that they had found no better way than this choreographic march to summon up his gaiety. Behind Saint Nicholas came only a procession of the people. This triumphal march, which had started around noon, was hardly finished by five o'clock. Then the carriages could once more get around in the streets; the Marine promenade started once again".

But the culmination of a day in the life of a Leopard was a reception given by one of his peers. The unbelievable luxury of these festivities was, in Sicily, a tradition that went back to the 16th century and every

visitor, including Count de Borch, who traveled to the island in 1777, considered that "it was impossible to do things with more magnificence, more taste, and more voluptuous refinement". The pride in appearances and the tradition of hospitality were combined to maximize a delight in festivities whose oriental precedents were quite evident. To tell the truth, this veritable folly was one of the main reasons for the ruin of great families. For example, in May 1799 Ercole Michele Branciforte, Prince of Butera and a member of the Lanza family, brought down from Mount Etna 5,000 kilos of snow on the backs of mules. The altitude from which this descended was 3,000 meters and the distance traveled was the 200 kilometers to Palermo. The purpose was to make up sherbets and ices for 300 people at a party where the menu consisted of a hundred different dishes among which were such rare delicacies as foie gras and moray eels. And this particular party-giving Leopard paid annually around $2,500,000 interest on the mortgages taken out on his immense properties.

If we are to believe the chapter in which Lampedusa describes a reception given by the Prince Panteleone, the lavishness of 19th century aristocrats was equal in every way to that of their ancestors. Luxury did not only reside in the supremely refined dishes they served up ("monotonous opulence... one could never finish the meal, as is usually the case"), but in every detail: an army of liveried servants, in breeches and white silk stockings, impeccably bewigged, an endless suite of large salons (Visconti used those of the Gangi palace for his film *The Leopard*), the beauty of the tapestries, the flash of gold reflected by candlelight ("standing on high, pedestals of shining metal were six figures of athletic men and six figures of women, raising above their heads a silver-gilt branch crowned by the flame of twelve candles"). An enormous quantity of silver was used for the occasion: knives and forks, plates, platters, tureens, salad bowls, fruit dishes, centerpieces. "Who knows how many acres of land that cost?" wondered the Leopard. And there was, of course, a mass of the flowers that so abounded in Sicily that nobody bothered to mention them. Nobody left before six in the morning. As the Leopard didn't like dancing, he would often have preferred to go to bed earlier, but "that would have meant proclaiming that the party wasn't successful, and would have offended the hosts after the poor people had gone to so much trouble".

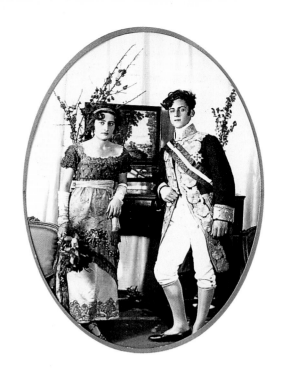

Donna Francesca Licata di Baucina and don Biagio Licata di Baucina in the diplomatic uniform of the Kingdom of the Two Sicilies. The photograph was taken at a costume ball whose theme was Naples at the time of Lord Nelson and Lady Hamilton.

Detail of a 1790 ball gown in the Malvagna palace. Opposite. *The gallery of mirrors at the Gangi palace.*

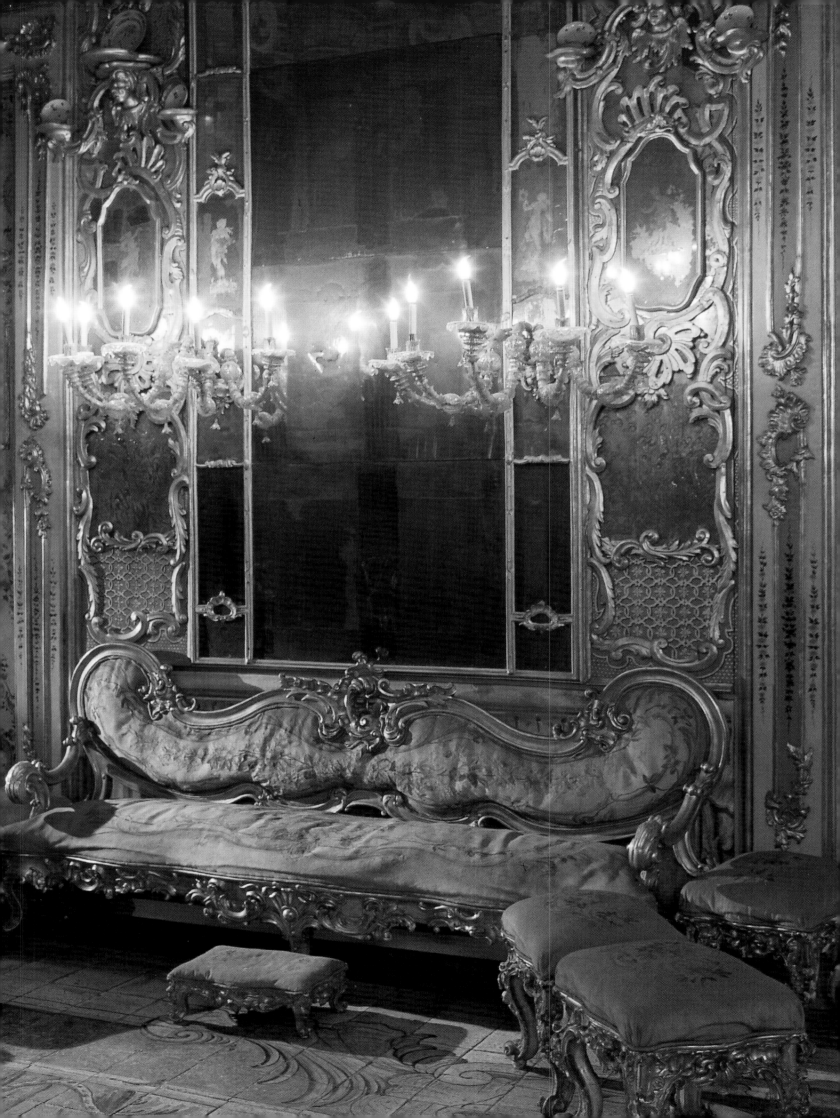

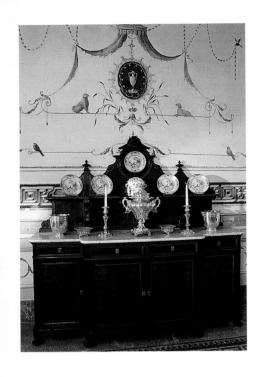

The extremely fine porcelain service which served sixty – and I believe that was the number of guests – came from the manufacture of the Duc d'Artois, a factory that was as important as Sèvres. The service had hundreds of pieces, was extremely rich in accessories, wine coolers, fruit baskets, burettes, salt cellars of varied shapes decorated with blue lilies and miniature pink tulips, festooned with laurel leaves and small red berries, covered in gilt volutes. Dacia Maraini, *Bagheria*.

Above. *On the credenza in the dining room of the Spedalotto villa in Bagheria, there is a silver samovar and plates from the French East India Company.*
Right. *A Meissen plate and candy dish from the Lanza Tomasi palace.* Opposite. *The dining room of the Gangi palace that was transformed by Marianna Valguarnera. The ceiling was the work of Giuseppe*

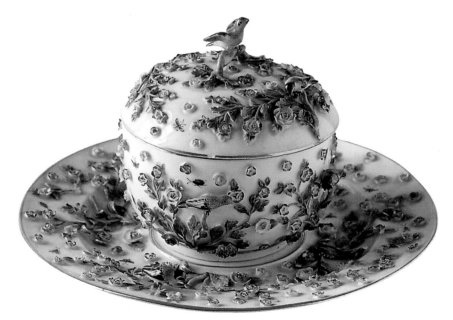

Velasco, *also known as Velazquez (1750-1827), a painter from Palermo who worked in many of the city's churches. On the table is an elaborate silver gilt candelabrum.*

Overleaf. *Paris porcelain plates and Murano glass bonbonnières are placed on neo-classic consoles.*

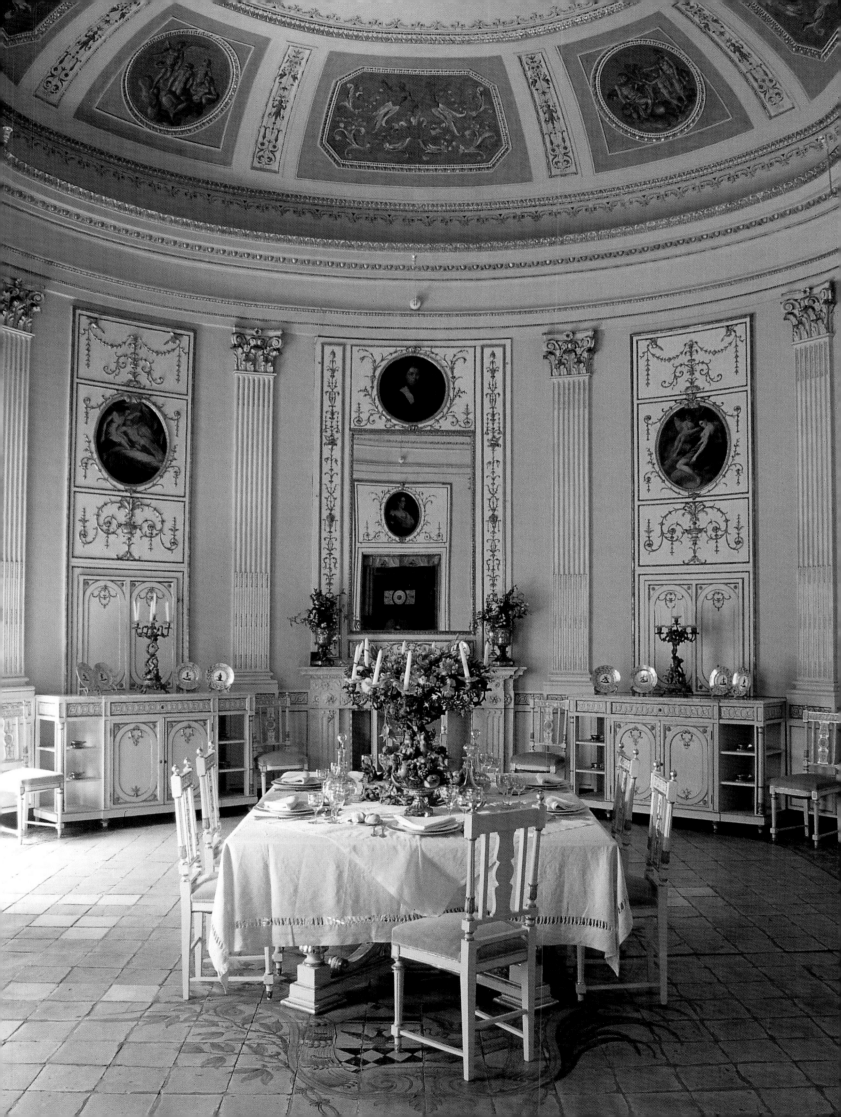

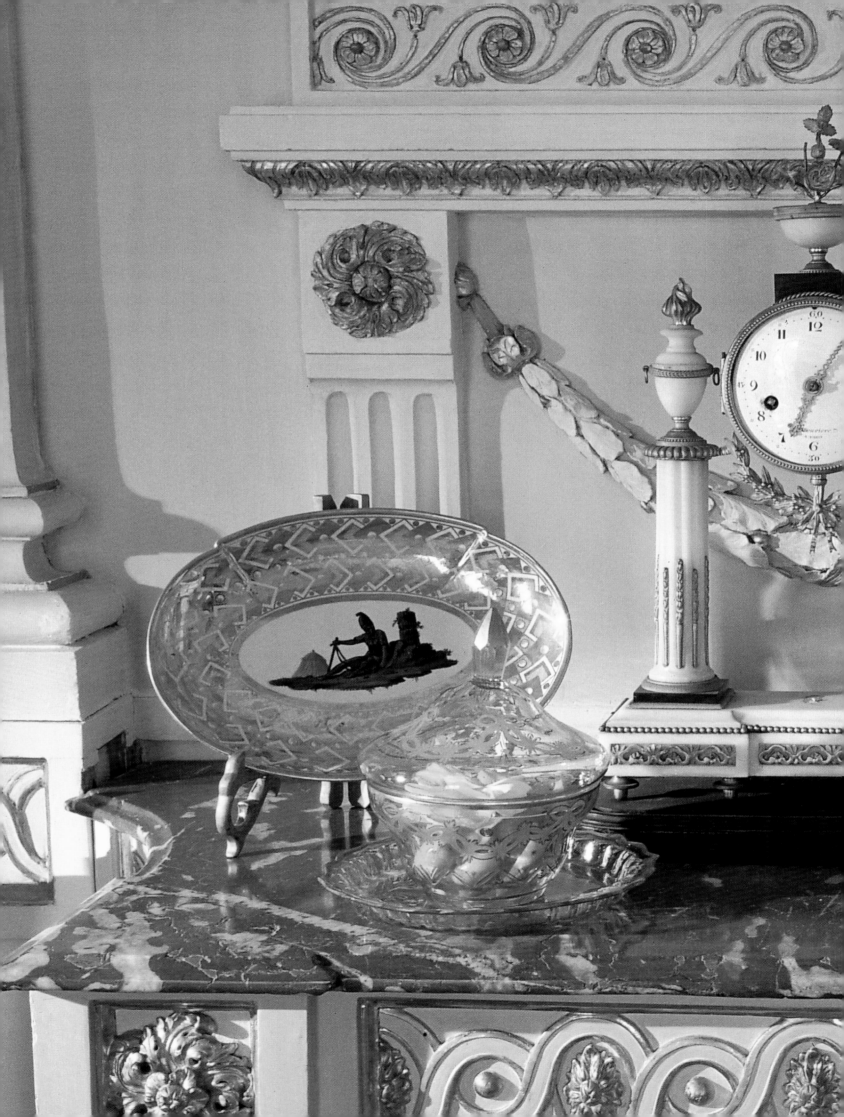

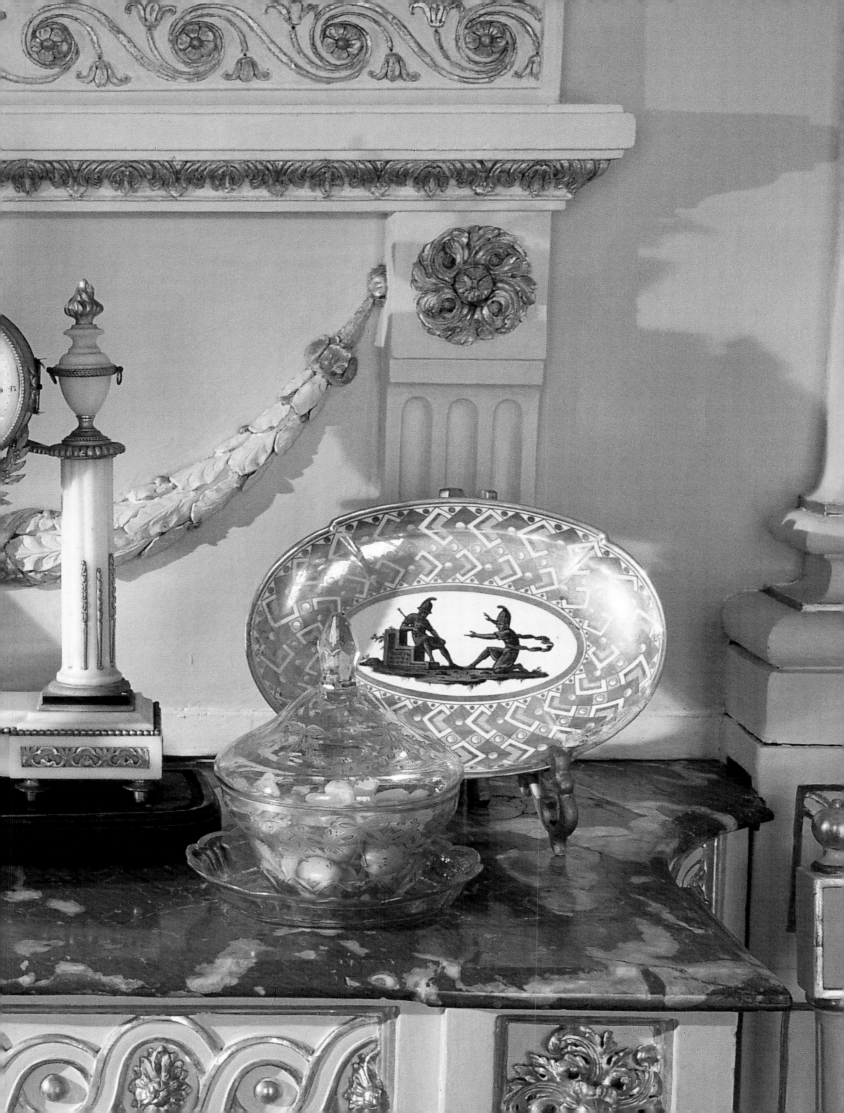

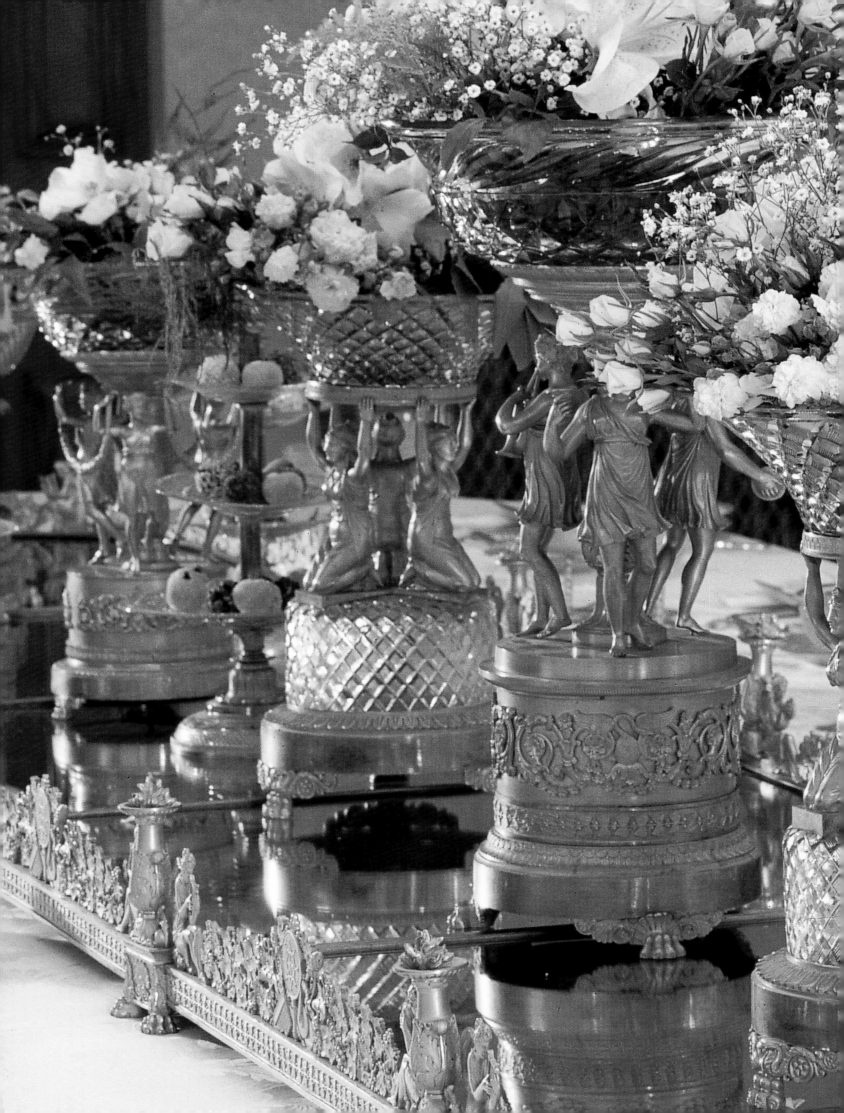

Previous pages. *A fabulous Empire centerpiece in crystal and bronze gilt is attributed to Philippe Thomire. There is another example at Malmaison, outside Paris. Opposite. A St. Louis glass crystal service from the Alliata Pietratagliata villa.*

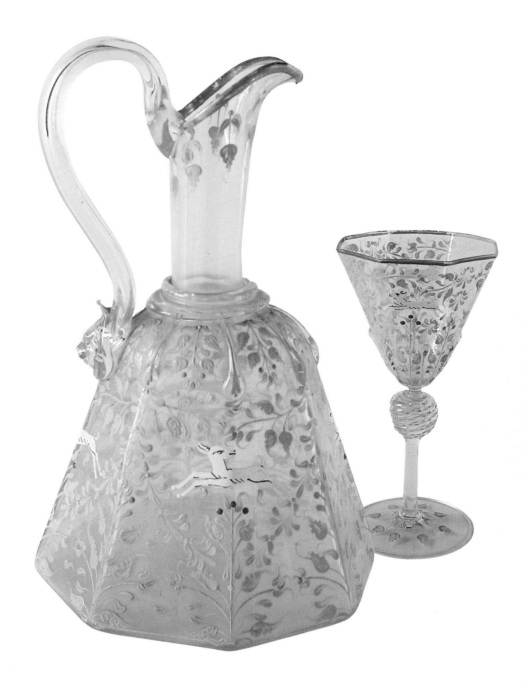

Above. *This polychrome Murano glass service, with "the running dog" motif, has eighty pieces. There are small holders for place cards for every guest.*

Overleaf. *Meissen centerpieces from the Malvagna palace in Palermo.*

In the ballroom, there wasn't just gold; gold smoothed out the cornices, gold was worked into the door frames, clear and damascened gold, nearly silver, highlighting a darker background, on the panels of the doors including the inside shutters, that closed the windows, cancelled them out, gave the proud room the feeling of a screen that excluded any relationship with the unworthy world outside. All this had nothing to do with the impudent gold decorators use today, but was instead a worn gold, pale as the hair on certain northern lasses; gold that carefully hid its price, with a modesty that is lacking today, doing so in a precious manner that showed its beauty but made one forget its value. Here and there, on the paneling, on knots of rococo flowers of a sweetly faded color, there was an ephemeral red, a reflection coming from the chandeliers. Lampedusa, *The Leopard*.

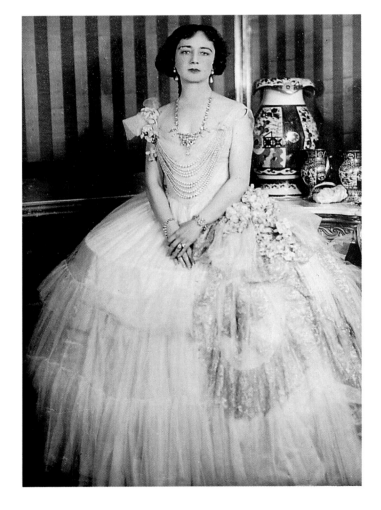

Giulia Alliata de Monreale,
Princess Gangi in a ball dress.

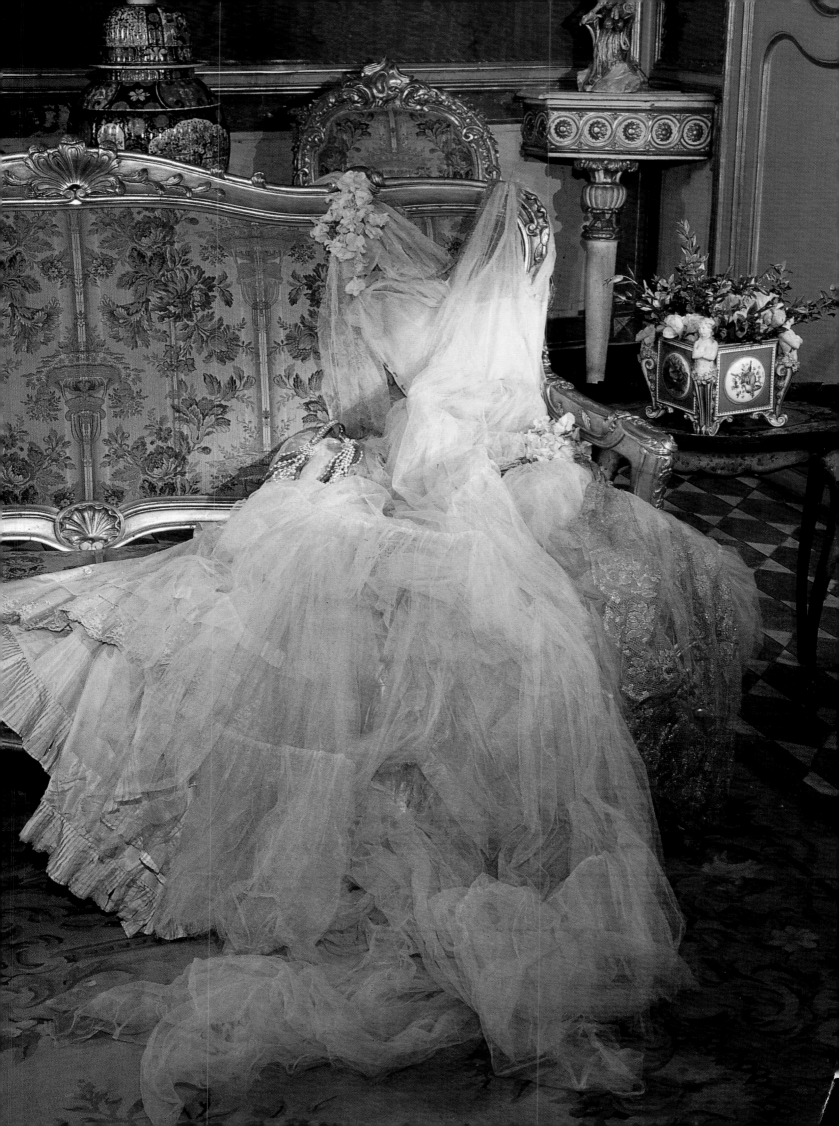

Overleaf. Right. *The Marchesa Giulia Paternò di Spedalotto at the "Marie Antoinette" ball in the Chinese cabinet of the Palazzo Gangi. Left. A bench in the Sicilian Baroque style, recovered with an Aubusson petit point* tapestry; *it is to be found in the gallery of mirrors of the Gangi palace. On a Chinese porcelain plate are* Minni di Vergini, *or Virgins' breasts, a traditional pastry filled with chocolate and candied fruit.*

Above. *Caterina Ugo, Marchesa Delle Favare at a ball. Right. a* peniche, *a piece of furniture quite characteristic of the Second Empire of Napoleon III, known in English as a "pouf", in one of the salons of the Aiutamicristo palace.* Right. *As in Spain, for obvious reasons of the local climate, fans weren't only a pretext to carry something pretty, but an indispensable accessory which lent itself to an infinite variety of decoration.*

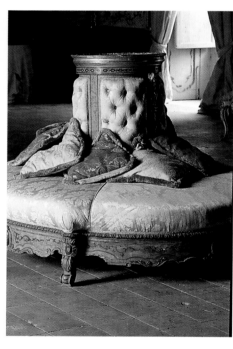

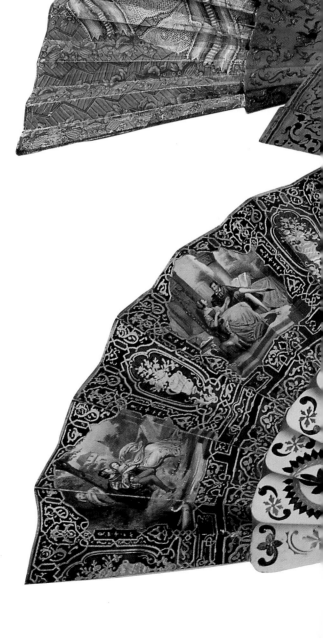

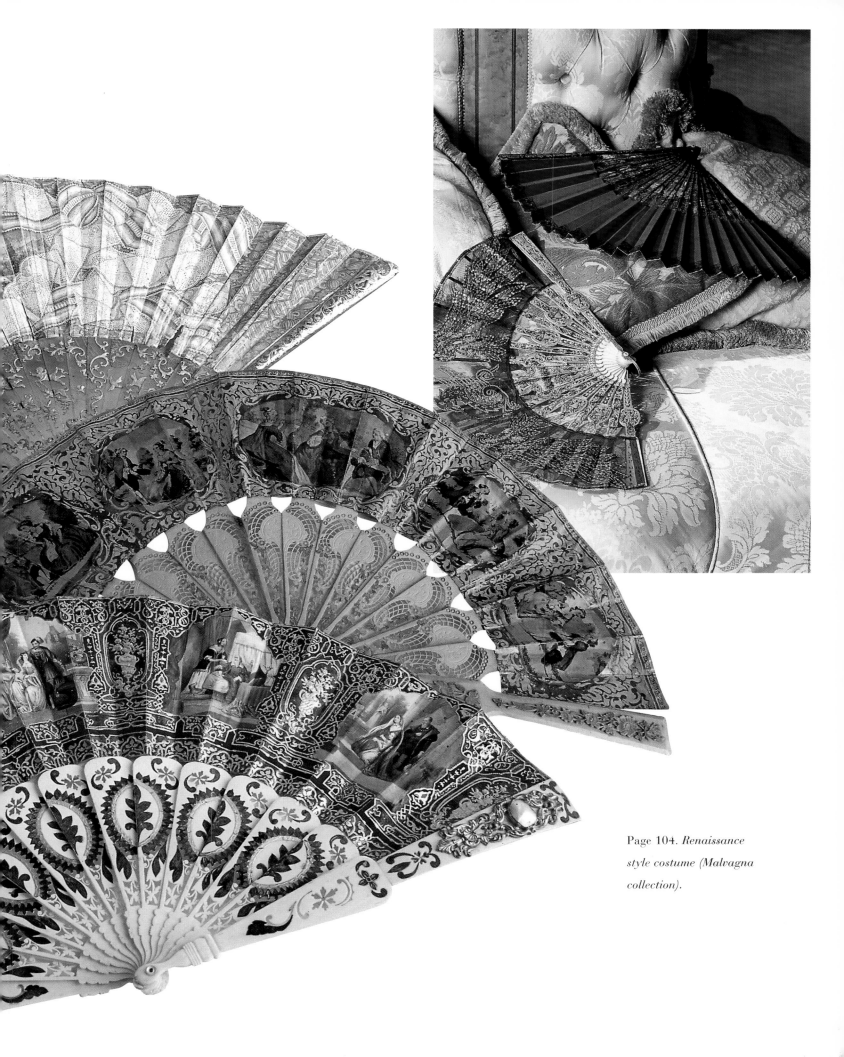

Page 104. *Renaissance style costume (Malvagna collection).*

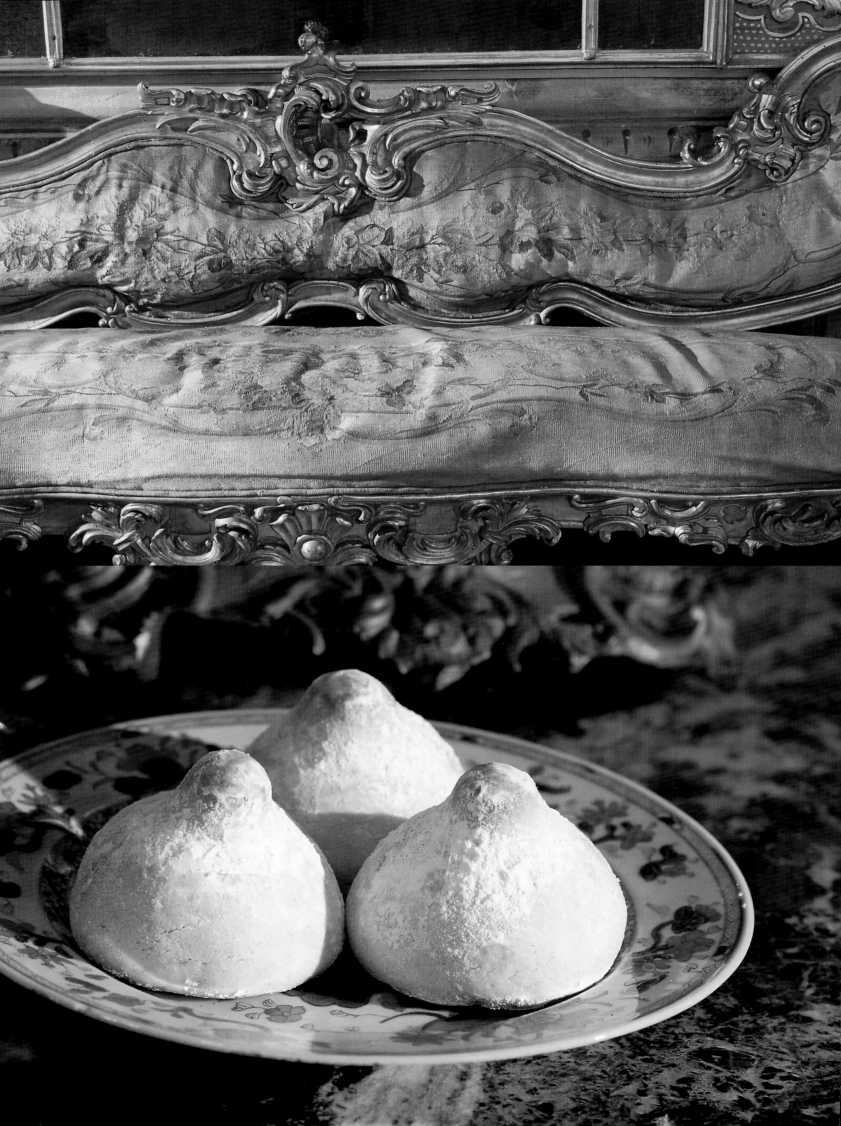

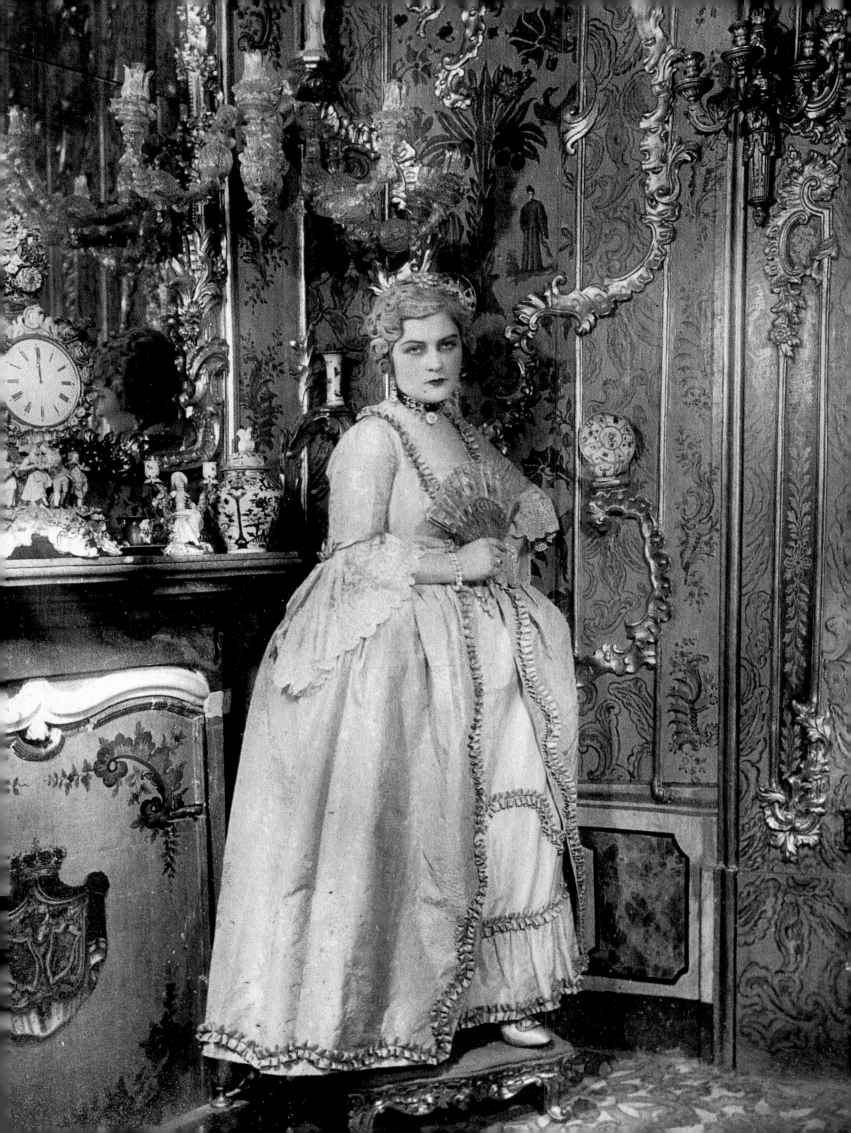

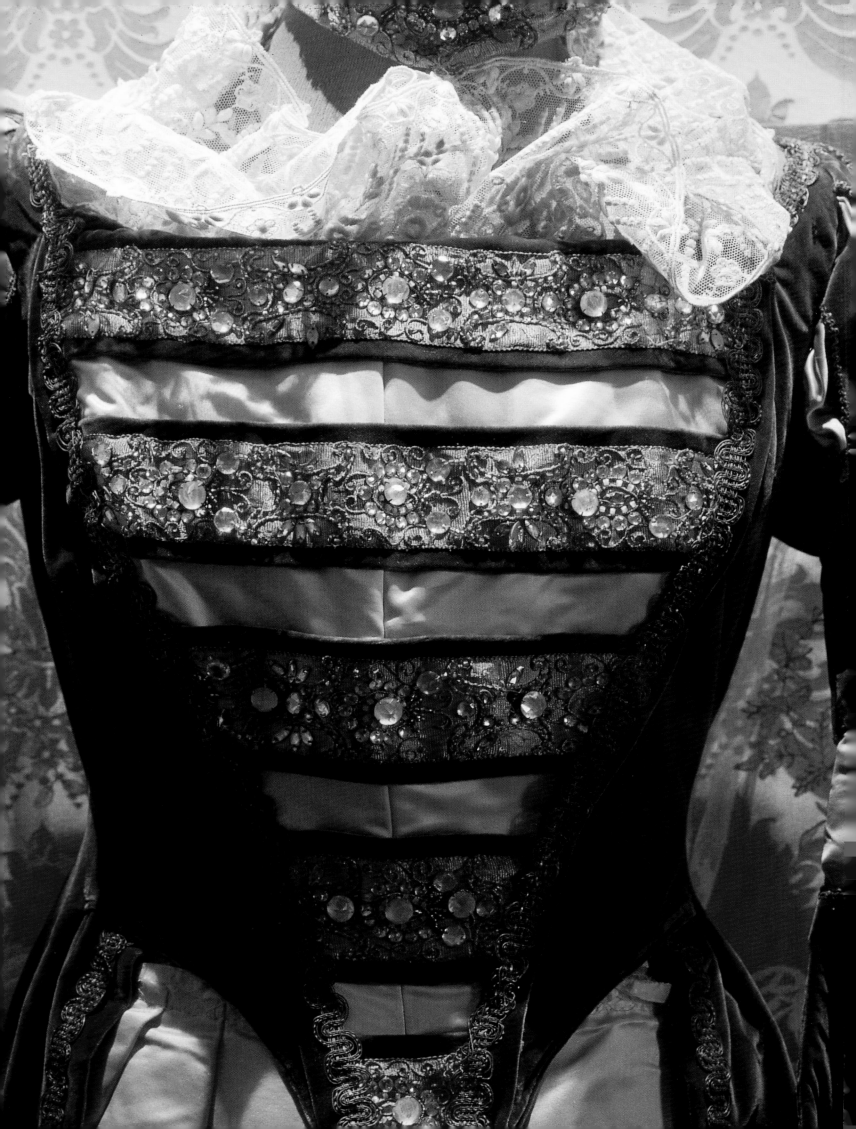

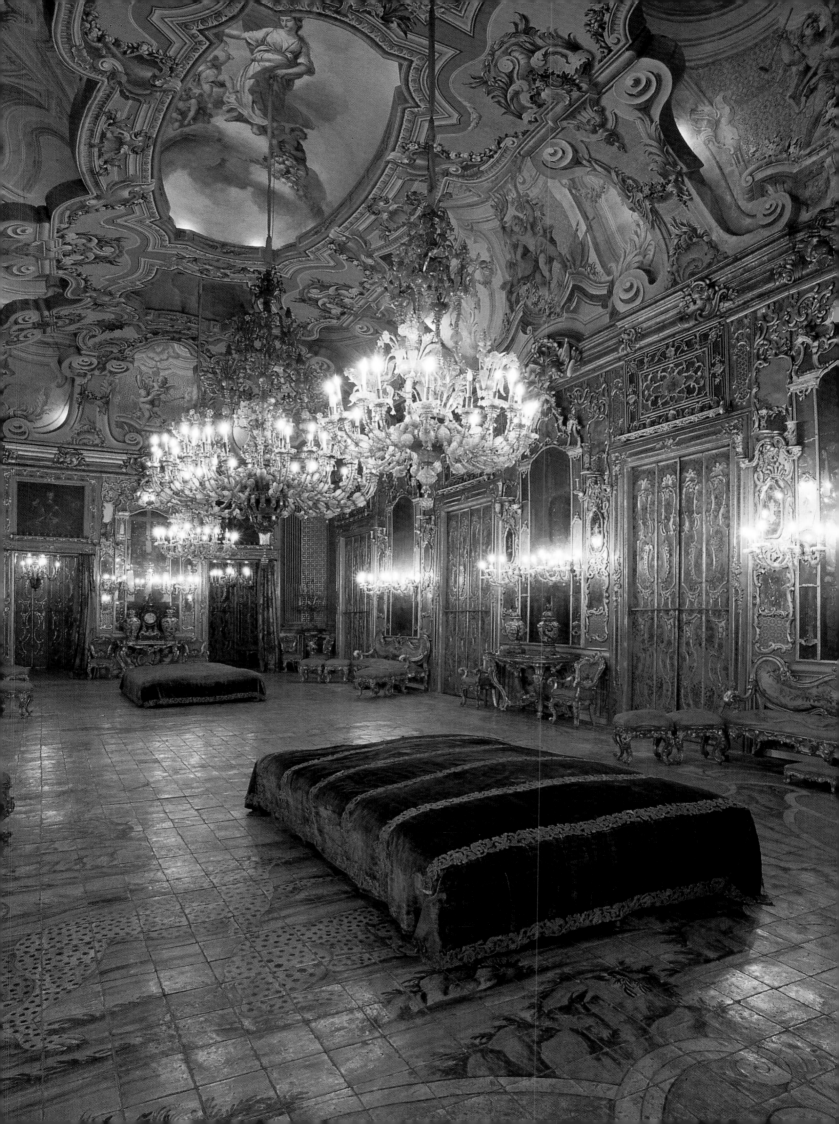

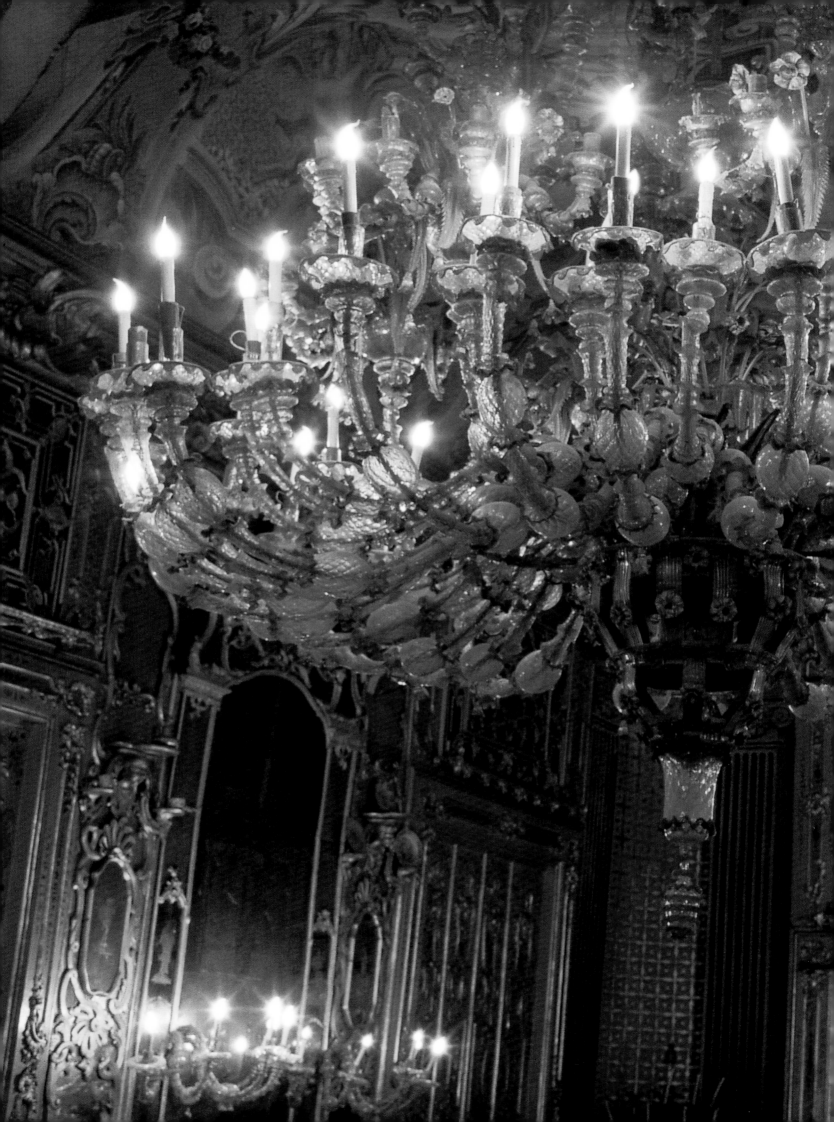

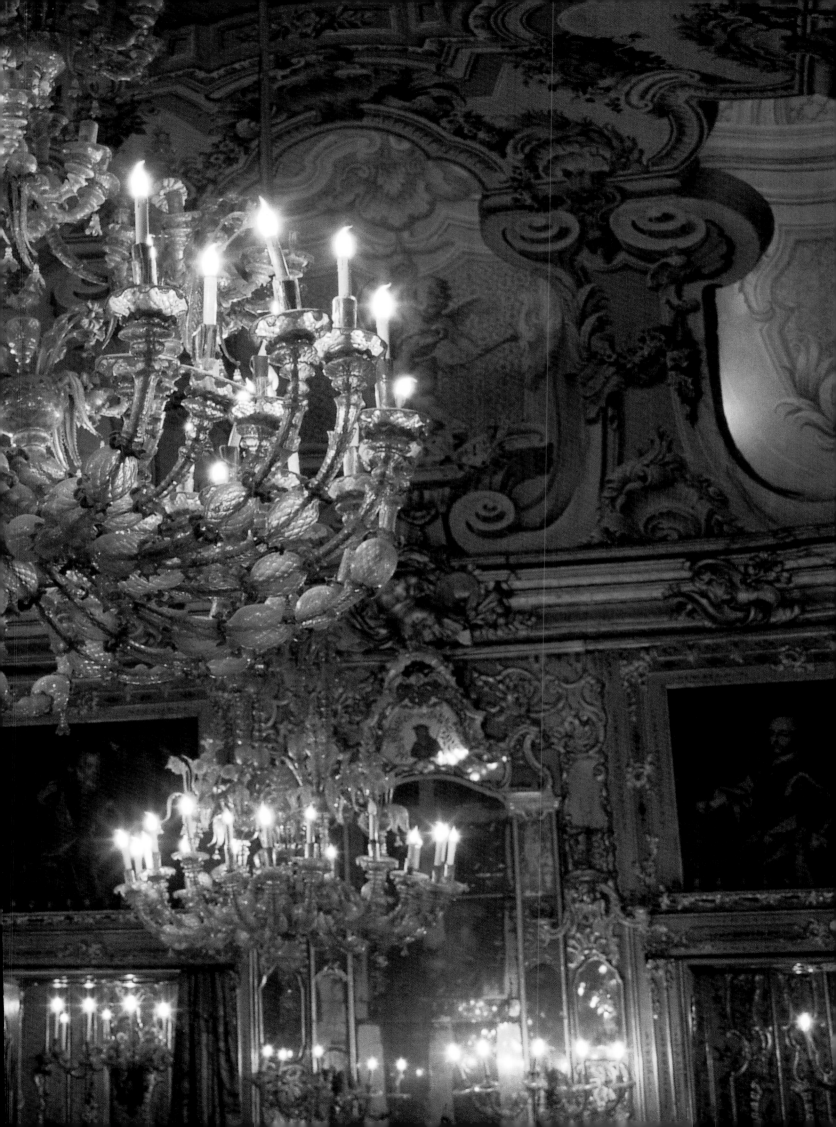

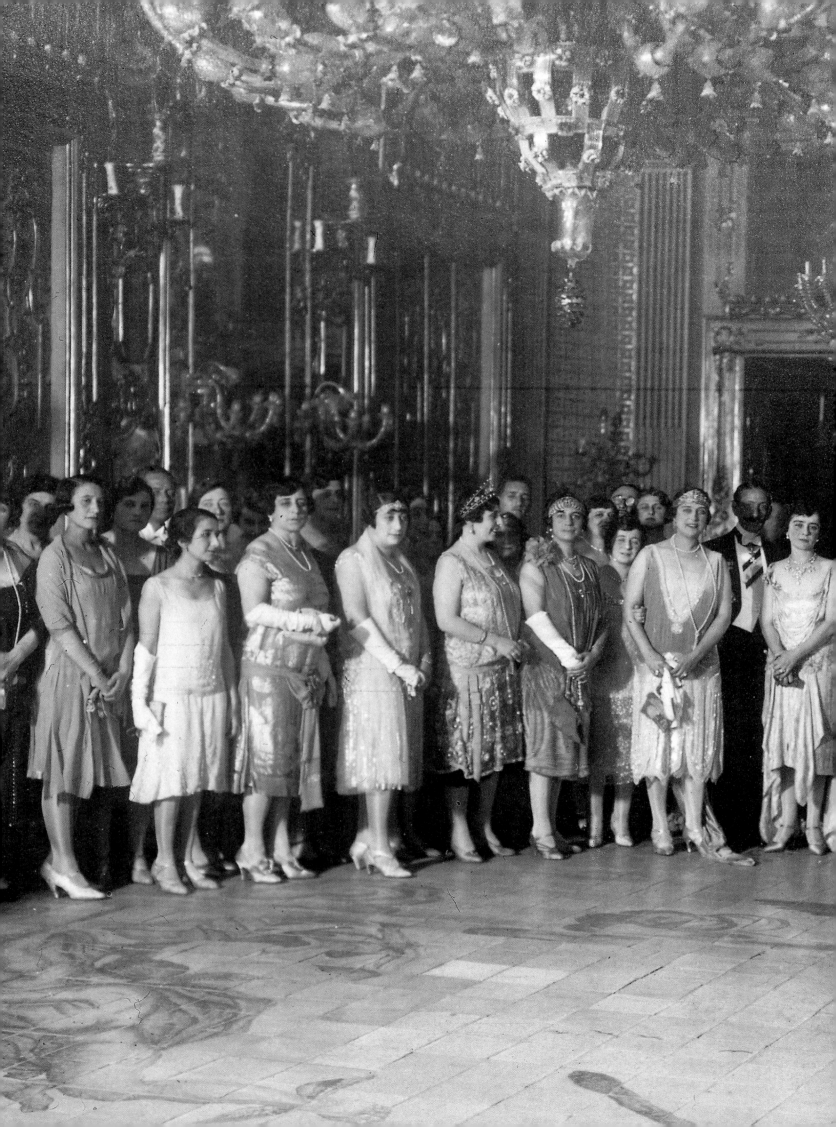

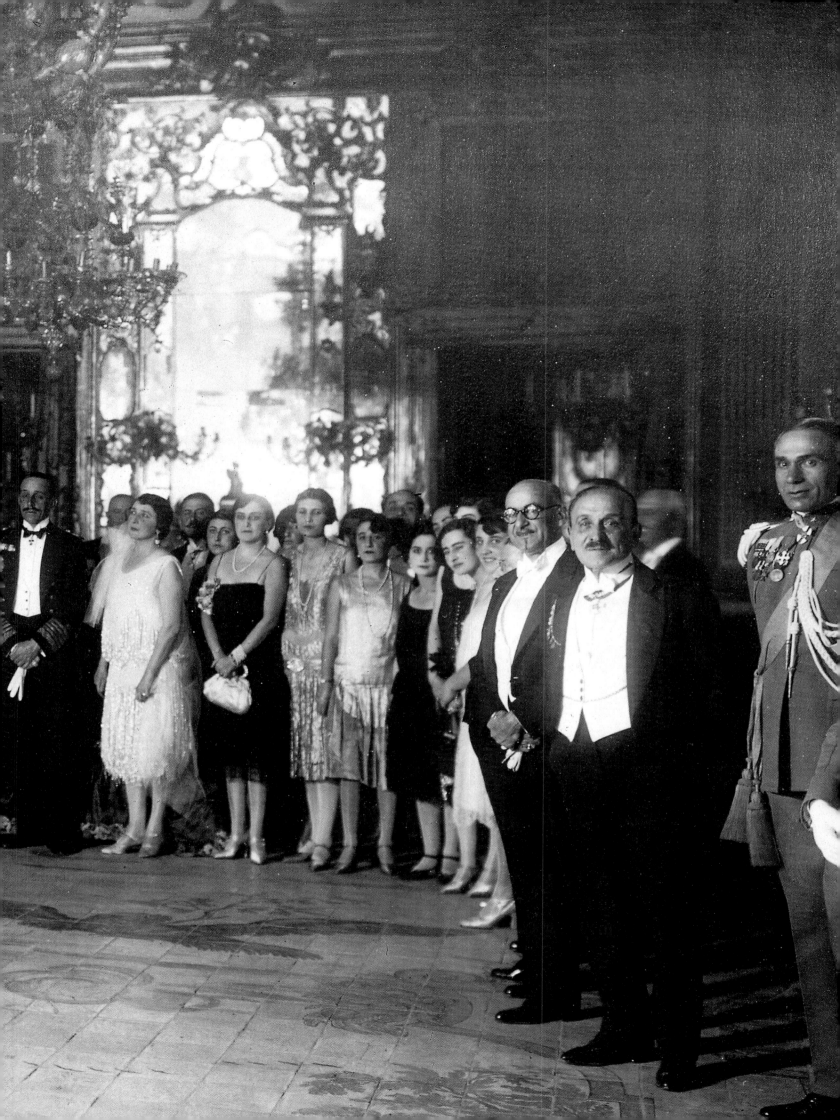

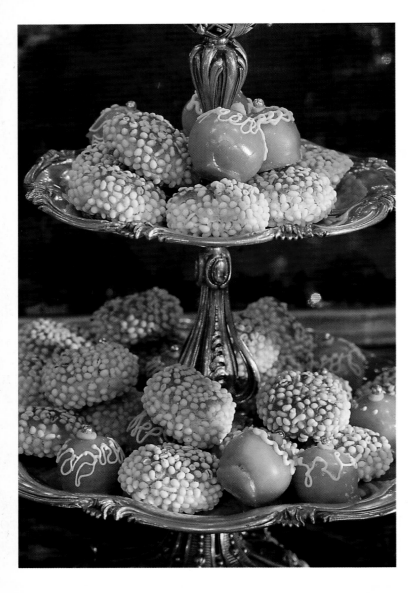

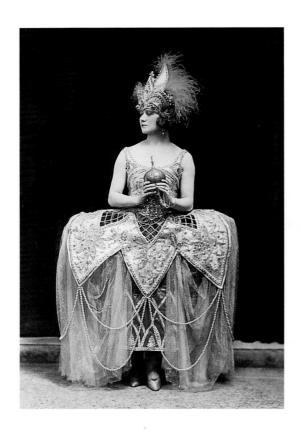

milk in abundance. That is the basis of an excellent production that is as famous in Italy as it is abroad. The most characteristic forms are nougats, candied fruits, cassatas, cannolis, ices and sherbets".

Below. *Concetta Lanza di Scala, photographed in 1931 at a ball inspired by the theme of incense.*

Opposite. *Detail of the hall of mirrors of the Gangi palace.*

Pages 105-109. *The hall of mirrors at the Gangi palace, with guests at a ball in the 1930s, gives an idea of the magnificence of the last days of the Leopards. Three 18th century Murano glass chandeliers, each with a hundred branches, illuminate this magnificent suite of rooms, whose double ceiling is the work of Gaspare Fumagalli.*

Above. *The* Italian Guide to Gastronomy *had the following to say about Sicilian sweets in 1931. "Sicilian pastry has an extremely vast selection of natural ingredients, a great variety of different sweeteners, aromas, and flavors, fruit juices and pulps, grains, leaves and roots, as well as the best qualities of wheat flour, honey, wines, eggs and*

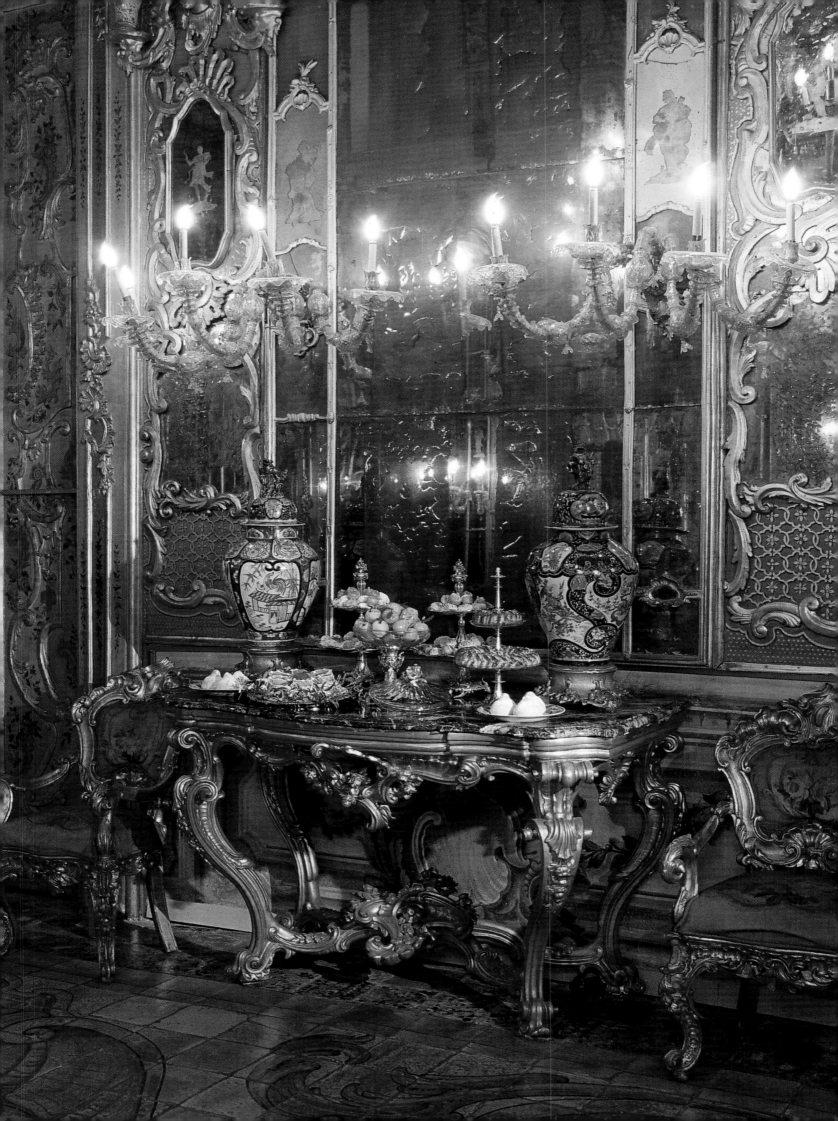

The country villa

Right behind Palermo, declares the 1877 *Guide Hachette*, there was a large and fertile plain, with a great number of country houses, to which the poetic name *Conca d'Oro*, "The Golden Shell", has been given. If we remember that in Italian a villa means a country house far vaster and more luxurious than its counterpart elsewhere, we will understand the meaning of the word *villegiatura*. To tell the truth, in the case of Sicily and Palermo in particular, if the word's entymology is Latin, its origin is Arabic. In fact, it was the Arabs who, around AD1000 established parks, gardens, and orchards, planted with vegetables, sugar cane, carob trees, pistachio trees and date palms. The Angevin and Aragon invasions brought a long period of neglect and decadence which lasted until the 17th century. It was then that several Leopards imitated Prince Giuseppe Branciforti di Pietraparzia who, while definitely not the first, built a magnificent residence at Bagheria, the Villa Butera. These villas multiplied until the first decades of the 19th century, and even later, representing a panoply of varieties of the Palermo version of the Liberty style that was in fashion at the end of the 19th and beginning of the 20th centuries. They were built throughout the *Conca d'Oro*, but aristocrats in general preferred the Piana dei Colli to the north, and the small village of Bagheria to the south of Palermo. Despite the haphazard urban development of the 1950s and the extremely powerful pressures of real estate promoters, there are still about 200

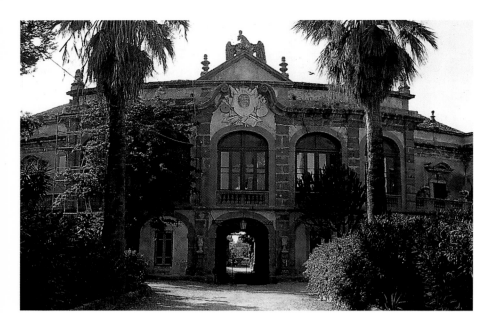

As wrote a late 19th century guide, "Bagheria (Bagaria), a place filled with the villas of the rich inhabitants of Palermo: among these are the Valguarnera villa, the Villa of the Prince of Butera, remarkable for its street of gardens". The door of the

Villa San Marco opens on to an orchard.

left, some of which have been completely engulfed and integrated into the city. As everywhere in Sicily, two pillars frame the entrance to a property, their height and decoration depending on the taste, fortunes and pretensions of the proprietors. Originally pleasure gardens, and always very vast – as the useless is a sign of power – they are set out "in the ancient manner", with geometric parterres with elegant embroidered designs, and are laid out in such a way as to create a majestic perspective coming from and going to the main building. At the time of *The Leopard*, however, a freer, more casual English style replaced these classical alignments.

Many villas were characterized by a double, monumental outside staircase which ensured ease of access between the garden area and the *piano nobile*. These often reached more than one floor, rarely more than two. Between the two flights of stairs there was an enormous vault which allowed carriages and cars access to the back courtyard and the common areas. The structure of certain villas, especially those on the Piana dei Colli, led one to believe that they were originally true country houses, even fortifications, transformed into palaces. Others, on the contrary, above all in Bagheria, are pure Baroque or neo-classical creations. A few , similar to the *parcs aux cerfs* of rich subjects of the French kings, merited being called "follies", more because of the cost and fantastic architecture than the lifestyle led there. The most famous of these was the villa built in Bagheria in 1715 by the Prince of Palagonia, later decorated by his grandson, Ferdinando Gravina, in a most unusual style. In addition to other extravagances, he erected six hundred effigies of monsters, seventy-two of which have escaped the ravages of time. and the terrified

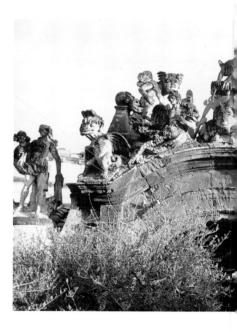

Above. *"The odd Sicilian taste is best represented in the villa of Prince Palagonia".* Guide Hachette, 1877.

*The staircase of the
Spedalotto villa leads to a
terrace overlooking the
gardens. Note the
Caltagirone tiles on the
steps.*

fury of the local population. These oddities of the Prince of Palagonia still fascinate visitors, either filling with horror such wise spirits of the Age of Enlightenment as Goethe, who visited the villa in 1778, or creating delight in contemporary visitors who see in them reflections of the subconscious. We do know that the Prince of Palagonia was in no way a follower of the Marquis de Sade. Cultivated, pious, and charitable, he was simply taking the Baroque to its outside limits in a way that was unique to Sicily.

The beauty of the gardens and the joys of nature, the principal benefits of life in the country, were not always the unique benefits of being there. Sometimes living in a country villa was the result of disgrace or the disenchantment of a great gentleman, as was the case of the Villa Butera, one of whose towers, on the façade facing Palermo, carried the inscription "O Corte a Dio" (farewell, dear court). The possession of a villa near Palermo, such as the Villa Niscemi on the edge of the lovely Chinoiserie filled Favorita Park, a place where Fulco di Verdura passed his childhood, limited the inconveniences of the misunderstandings of a couple. Other villas, surrounded by a cultivated estate, also conserved the character of the traditional residence of a country squire.

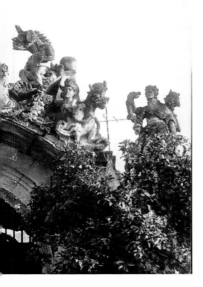

The dolce Villa

We would think today that noble Palermitans lived in their villas in the summer, when the sun was at its strongest. But no. Spring and fall were the seasons for going to one's villa – or to the country. In addition, every town was situated near the seashore, and at the time of *The Leopard* doctors advised against swimming in the sea except for people with serious diseases of the nervous system. At the beginning of the 20th century, reports Fulco di Verdura, Mondello – the great sea resort at the very gates of Palermo – was nearly deserted. High society had reserved for its personal use "a row of wooden shacks built on stilts and equipped with a platform looking out to sea. Inside, a trap-door opened on to a staircase that permitted ladies in bathing costumes to get in and out of the sea without being noticed".

In 1860, there wasn't a meter of railroad in Sicily at a time when the British rail network had 17,000 kilometers of track against 10,000 for France. Despite Garibaldi's promises, the first Sicilian railroad tracks were laid in the early 1870s. Thanks to part of a line intended to link Palermo to Catania, one could soon travel by rail the fifteen kilometers to Bagheria in half an hour. There were three trains a day; the first-class one way ticket cost around the equivalent of $8.00. One might think that this new facility would have encouraged more frequent visits to the properties, but in fact, forty years later, Fulco de Verdura was still complaining about how arduous the trip was.

On many levels the country life of the Leopards differed little from that of Palermo. The decoration and furnishing of these villas would never have made one think of the exuberant and nearly tropical nature in which they were set. Period photographs of the interior of the Villa Tasca on the road leading to Monreale, which was the property of Count Mastrogiovanni Tasca-Lanza, several times mayor of Palermo, show an accumulation of Louis XV furniture, heavily padded armchairs and large sofas piled up with cushions and embellished with lace, all sitting on heavy wall-to-wall carpets.

The dinner table was equally elaborately decorated. The novelist, Dacia Maraini, who was a member of the illustrious Alliata family, owners of Villa Valguarnera, the most beautiful in Bagheria, recounts the instructions of his relative, Prince Giuseppe, on this subject. "The table must be sufficient in size to hold a small Doric temple in the center, with colonnades, balusters, tripods and pairs of statues at the end, and other small temples, rather like gloriettes. These monuments must be populated by a crowd of Capodimonte porcelain figures of shepherds, young girls in the manner of Reynolds rather than Watteau, in order to respect the dominating English influence prevalent in Sicily."

Leopards in the country apparently woke up slightly earlier than they did in town, then paid each other visits and took walks, stopping here and there to savor a *granita* in the "coffé houses" [*sic*] of their hosts. These houses, referred to in English, were small kiosks scattered throughout the garden, where servants served refreshments. People worshipped in their private chapels and, as in town, there were receptions and balls, during which the garden served as a place to set off fireworks, and, again as in town, time was spent gossiping, reading magazines, playing cards and billiards. Quite exceptionally, Prince Giulio Tomasi di Lampedusa installed an astronomic observatory in his villa at Piana dei Colli, situated between San Lorenzo and Pallavicino. This grandfather of

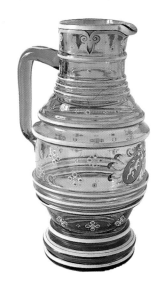

If Vietri and Capodimonte porcelain are the pride of the Kingdom of Naples, Caltagirone in the province of Catania is known for making "the Sicilian faience". Since the Arab occupation, ceramics have been produced there that are famous for their colors and realism.
Opposite. *An antique Ginori soup tureen with the arms of Prince Gangi.*

From top to bottom. *Vietri glass and porcelain, c.1820. A sixteenth century Caltagirone lion. An 18th century Meissen figurine.*

Lampedusa was the inspiration for his hero's interest in cosmography and meteorology.

Villa life offered children infinitely more varied possibilities of distraction than life in town. Specifically, they could have closer and more frequent contact with their pets – dogs, cats, mules, donkeys or horses – not to speak of beasts from a more exotic menagerie; grass snakes, mongoose, even a couple of baboons which, according to Fulco di Verdura, had to be part of any respectable villa. Why, nobody can really remember, but they were still *de rigueur*. Verdura also tells of the arrival at the Villa Niscemi of a camel, which aroused excitement among all the neighbors.

Donnafugata

If we consider the stretch of railroad that linked Siracusa and Agrigento, we must notice that between the two beautiful Baroque cities, Ragusa and Cosimo, which were fifteen kilometers apart, the line took a sudden curve towards the south-west for no apparent reason, a great detour which more than doubled the length of the trip. Careful observation shows that this was done to serve a small station known as Donnafugata.

Those familiar with *The Leopard* will immediately think of the village in which a good part of the novel takes place. That is not the case. If Lampedusa did borrow the name from here, he had never visited it as it had no attraction for him. In fact Donnafugata is neither a town nor a village, but a simple place name. It housed, however, one of the most flamboyant Sicilian aristocrats of the 19th century, the Marchese Corrado Arezzo, Count of Celano and Baron of Pescina, a grandee who lived from 1824 to 1895. No doubt he was a Leopard of the provinces, different from those we have discussed previously, but one of the richest of his region. Responsible for many public affairs, he spent more time in Palermo, Turin or Rome than in his residence. It was undoubtedly to satisfy the desire of this influential personality that the official responsible for the Sicilian railroads consented to divert the trains from their straight line.

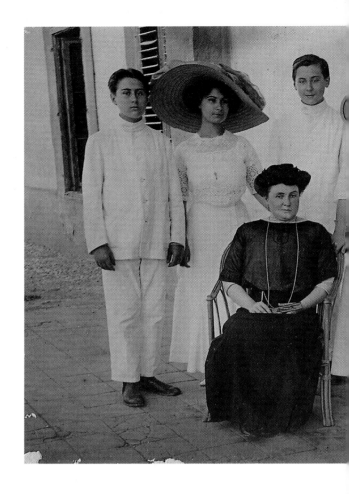

A vase in the gardens of the Villa Palagonia. Sicilian gardens, the pride of their owners, could be enjoyed the whole year round. Palm trees, cacti, citrus fruit trees, eucalyptus, and cypress made up an earthly paradise.

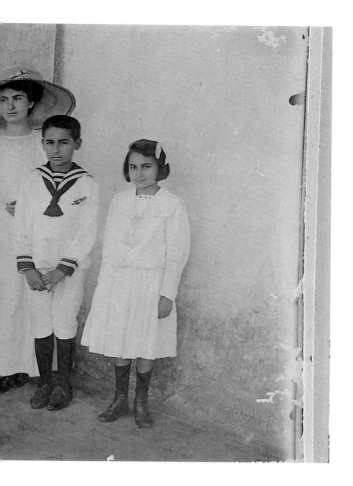

Silvia Paternò di Spedalotto is seen in 1910 with her children, Rosalia, Silvia, Achille, Ettore and Costanza in the family villa.

Donnafugata – we can well understand why this name enchanted Lampedusa – dated from the days of the Arab presence in Sicily. The Arezzos, whose origins went back to the 14th century, established the residence that Corrado rebuilt in the Venetian Gothic style. It had no less than two hundred and twenty rooms, all surrounded by a seven hectare park. The property even included an art gallery with works of optimistic attribution. There was also a room for heraldry where one could see the seven hundred and thirty-four coats of arms of the Sicilian aristocracy.

Seven hundred and thirty-four? But the official Golden Book only had two hundred and forty-five families, plus another two hundred that were extinct or second class. The truth is that, as one got further away from Palermo, things got slightly confused. Was Donnafugata a villa, a castle, a domicile or a country villa? Wasn't there also at Ragusa a palace (curiously called Donnafugata and not Arezzo) whose paintings, still written about in 1968 guide books, are at Donnafugata? And the Marchese Corrado, who fought against the Bourbons of Naples and then became a senator of the Kingdom of Italy, a prosperous and industrious man earning his income from the nearby asphalt production and the slightly more distant sulfur at Caltanissetta? Was he really a Leopard like Fabrizio Salina, Lampedusa's hero, a subtle, cynical, skeptical, and resigned hero, well on the way to extinction?

It's not really clear cut. As Dominique Fernandez writes, with great subtlety and elegance, about the disputed origin of the name Donnafugata. "Was this the name of a lady who had fled, been kidnapped – which even in Sicily is not the same thing – or simply the corruption of an Arab name signifying fountain of youth? On Pirandello's island, attempting to establish a single truth would prove that one was mad".

Statues are hidden in the bushes of the Solanto castle. The whiteness of statuary was a wonderful highlight to green planting, and was much used by Lenôtre in his great gardens at Versailles.

The villa of Prince Campo-Franco is, without doubt, one of the most delightful that can be seen, above all for its location: the four windows of the dining room open on to four different vistas, one of the sea, one of the mountains, one of the plain, and one of the forests.

After dinner, we were served coffee on a terrace covered with flowers; from this terrace we could see the entire gulf, part of Palermo, Mount Pellegrino and, finally, in the middle of the ocean, the island of Alciuri, like a haze floating in the horizon. The hour we spent on this terrace, during which we saw the sunset and the landscape in every gradation of light, from brilliant gold to dark blue, is one of those indescribable hours that one can summon up in memory by closing one's eyes, but which one can not make understood either by the pen or the paint brush. Alexandre Dumas. *The Speronare*.

Above. *Ettore Paternò di Spedalotto in 1930.* Right. *Euphorbia canariensis.* Opposite. *An 18th century bust in the gardens of the Solanto castle.*

Overleaf. Left. *The Boscogrande villa between Cardillo and Sferracavallo on the northern surroundings of Palermo, was built but left unfinished by Giovanni Maria Sammartino, the Duke of Montalbo, in the middle of the 17th century; it is in the Louis XVI style. The Sammartinos had been established in Sicily since the time of Pedro of Aragon and were of either Catalan or Gascon origin. Seen here is a view of the façade and a detail of the flower covered balustrade.*
Right. *Countess Marta Airoldi with her children Pietro and Maria at the Villa Airoldi in 1910.*

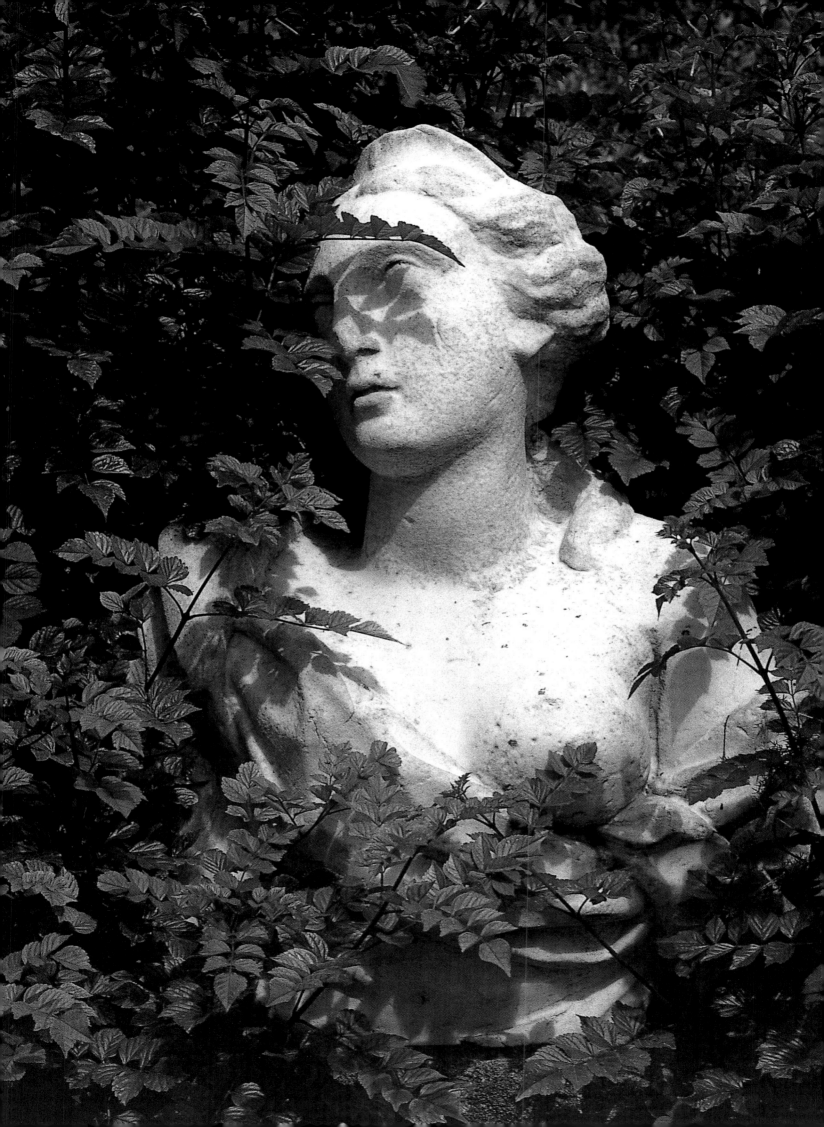

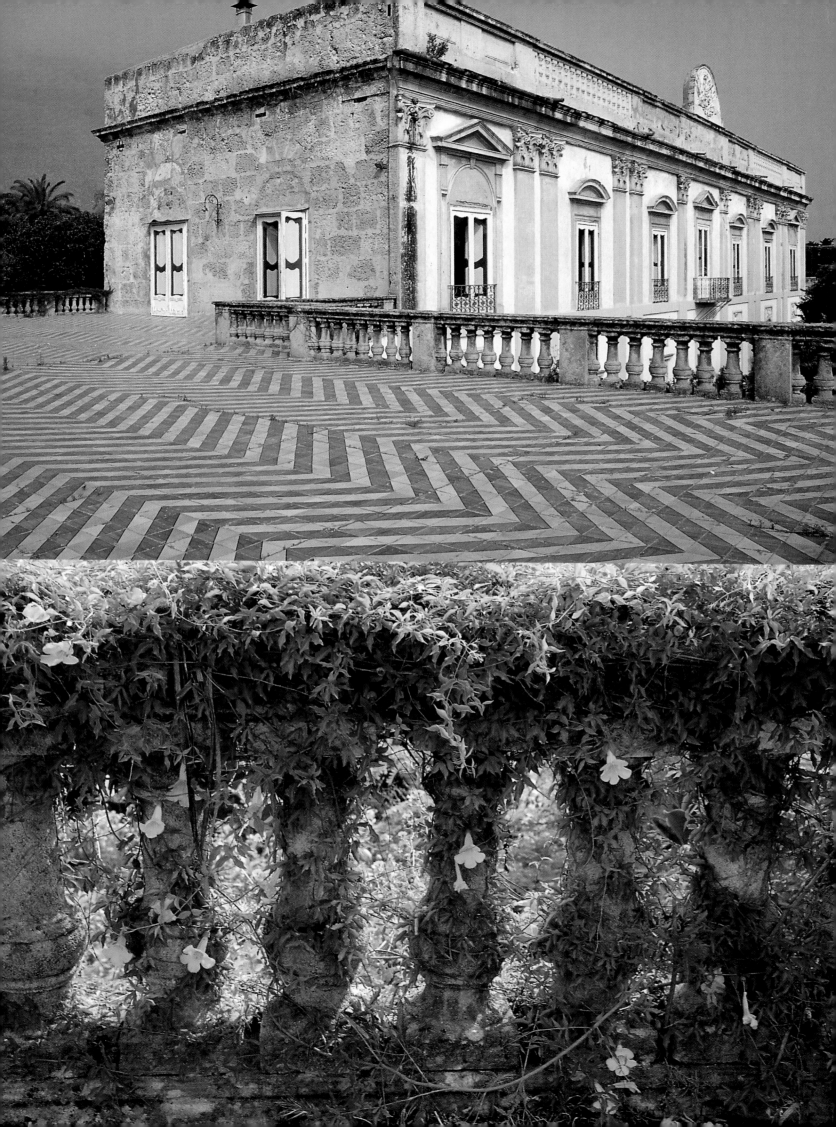

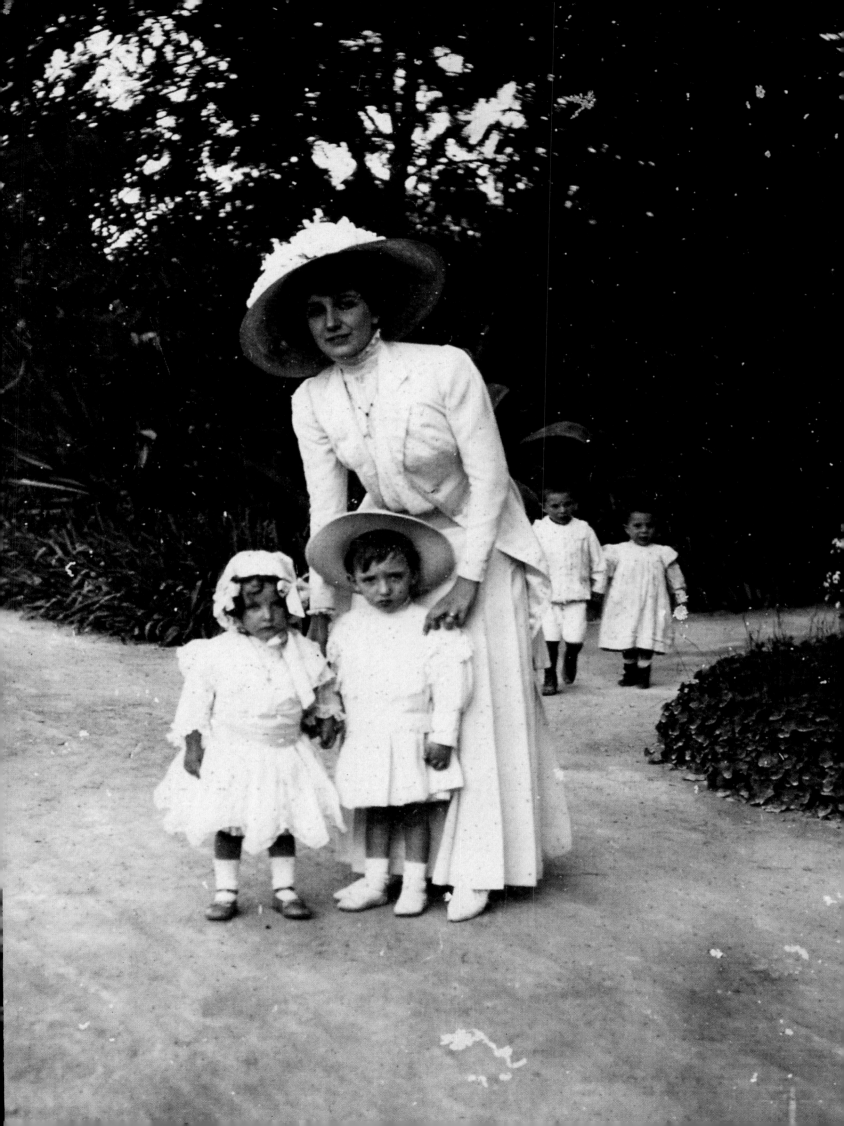

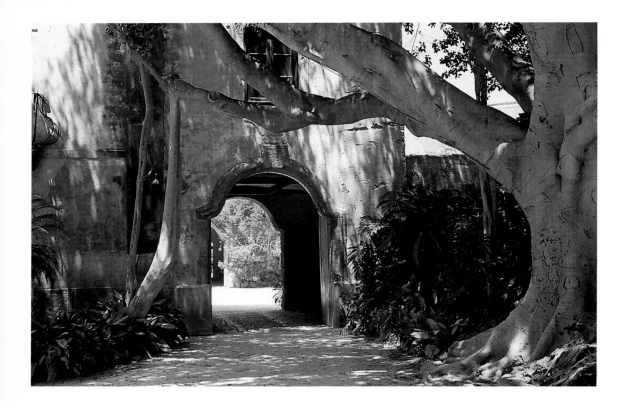

The Wirz villa in Mondello. Exactly as we see them today, most of the aristocratic gardens were planted in the 18th century. Their refinement and amenities responded to the Palermitan habit of talking walks – elsewhere public, here private – that goes back to the time of the Arab conquest. But the gardens also reflect the new interest of the Age of Enlightenment in botany, a fascination that the Sicilian soil could easily satisfy.
Overleaf. A Sicilian family on their terrace.

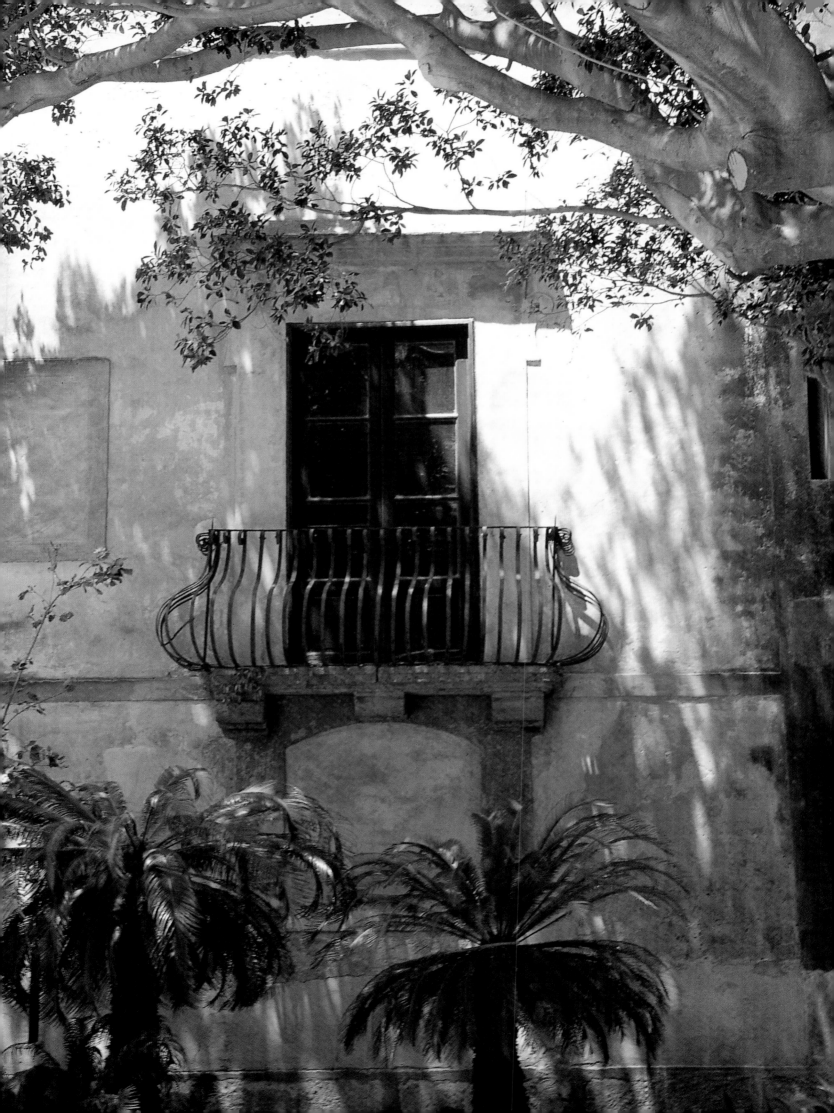

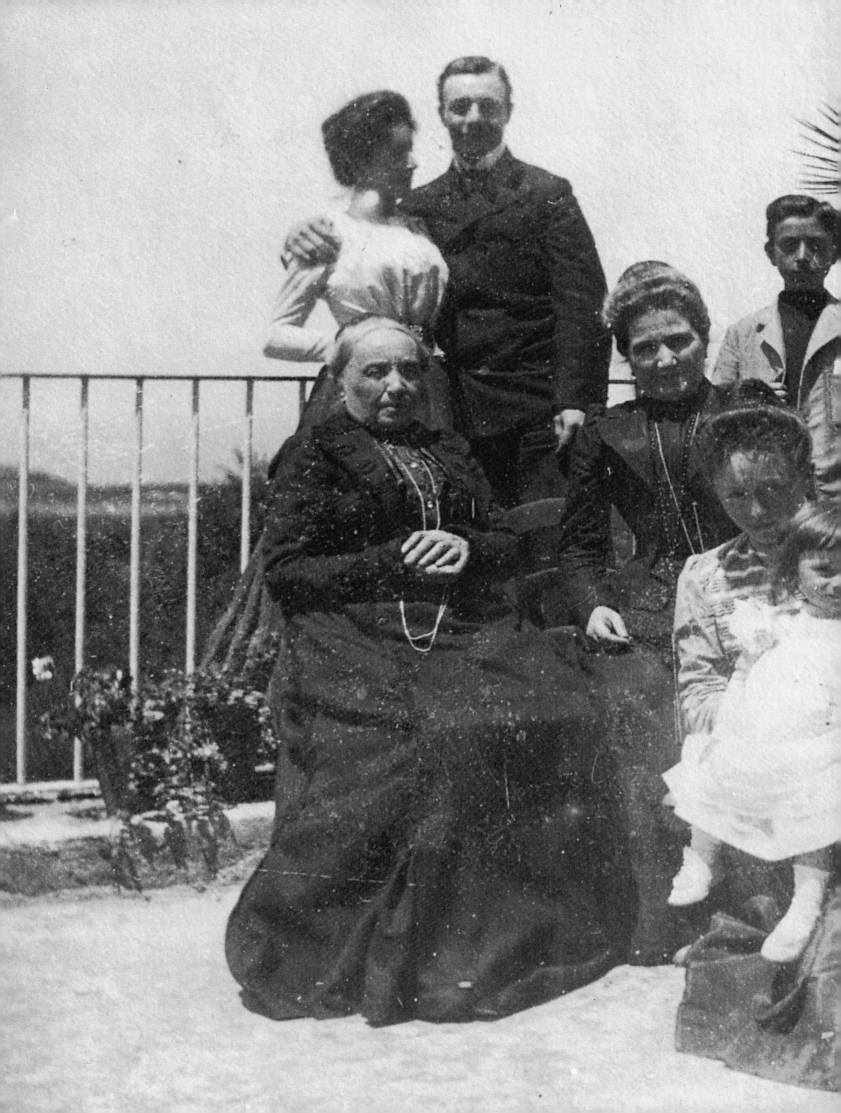

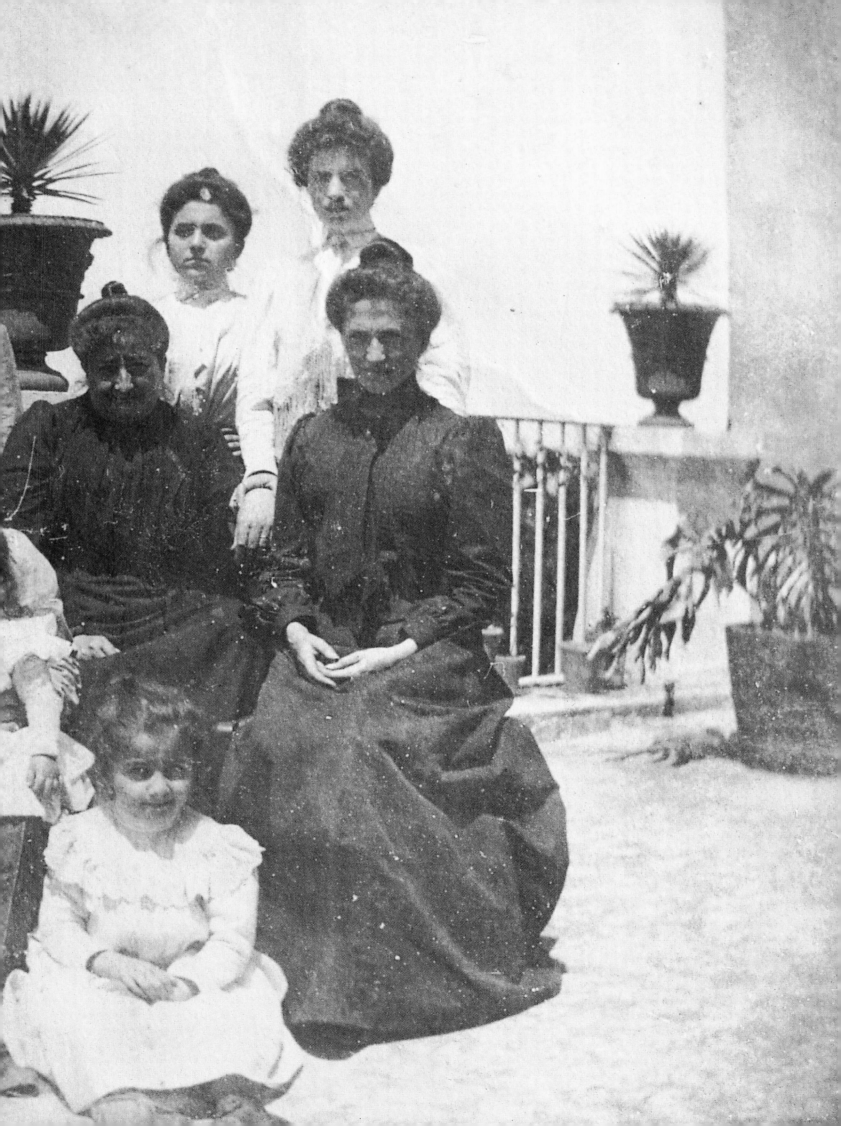

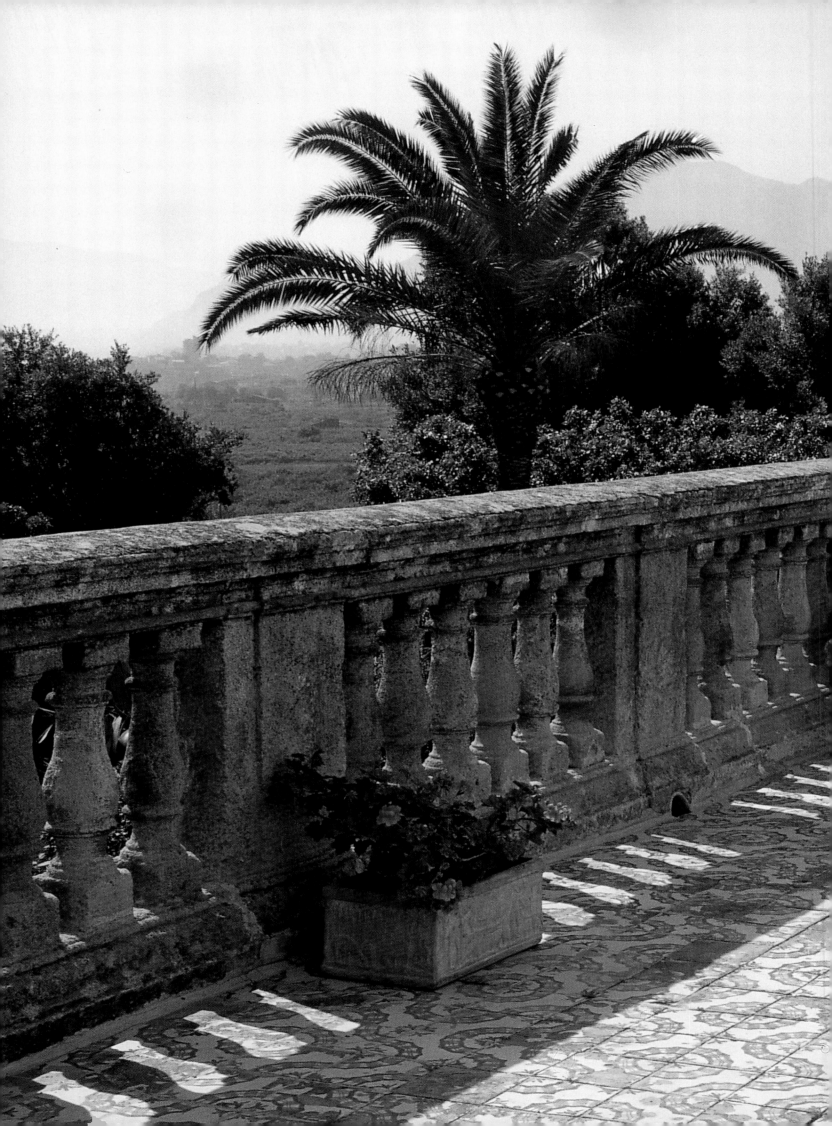

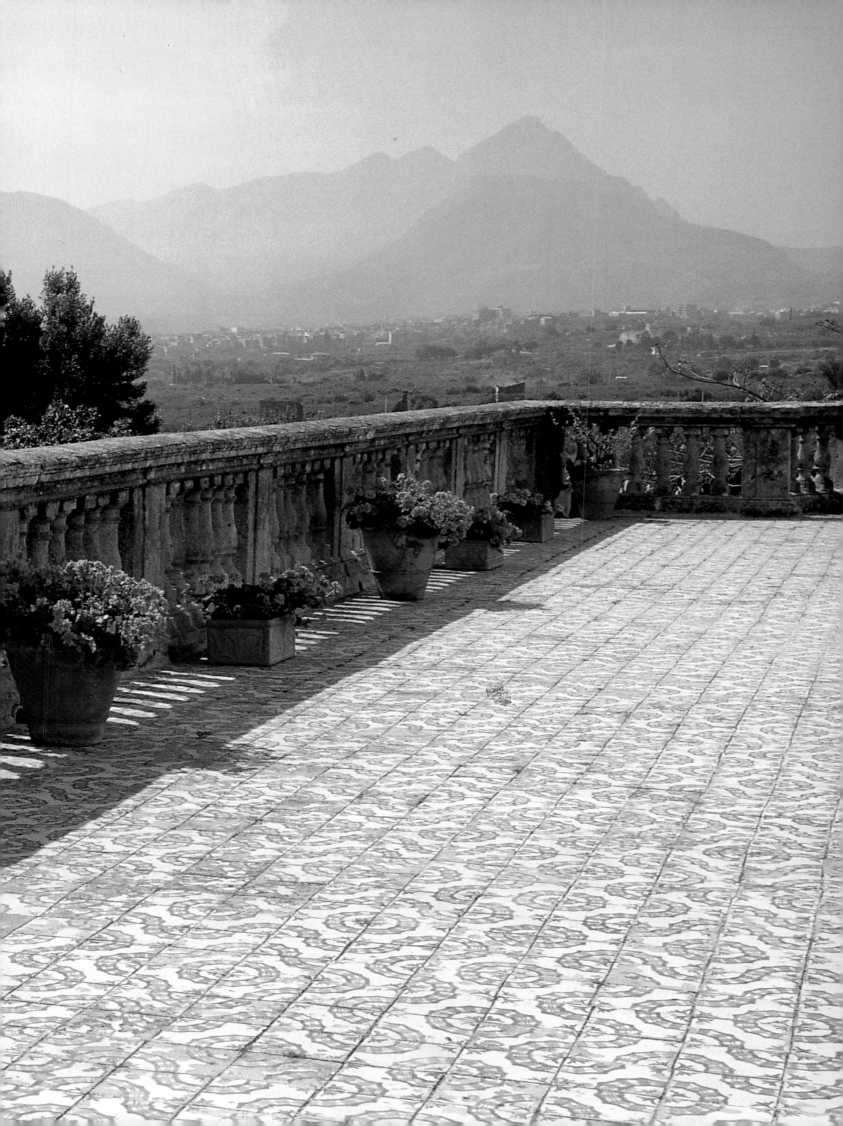

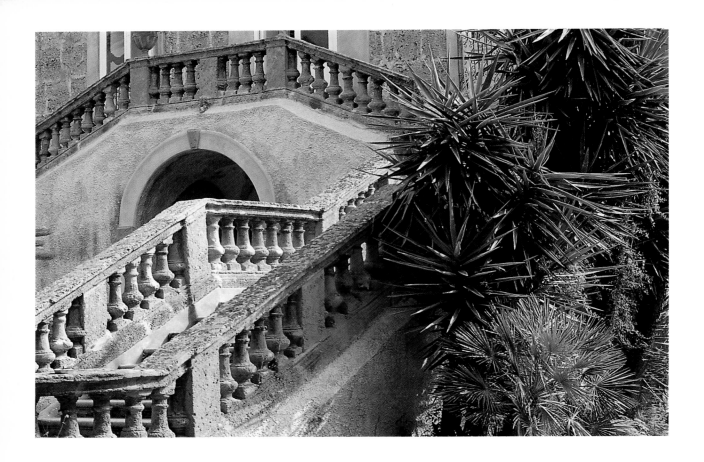

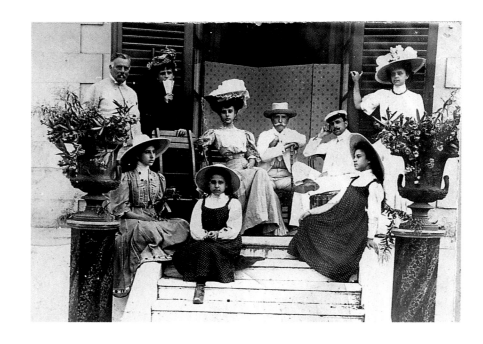

Preceding double page. *The
Spedalotto villa in Bagheria.*
Above. *Villa Boscogrande.*
Right. *A family group portrait
taken in around 1930, from the
Alliata Pietratagliata collection.*
Opposite. *A view of the Wirz
villa in Mondello, about which
Fulco di Verdura wrote in "A
Sicilian Childhood" as follows.
"In the summer, under the
delicate light of the late
afternoon in Palermo, a table
was set up in the garden.
English aestheticism was all the
rage and a taste for garden
parties was as prevalent in
Sicily as elsewhere. Nothing, to*
*me, seemed as enchanting as
tea taken in the garden, not far
from a path on which there
were pomegranates the color
of blood".*

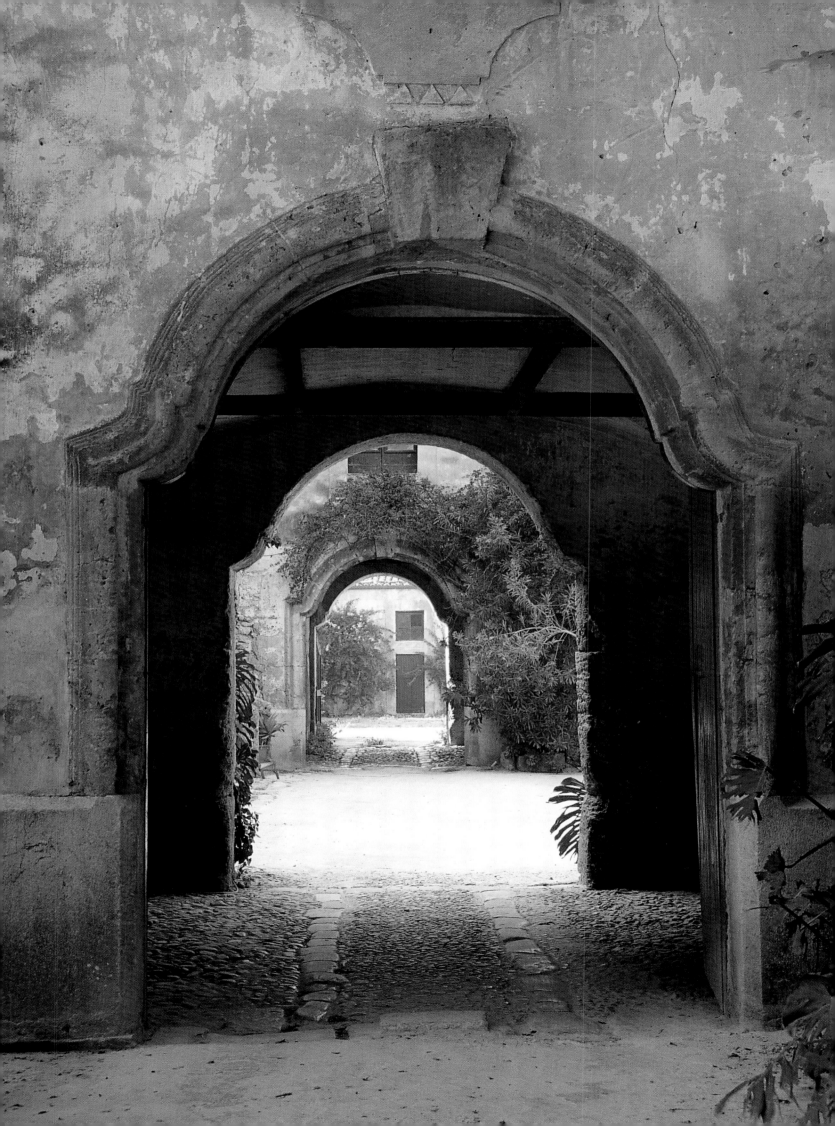

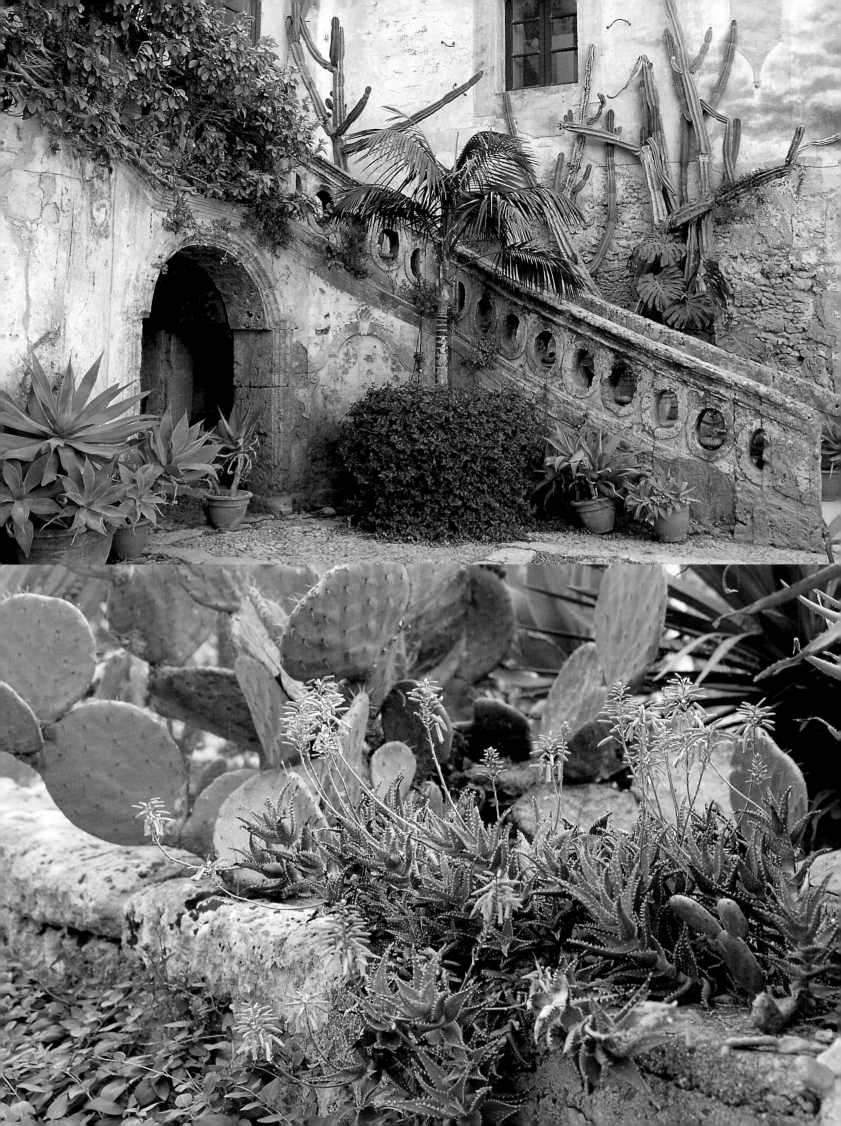

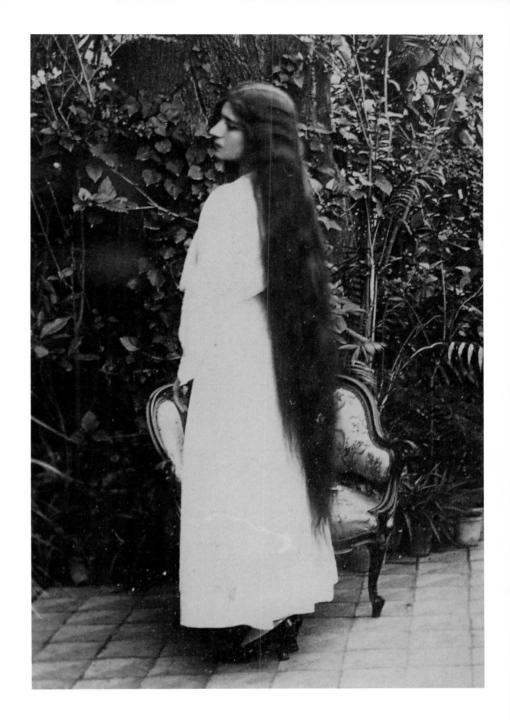

Opposite. Above. *Tropical plants in the botanical garden of the Wirz villa.* Below. Opuntia robusta *and* Haloe and Humvir *on one of the jetties of the old port.* Right. *Giulia Mantegna de Gangi.* "I know that here everything is theatrical. What I see is the usual tableau, simultaneously ambiguous and amused, of a century which loved profound metamorphoses accompanied by a witty caricature of oneself". *Dacia Maraini,* Bagheria. Overleaf. *The Solanto castle. The name of Solanto, above Bagheria, is in fact a corruption of Solunte (or Selinute), the Greek village whose ruins are very close. The Bourbons liked residing here in summer.*

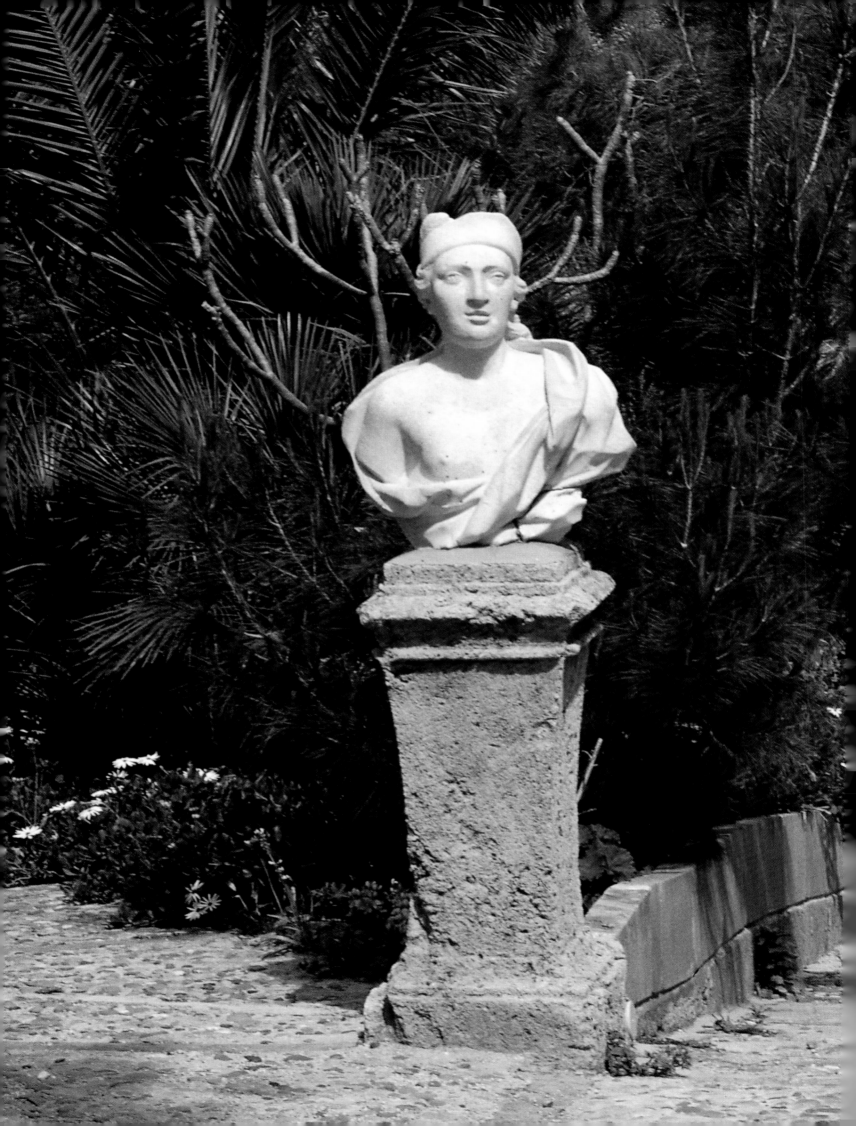

The Green Salon. Why was it so called? It is quite true that its decoration consisted of six pretty and well-executed tapestry panels in the Regency style which, at their center, had or didn't have, according to the case, light bowers entwined by rather timid and weak grape vines. But this little touch of green was quite slight in confrontation to the rest; the walls – all the walls – of the "green salon" were uniformly upholstered in blood red velvet. This is the way one saw this vast room, its shutters always closed. It was furnished with only a piano and long benches, also red and primly arranged along the wall; this served as a ballroom... Somebody, in order to frighten me, said that the piano, solidly planted in the middle of the room, was only a pretext for a piano; in fact, it wasn't there to make music, but rather to house a bear. Everything was believable, everything was credible in the Villa Niscemi. Fulco di Verdura, *A Sicilian Childhood.*

Above. *Giovanni di Simone.*
Left. *Detail of a floor.*
Opposite. *Painted, polychrome wooden door, with "grotesques". The walls are frescoed.*

"Missina 'ncignusa, Palermu pumpusa, Missina la ricca, Palermu la licca".
Translated from the Sicilian dialect as "Messina the ingenious, Palermo the pompous, Messina the rich, Palermo the exquisite".
A Sicilian proverb.

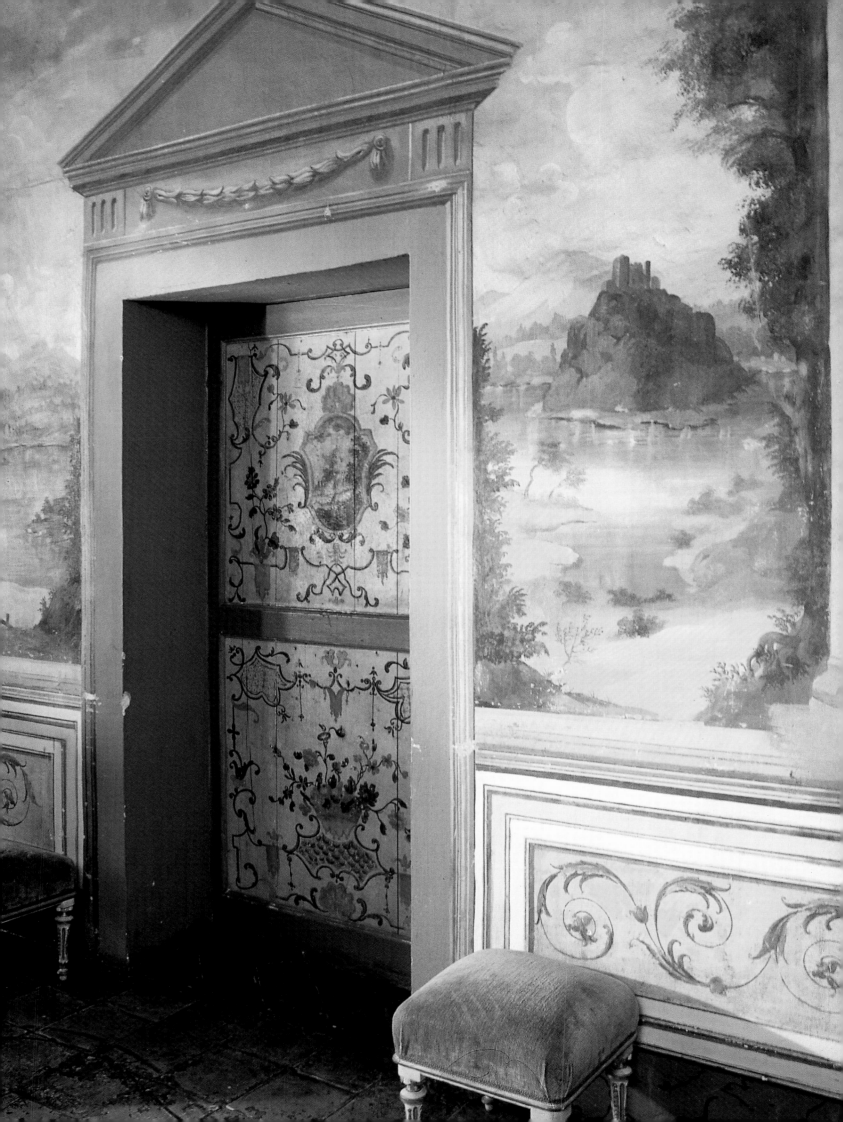

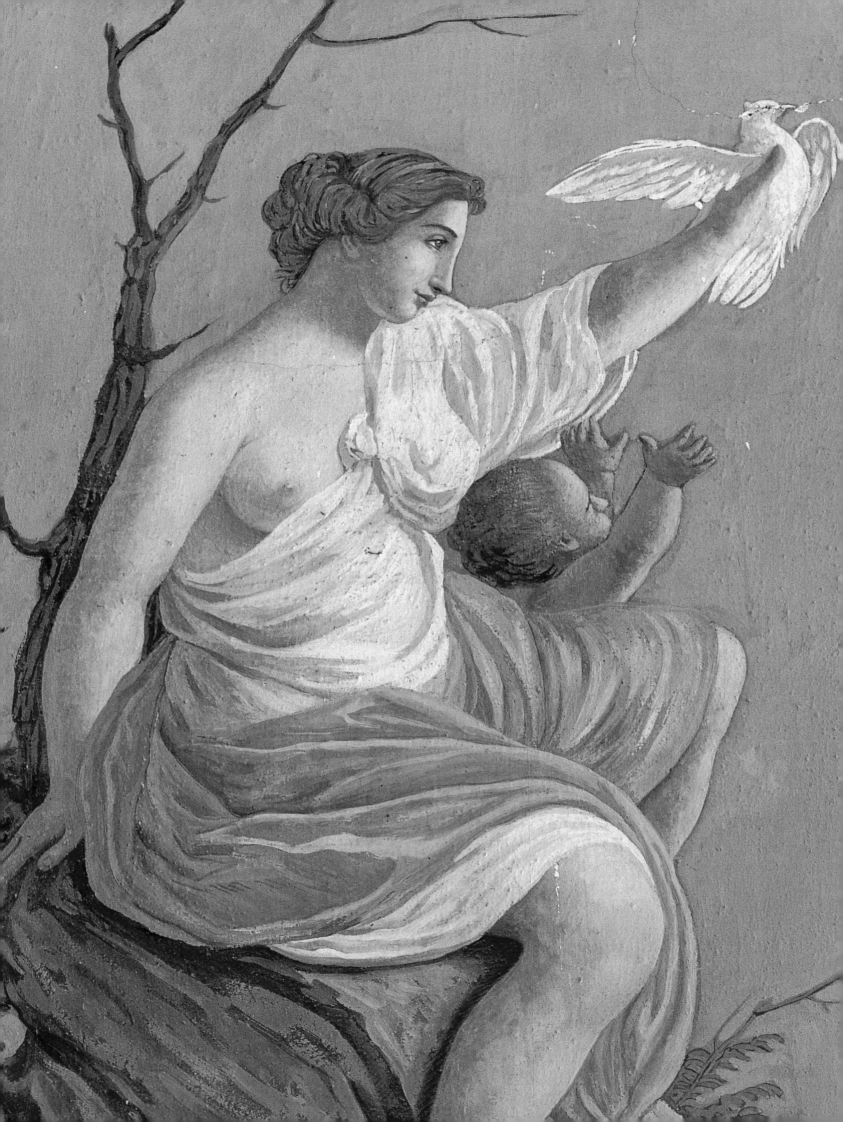

These pages, as well as the
two that follow, were taken
in the splendid Spedalotto
villa. The neo-classical style
shows clear influences of
Adam and Wedgwood, once
more a reflection of Sicilian
Anglomania. The severe
northern style has been
mitigated by rather Baroque
figures and by the use of the
colorful, typically Sicilian
ceramic floors. In St.
Petersburg, and particularly
at Pavlovsk, there was a
similar adaptation, there
involving elaborate use of
the semi-precious stones and
marbles that abounded.

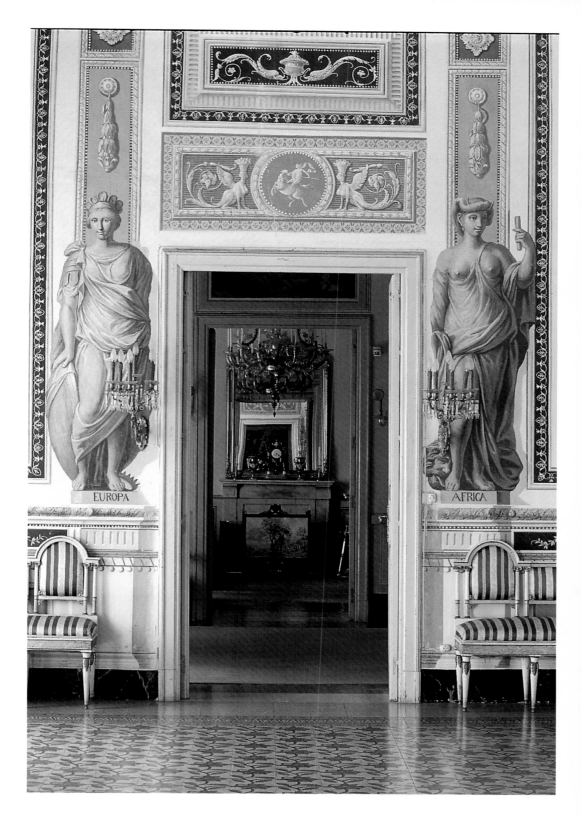

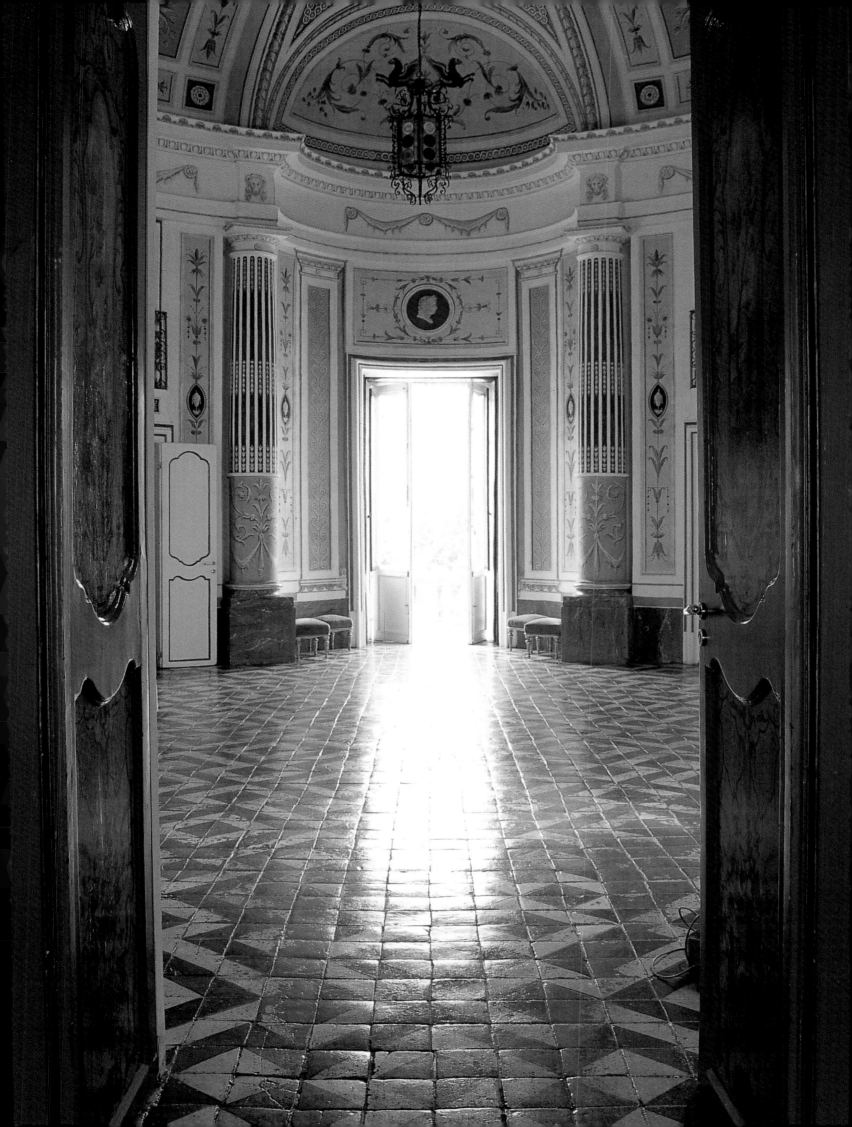

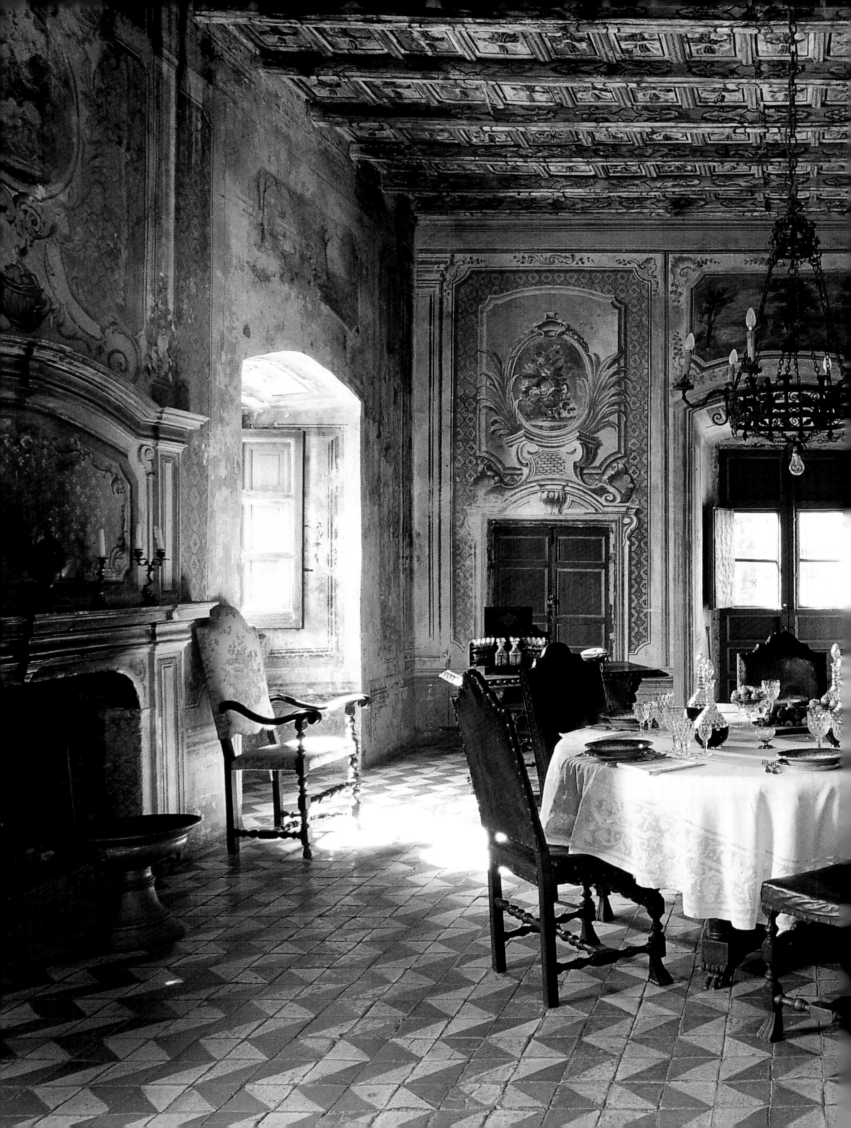

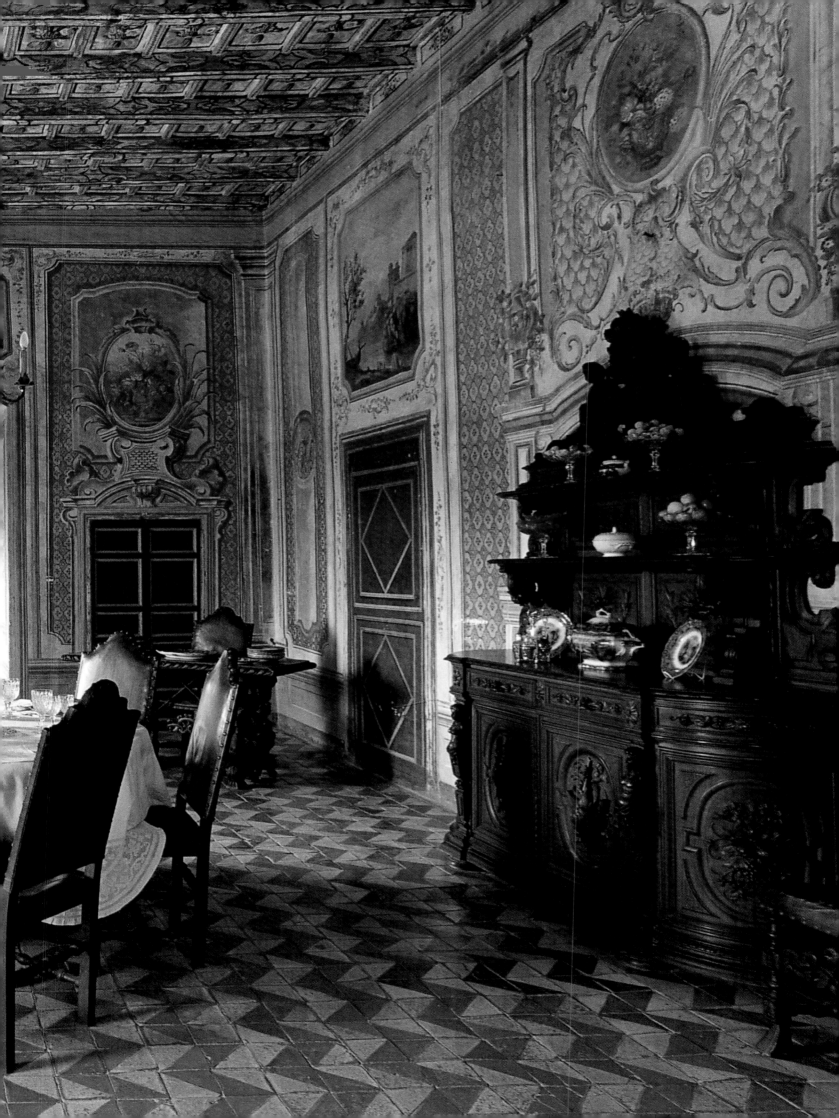

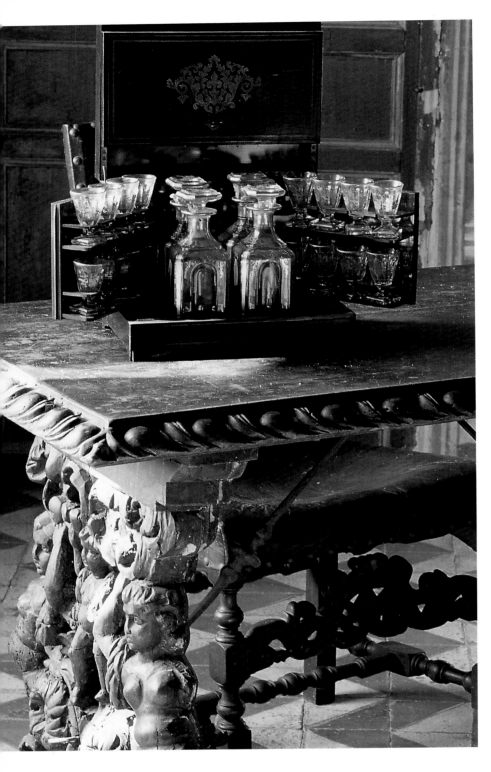

Opposite. *The most Sicilian of all nectars was invented by an Englishman who wanted to imitate a Spanish wine. It was, in fact, John Woodhouse who, at the end of the 18th century, created Marsala, a substitute for the sherry which had been kept off the island by Admiral Nelson's continental blockade. Like Woodhouse, many of the island's successful entrepreneurs were English, but, because of their fortunes and the prestige of their race, they quickly established close relationships with the Sicilian aristocracy. A plate* of Sostanza *(opposite), the most calorie filled Sicilian dessert, is a perfect match for Marsala wine.*

Previous pages. *The dining room at the Wirz villa, restored in the 18th century. The leather covered chairs are of the previous century, and the coffered ceiling and walls are elegantly decorated and frescoed.*

Above. *Detail of a table sculpted out of walnut.* Right. Collesano ceramic *votive statue (1850) from the Malvagna palace, whose purpose was to protect the harvest.*

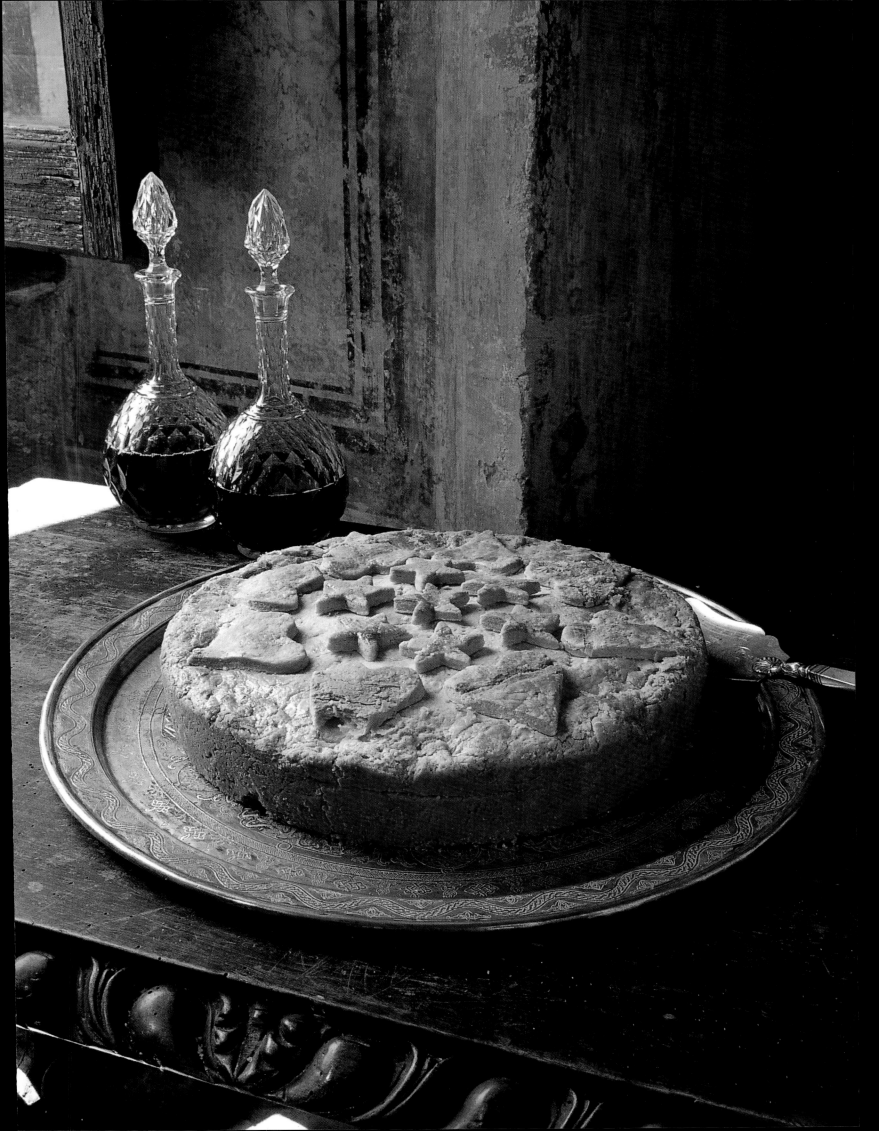

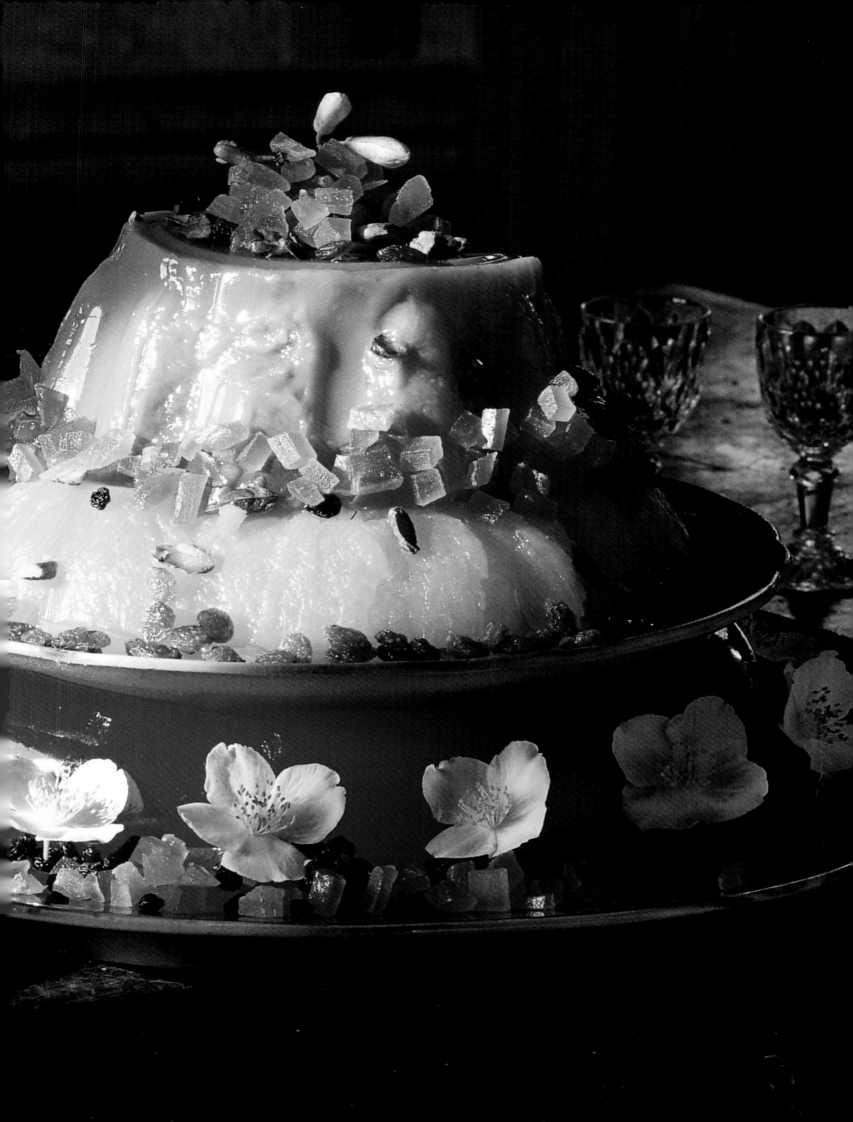

This early 19th century dining console has a wooden leaf which, when raised, allows dishes to be placed on a marble slab inserted into the wood, in this case illustrating exotic fruit. Wild acanthus is placed in the vase.

Previous pages.
Fruit puddings are not exclusive to English cooking. In Palermo, the gelu di mulinù, based on watermelon pulp enhanced by jasmine and flower water, is traditionally served at the Feast of Saint Rosalie.

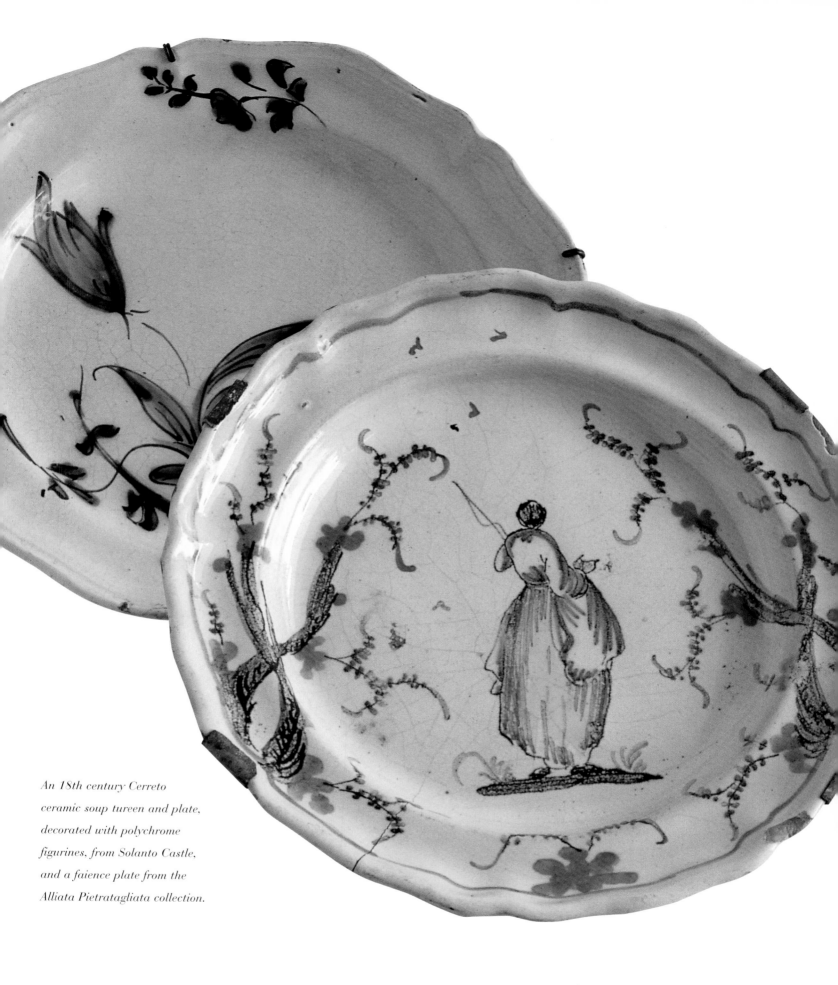

*An 18th century Cerreto
ceramic soup tureen and plate,
decorated with polychrome
figurines, from Solanto Castle,
and a faience plate from the
Alliata Pietratagliata collection.*

Left. *cupboard for dishes in the Gangi palace.* Top to bottom. *Every traveler to Sicily complained – as many still do – of the lack of heating. Although winter is short and not terribly rigorous, wood is rare and coal nonexistent. Most rooms had neither fireplace nor stove, and these small porcelain hand warmers from Caltagirone proved quite useful.*
Opposite. *Family linen of the Wirz family, embroidered with their coat of arms.*

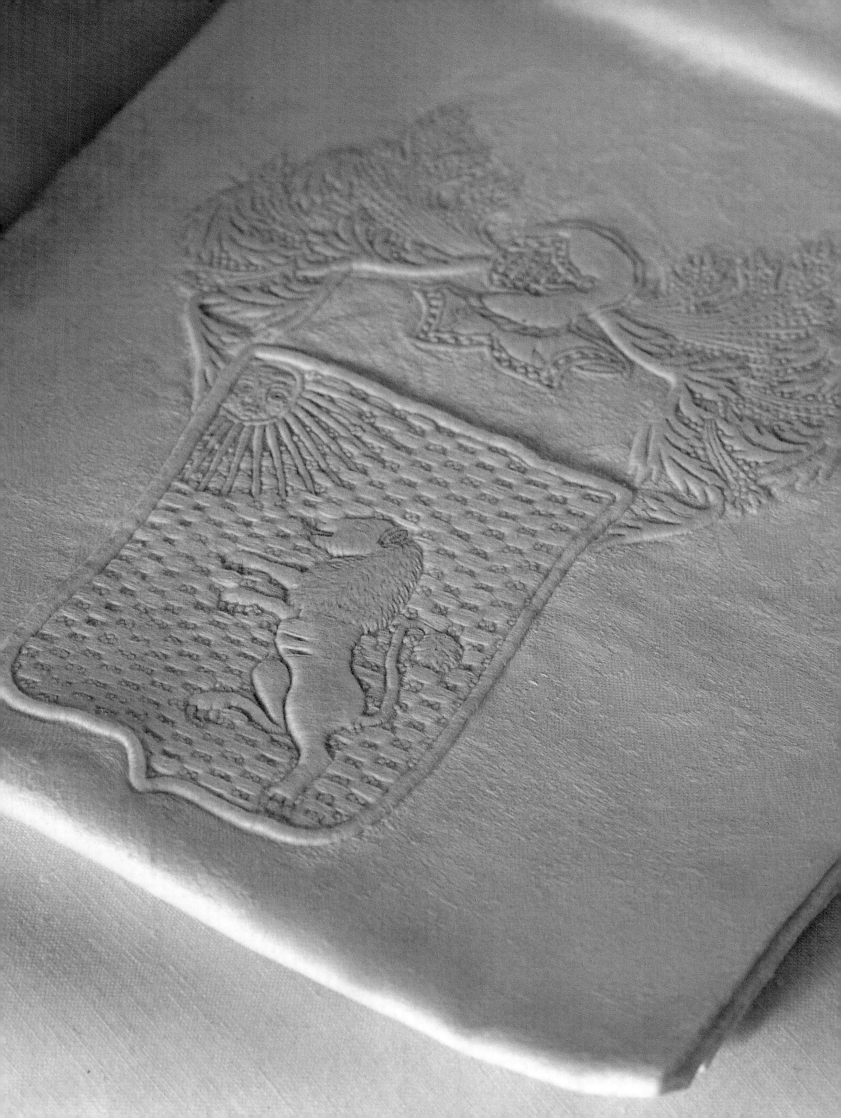

The countryside

Left. *Landscape in the heart of Sicily, near Enna.*
Below. *A cheese strainer, as well as Sicilian* provole *and* cacciocavalle.

The imaginary Donnafugata of Prince Salina, like the real Santa Margherita di Belice of the Prince of Lampedusa, is a market town. But to represent the country dwellings of the Leopards as their equivalents in France, England or Tuscany, as scattered castles or manor houses, isolated in the woods, in the hollows of valleys or on the sides of hills, would be a mistake. In Sicily, a country where people live in groups, the peasants themselves live in the town and travel several kilometers every day to get out to their fields and return home. One is limited, therefore, to the simple definition: "The countryside is something far away."

For the Leopards, visiting their lands once or twice a year constituted a long and difficult expedition; in fact, people remade their last wills and testaments before leaving. In 1905, Jules Gourdault, in his very popular book *Picturesque Italy*, wrote of Sicily, "Today, even though the famous gang of Leone, who was killed in 1887, has been dispersed, the country can hardly be considered quite safe". The ferocity of Sicilian bandits, nevertheless, remains a controversial subject. In the 18th century, most travelers whose opinions could be trusted practically denied

their existence. The bandit phenomenon reappeared in the 19th century, but one might wonder whether this wasn't simply a reflection of Romanticism.

In reality, the lack of comfort when traveling was far worse than the dangers. "Dear God, Dear God", exclaimed a French governess in the employ of Marshal Bugeaud, it's worse than Africa". We have discussed the limitations of Sicilian railroads. The road network, building of which only really started in 1838, was not much more advanced. Except for the two axes joining Palermo, Messina and Trapani, a traveler had to deal with rocky and uncomfortable routes which, often lacking bridges, forced him to ford dangerous streams and rivers. Whenever possible, travelers profited from the legendary Sicilian hospitality – in convents, with friends, even staying with strangers – in order to avoid the rare and abominable *locandas*, or inns. Often, when their itineraries permitted, voyagers or tourists tried to go by sea; a good example was Alexandre Dumas on his *Speronare*. The 1877 *Le Guide Hachette* mentions that "the most common form of travel is on horseback or more often by mule", but points out that "in fine weather, from time to time, a steamboat goes around the island visiting the main sites, leaving travelers time to see the curiosities".

At the beginning of the twentieth century, the young Lampedusa still took twelve hours to travel the eighty kilometers from Palermo to Santa Margherita di Belice. At the time of his grandfather, the arrival of a Leopard entailed as much solemnity as the trip itself entailed fatigue. The local dignitaries and the cream of the township greeted the visitors before they had time to settle in, then everybody went to the cathedral for a *Te Deum* accompanied by Don Ciccio, the organist, "who imperiously attacked *Love me, Alfred*". To tell the truth, the use of romantic songs or operetta arias in church was not only a Sicilian custom; in Paris at that time priests attempted to elevate the spiritual level of their parishioners with songs from the musical comedies playing on the boulevards.

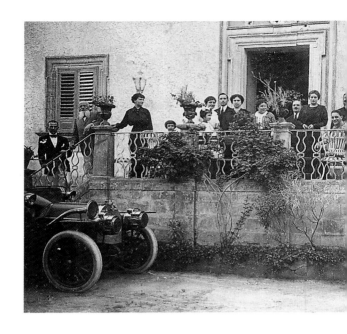

The family of Baron Del Bosco, in their country villa in Siracusa. "Towards 1905, the only automobile in circulation in Palermo was 'The Electric' belonging to the old Signora Giovanna Florio".

Staircase leading to the wine pressing equipment used during the grape harvest by the pickers who unloaded here their baskets filled with grapes. This building is still part of a working farm.

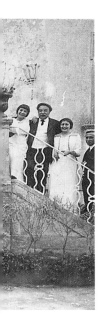

A Sicilian Vatican

We have not been naïve enough to consider the house of a Sicilian aristocrat in the fields as a simple cottage. Likewise, the main church of Santa Margherita de Belice was none other than the private chapel of the Lampedusa family, made available free of charge to the local population. The immense palace of the Filangeri di Cutò family, maternal ancestors of the author of *The Leopard*, "made one think of a sort of closed and autonomous ensemble, a sort of Vatican"; built in the 17th century, refurbished during the following century, it had no less than one hundred rooms, of which about thirty were devoted to friends (this was known as the *forestiera*). In addition there were reception rooms, a theater and immense common areas "all enhanced by an enormous and sumptuos garden, with its own vegetable park".

The fact is that the ancestors of the Leopards had not built their real or imaginary Donnafugatas as secondary residences. These enormous houses, which still exist, in various states of ruin, in many Sicilian cities or townships, bear witness to an age when great feudal lords lived on their lands before abandoning their supervision to all powerful estate managers, before mortgaging or selling them so that they could blaze away their fortunes at the courts of Palermo or Naples. Due to this, the annual or biannual visits of an owner to his fiefdom, even if they permitted him to enjoy the countryside, were first of all explained by his obligation to spend some time with his vassals, and by the necessity for any proprietor to supervise his accounts. This allows us better to understand the suffering he had to endure, the *Te Deum*, and all the other protocol similar to a state visit.

Even before getting into a hot bath, one nearly as comfortable as in Palermo, Prince Salina received Onorifio Rotolo, the manager of his estates. The summing up of the accounts showed a profit of 3,265 *onces*, that is to say about $200,000. For a Leopard with the obligation of supporting a large family, employing dozens of servants, keeping up a town palace and country villa, this was too little, in fact far too little even if one added on the *carnaggi* or rents in kind, even if one were to enforce the strictest savings.

A garden of the Case Del Biviere. On the right are attennata cacti, *and bordering the steps* Pachyveria Hagey.

Those who enjoyed revenues outside their lands were few in number. Some had interests in the then very abundant Sicilian sulfur mines, which supplied seventy-five per cent of the world's needs at the time. Others possessed shares in a *tonnara*, an extremely complicated apparatus of nets and pontoons in which tuna were caught before being slaughtered with a nearly ritual cruelty. And no Leopard would deign to participate in any commercial or industrial activity.

Sicily's attachment to the Italian kingdom brought disastrous consequences for the south of the nation and for Sicily itself. The liberalization of foreign exchange, favorable to the industrial north, forced Sicilian farmers to compete against American grain and French wine, and these farmers – thanks to a lack of lucidity or their imperiousness – were unable to compete. Thus, the Leopards had to live off their capital, selling their land piece by piece to rich peasants such as Mastro-Don Gesualdo or Calogero Sedara, whose future Lampedusa's hero predicted, when speaking in 1860; he would become a deputy in the parliament in Turin, acquire the property of the church, and become the main landowner of the province. Tancredi, a character in the novel who supported Garibaldi against the Bourbons, was doubly wrong when he affirmed that everything had to be changed so that nothing would change.

The pleasures of solitude

Strictly speaking, the idea of solitude, a theme so dear to classics of literature, does not really apply to the Leopard's Donnafugata. Certainly the difficulties of travel prohibited Sicilian aristocrats from visiting each other as often as their British or French counterparts, traveling from one great country house or château to the other. The vast suites of rooms of the *foresteria* of Santa Margherita de Belice often remained empty. On the other hand, during their visits the sovereigns of these country domains regularly invited the local notables for dinner and there were card games on average twice a week. That alone should suffice to characterize country life. In fact, the Leopards would never have imagined receiving in their Palermo palaces or country homes at Bagheria as varied a cast of characters as Lampedusa describes in his writings. To mention a few, there was an honorable but bastard old uncle who had fallen

It took quite a long time for oranges, mandarins, lemons and grapefruit to secure an important place in the island's economy. Cultivation of vegetables, limited to the coastal areas, required a lot of water and care, and until the middle of the 19th century was mostly limited to the personal use of a family.

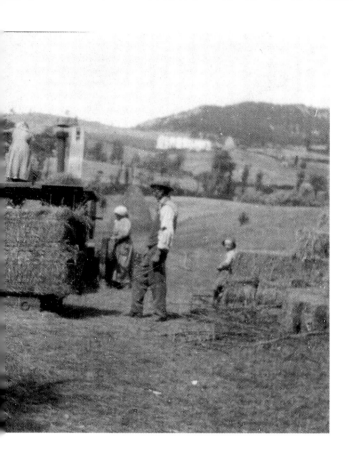

Cereals grown in the latifundia *of the Sicilian aristocracy were for a long time the basis of the island's agricultural production.*

Lemons aplenty await delivery in lovely baskets put into a donkey cart.

into debt, local landowners who were rather rough around the edges, the husband of a mad relative, the schoolmaster, an engineer, an intellectual playing Chopin on the piano, and "many others we saw less often". Noble obligations, as much as the need to combat boredom, justified such a mixture of social classes. Lampedusa's hero was exceptional in this regard. In fact, only middle class males normally participated in the feasts and diversions.

Thanks to their ancestors, Leopards resident in the country at the end of the 19th century could also go to the theater. Many great Sicilian country houses had their own theater, built when the island lived in the image of Naples where theater, as opera or dramatic art, was more than a spectacle, more than an institution, and reached the dimensions of a veritable cult. Three days, or twelve hours distant from Palermo – depending upon the year in which one traveled – the theater in Santa Margherita de Belice, which Lampedusa describes, was not a "pocket theater"; white and gold, it had two rows of eleven boxes upholstered in blue velvet, seats on the ground floor or parterre, a balcony and a sumptuous "Royal Box", in this case that of the Filangeri-Lampedusas; in all there were three hundred seats.

The amazing thing is that at the end of the age of the Leopards, between the end of the 19th century and the Second World War, this theater was still in use. It did not, of course, have a regular company, and did not use local amateur actors, but relied on one of the many itinerant troupes that went from city to city, palace to palace, to perform the romantic repertoire, occasionally Shakespeare and occasionally some small French libertine farce. On such occasions the actors borrowed furniture, accessories and sometimes even dresses from the owners. Thanks to these possibilities, they stayed two or three weeks, earning a good fee every evening from the local peasantry. Needless to say, the high standards of the Teatro Massimo was not required by the Filangeri family in Santa Margherita de Belice.

In the center or north of Italy, in France, Great Britain and elsewhere in Europe, the time passed by aristocrats on their lands was synonymous with hunting. Certainly every morning Prince Salina went around the countryside with a rifle and his hunting dog – if, as Lampedusa points out, one could call such rough land the countryside. But he hunted alone or, to be more precise, with Don Ciccio. Quite happily they brought back a pair of partridges or a rabbit, which was elevated in their eyes into a hare. The prince and the organist spoke of politics and worldly things rather than swapping shooting lore.

The fact is that game in Sicily abounds only in the marshy areas of Lentini, between Catania and Augusta, which are rather insalubrious but contain a large variety of duck, woodcock and other water fowl – although nothing that would lend itself to armies of beaters or the colorful, joyous and sonorous foxhunts of European nobility elsewhere. One might wonder whether one of the reasons that inspired Sicily's princes, counts and marquises to desert their ancient fiefdoms was the impossibility of enjoying the aristocratic joys of a great hunt.

In compensation, a country stay offered the Leopards less extravagant, but certainly incontestable pleasures. Hell for travelers, Sicily was a tripper's paradise thanks to its extraordinary store of monuments, picturesque sites, and curiosities of all sorts. There was one visit that was obligatory – the excursion to a neighboring monastery with which the family had a special relationship, either an institution they protected (with monetary help, not the sword), or one where one or even several family members were in retreat, both male or female relatives living in a state of holiness. Nearly every Sicilian monastery produced sweets, such as the pink and green nougat that the nuns of the Convent of the Holy Spirit gave to Prince Salina, and it is no coincidence that the names of many Sicilian sweets are linked to religion. The nougat or *torrone* of Saint Agata in the region of Catania, near Enna the *barbe di San Paolo* or beards of St. Paul, made of egg-enriched pastry stuffed with sweetened ricotta and baked in the oven, the keys of Saint Julian, or *chiodi di San Giuliano*, a sort of frangipani cake that came from the province of Trapani, and of course the *minni di vergini*, nuns' breasts, the *ossi di morto*, or bones of the dead, made from almond paste that were consumed in Catania for All Souls' Day, the *trionfi di gola di Santa Caterina*, or triumph of Saint Catherine's throat, a reference perhaps to the succulence of the delicacy. And the clergy was not only famous for its sweets, but for other gastronomic delights such as the *cùscusu* of the nuns at the abbey of San Spirito d'Agrigento where they kept the recipe under lock and key; it was reputed to be an earthly delight.

The nationalization of church property in 1866 resulted in the sale of the church's assets and these religious and gastronomic excursions became less and less possible. Happily, there were still the delights of a picnic. These country outings bore no resemblance whatsoever to the naïve, sweet, petit bourgeois outings painted by the French Impressionists, nor to the extravaganzas seen in *Citizen Kane*. The Lampedusas liked to picnic at the Venaria castle, an old hunting pavilion they owned 400 meters up in the hills a league away from Santa

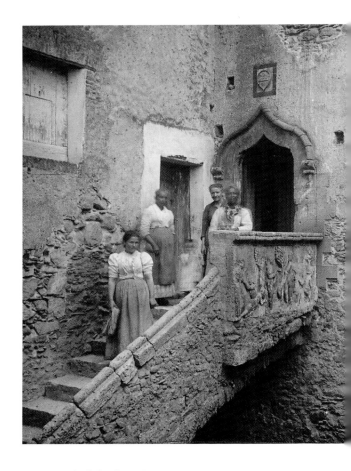

Courtyard of the Corvaia palace in Taormina, Local peasants pose on a staircase that dates from the Gothic period. Its elegance is enhanced by an ogival door and a sculpted relief.

Margherita di Belice; the ladies ascended in a dog cart, the gentlemen on the back of a mule. After "real falls, authentic donkey mutinies and pseudo tumbles offered up by love of the picturesque", the princes, their suite and several guests devoured meals prepared by the cooks. The menu differed little from what they would have been served at the palace: cold fish with mayonnaise, stuffed turkeys and, above all, the *pasticcio di sostanza*, a macaroni cake which the Leopards knew would appeal to the taste of their country visitors and thus was always served. Macaroni, parmesan cheese, raw ham, chicken livers, white meats and tomatoes were enhanced by truffles, onions and celery, all covered with pastry that glistened thanks to a brushing of egg yolk. This typical Sicilian dish was built like a Baroque palace, redolent with subtle and surprising flavors, and full of surprises.

On the other hand, the Lampedusas drank little. In Sicily, which produces such excellent wines, people don't drink much – perhaps because Sicilians find their intoxication and delirium elsewhere.

Cannoli *are one of the most popular Sicilian pastries. Formerly they were made only during the period of Carnival, but they are now found throughout the entire year. They make a particularly rich sweet and their complicated preparation involves confectioners' sugar, honey, flour, lemon rind, lard, sweet and bitter cocoa, bitter chocolate, strong coffee, dry marsala, ricotta, candied cherries and other fruits, kumquats, pistachios, egg and, according to the recipe, lots of oil for frying.*

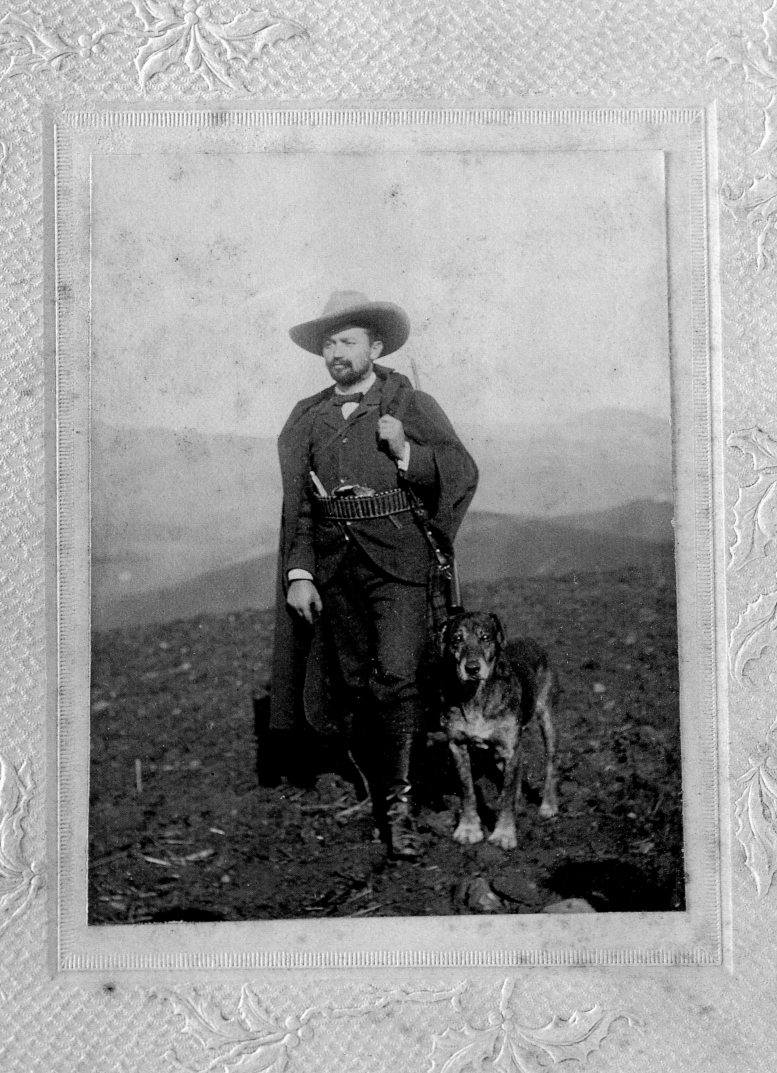

It was five in the afternoon. We had already been traveling for twelve hours. Lined up on the bridge was the municipal band attacking an impetuous polka. As far as we were concerned, our eyebrows were white with dust, our throats parched, but we forced ourselves to thank everybody and smile. A brief walk through the streets, and then we arrived on the square where we rediscovered the gracious lines of the villa; we crossed the threshold, a first courtyard, a vault, a second courtyard. The trip had come to an end. At the foot of the staircase, the household welcomed us, led by the irreplaceable intendant, minuscule under his white beard, and flanked by his imposing wife. 'How happy we are that you finally arrived'

Lampedusa, *The Siren*.

Opposite. *Baron Francesco De Simone Achates. "Don Fabrizio spent long hours hunting, from dawn to midnight. The trouble taken had nothing to do with the results; it is difficult, even for the best shots, to reach practically nonexistent targets"*. Lampedusa, The Leopard. *Right. Buildings of an agricultural property in Siracusa.*

Overleaf. *Farm property.*

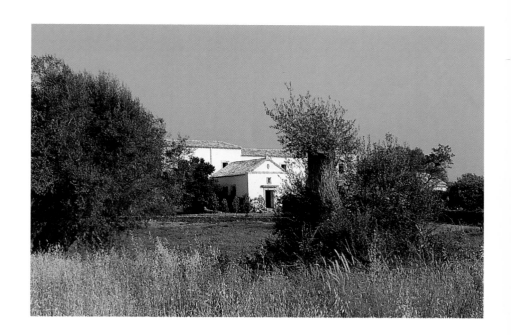

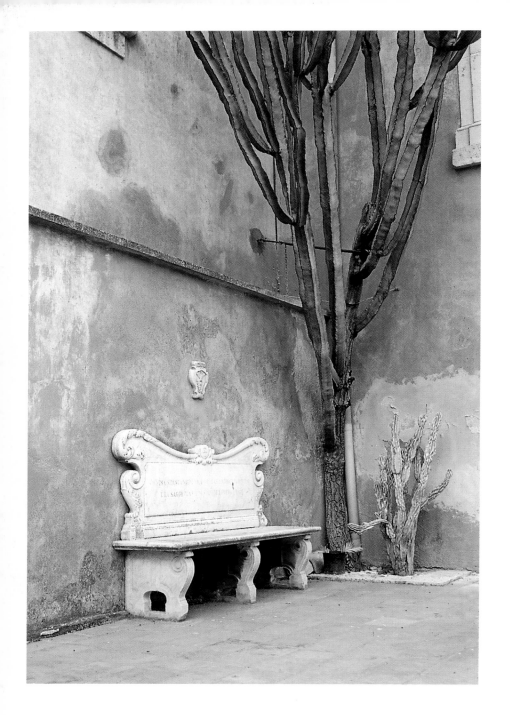

Previous pages. *Almond plantation in Siracusa. Wheat has been cut between the trees to create a path for picking the nuts at the end of the summer.*

Left. Euphorbia canariensis *in a corner of the façade of the Case Del Biviere. "Things were arranged so that we were able to enter into friendly relationships with the most ancient families of the high nobility of the country... Vast family and patriarchal tribes had been constituted due to local circumstances. An honorable and comfortable morality allows them to continue the enjoyment of old and large domains, as well as the amiable protection of their vassals". Richard Wagner to King Ludwig II of Bavaria, May 13 1882.*

Opposite. *A father and son, each holding the other's favorite playthings.*

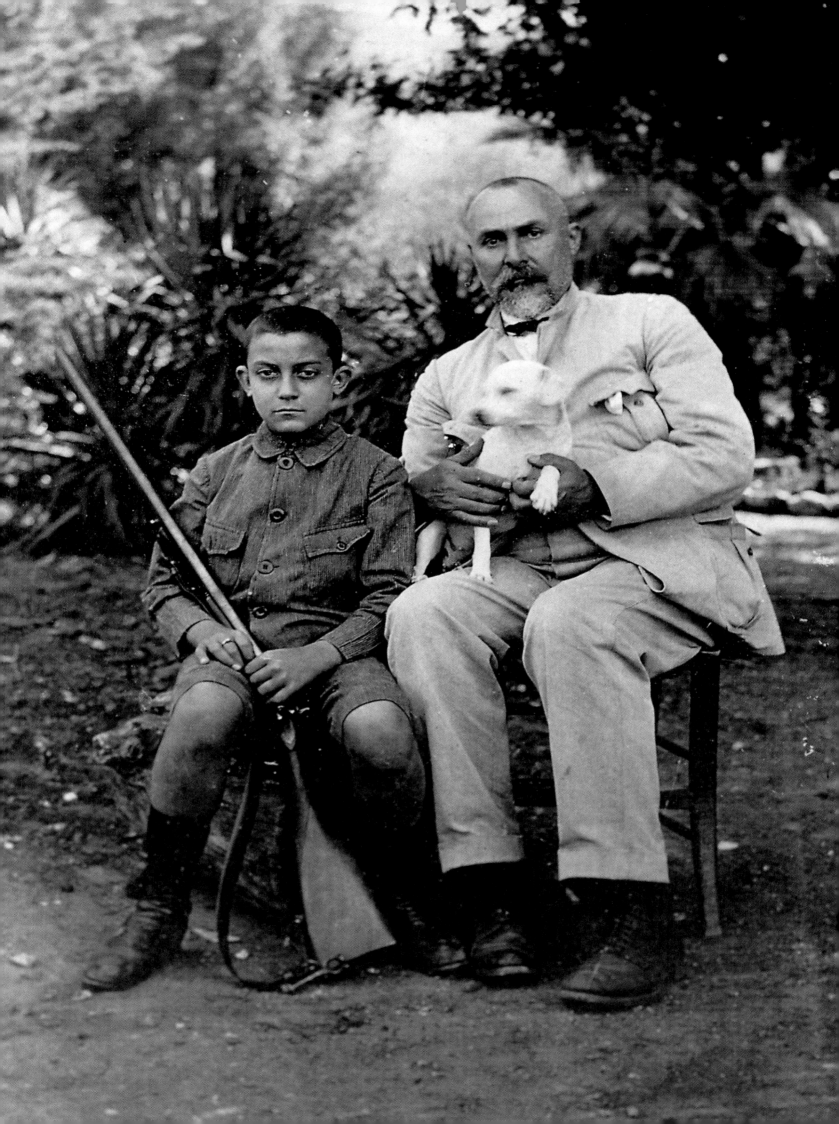

Sarde a beccaficu. *A very popular Sicilian specialty, the sardines in "beaked figs" are filled with a stuffing of anchovies, bread crumbs, capers, pignoli nuts, black olives, parsley etc., and cooked in the oven. There are several varieties depending on the locality, each adding different ingredients. They*

are eaten cold as well as hot.
Right. *A Caltagirone ceramic* albarello, *a form of vase very much in use in Sicily.*

Following four pages. *Visits to the countryside were the occasion of a (very relative) fraternization with the working classes. Food was a major preoccupation, as can be seen in this splendid Sicilian country spread that includes* arancini, *breaded and fried croquettes of rice and cheese, as well as pizzas and beans.*

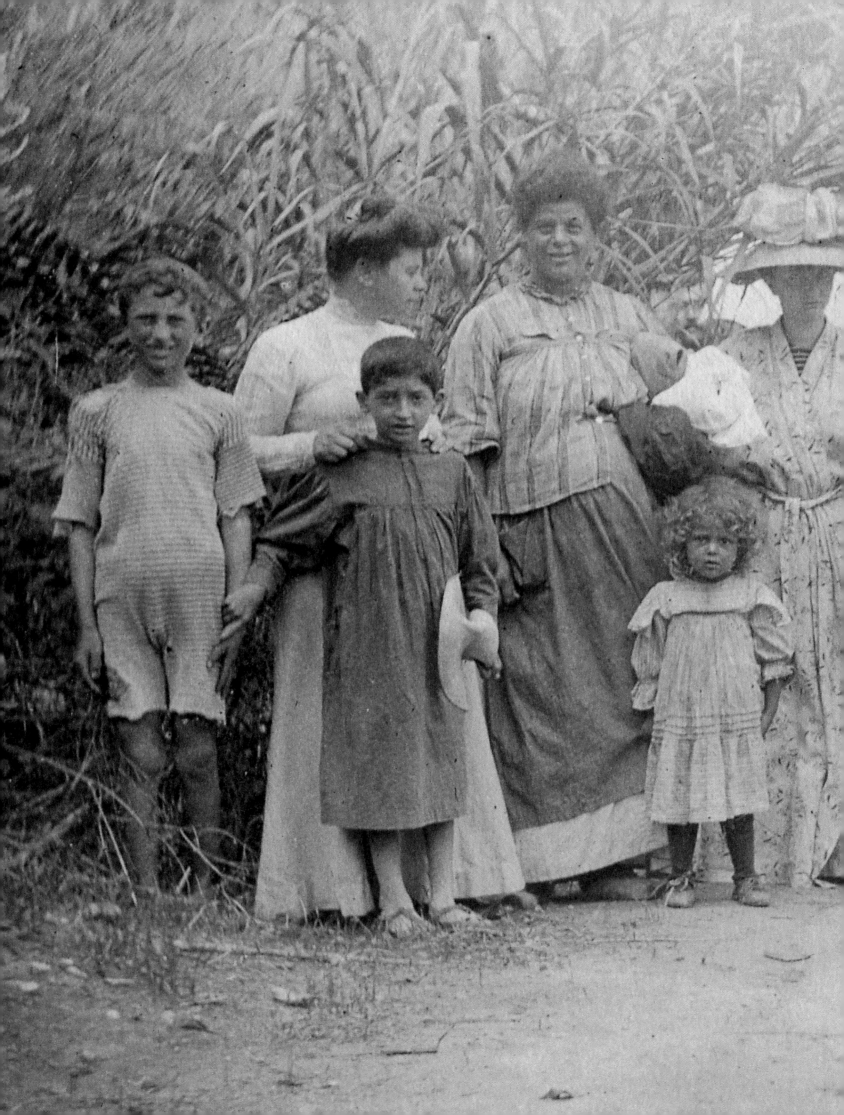

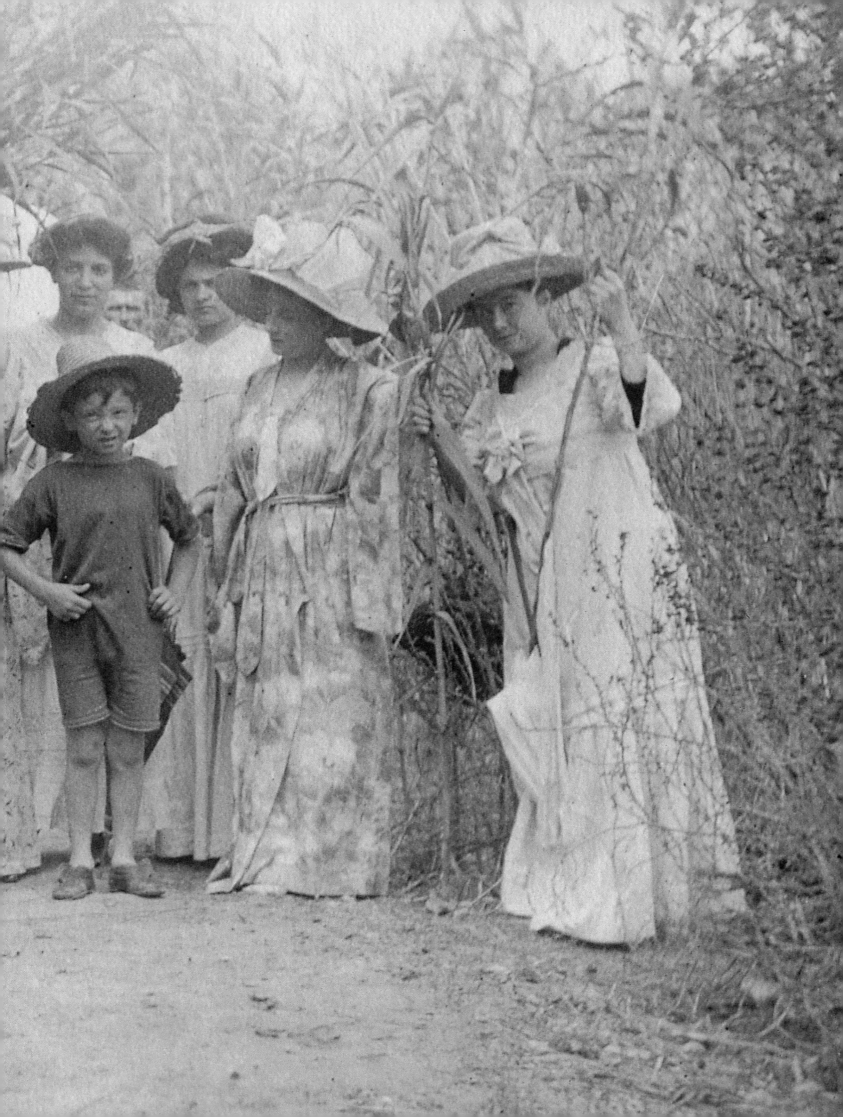

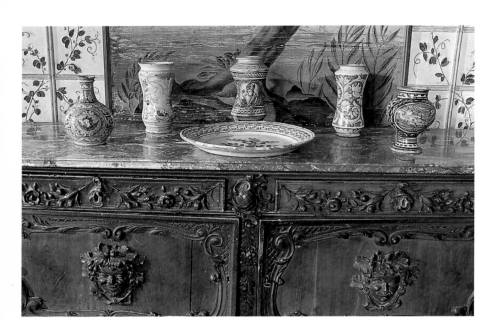

A dining room buffet carved
with heads of Bacchus, and
a bas-relief of fruit.

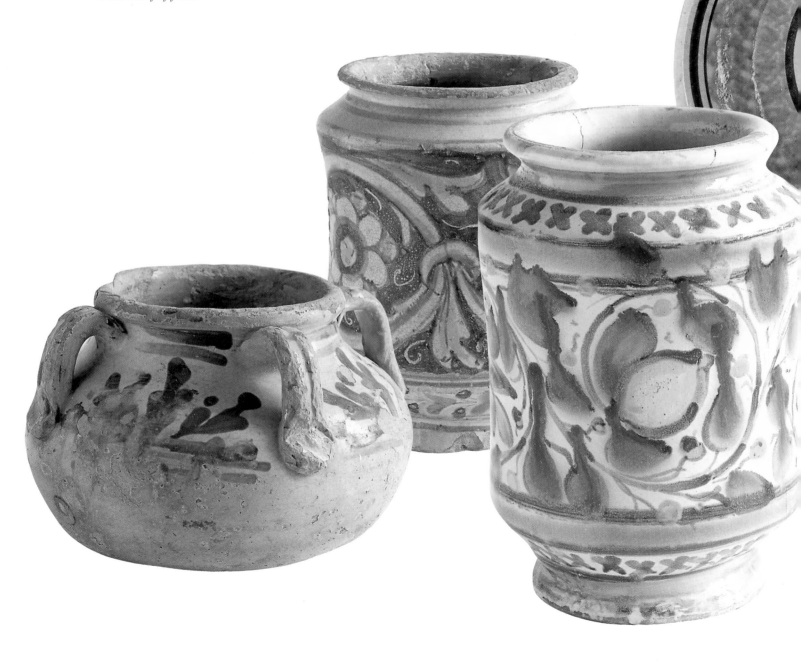

Below. Left to right. *A 16th century Trapani vase with four handles. A 17th century Burgio ceramic* albarello. *A 17th century Caltagirone* albarello *from the Beneventano collection.*

Plates for drying pulped tomatoes, from the end of the 19th century. Receptacle for salting olives, end of the 19th century. Wine pitcher.

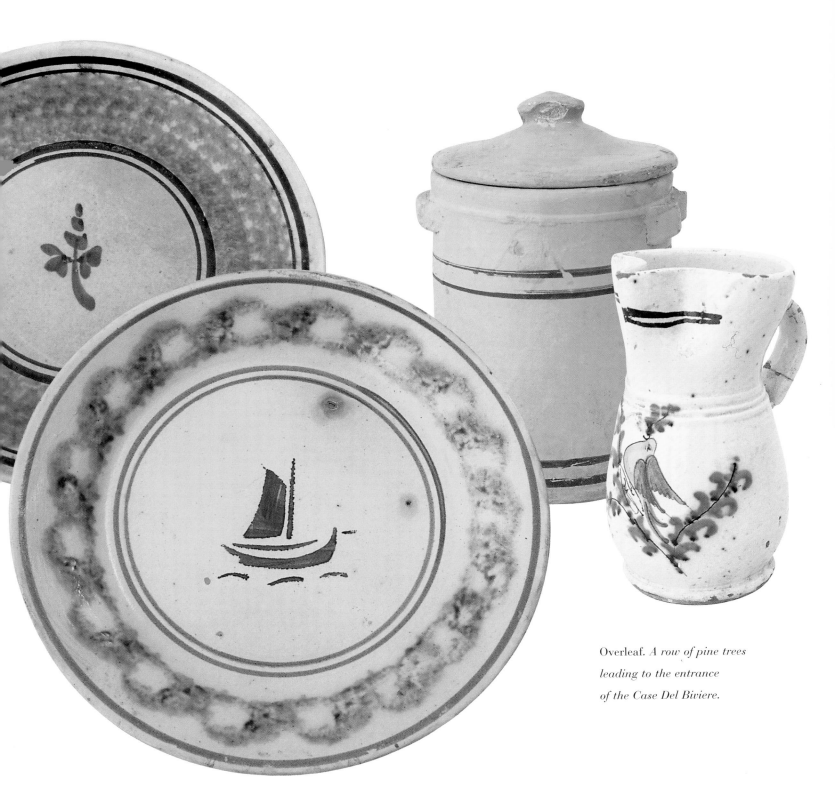

Overleaf. *A row of pine trees leading to the entrance of the Case Del Biviere.*

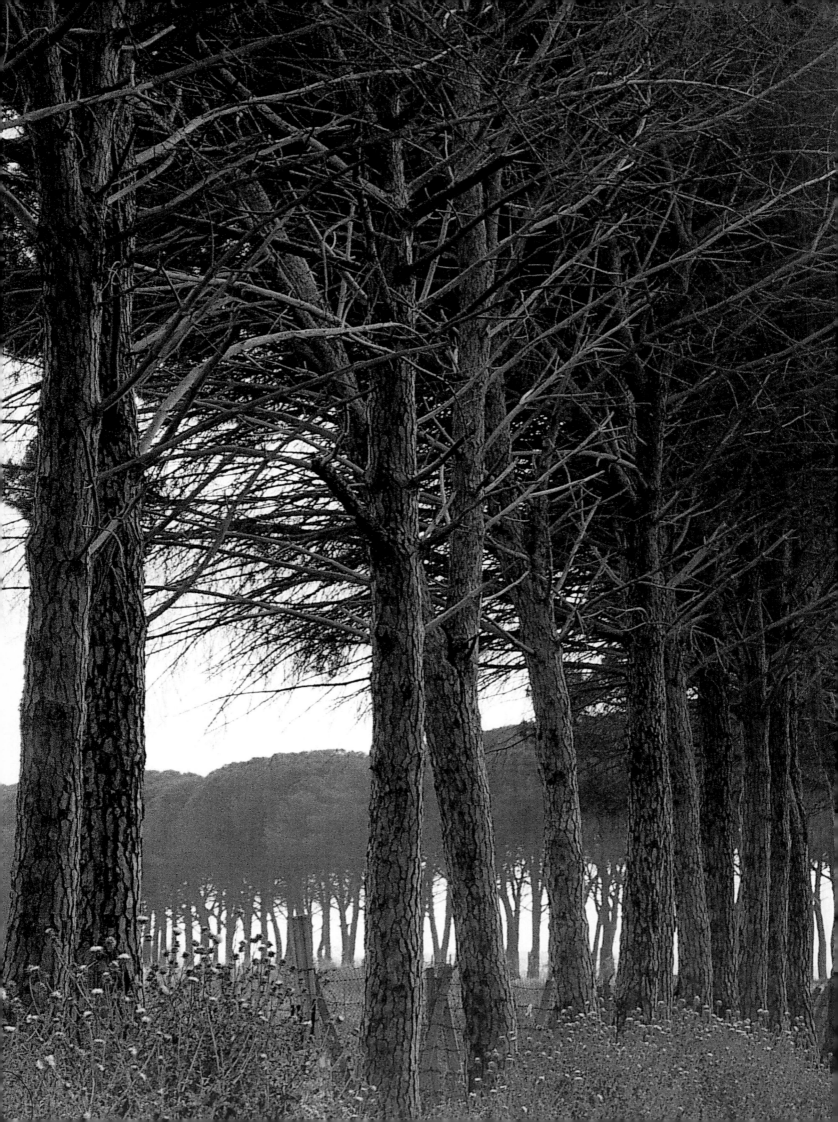

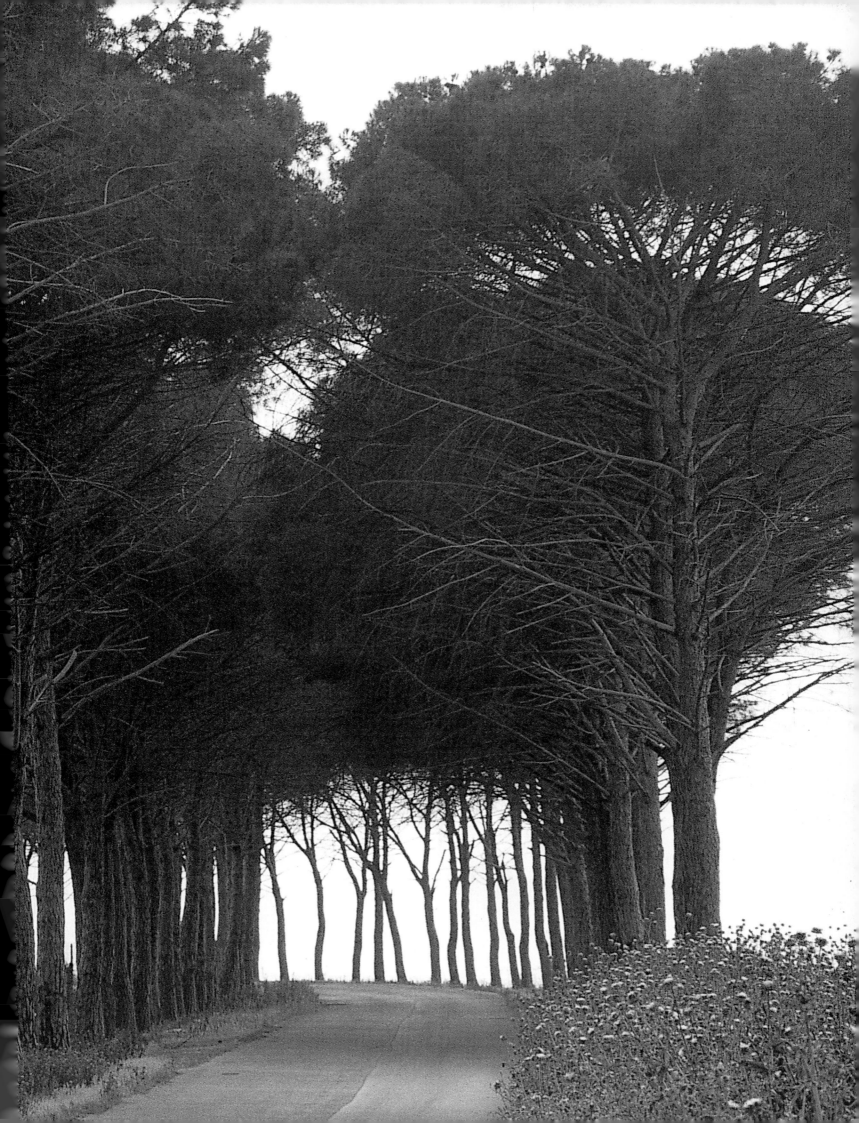

An ivory Christ in a pearl
mount, made in a convent.

Death
and transfiguration
of the Leopard

Thanks to the success of Lampedusa's novel and the even greater fame of Visconti's film, the search for the last Leopard has become, according to the author Ettore Serio, who wrote an excellent essay on the daily lives of Palermitans in the 19th century, "a journalistic and literary genre that is treated in a nostalgic manner". There are two recent examples; the first is that of Giuseppe Tasca, the Count of Almerita, who died in 1998 at the ripe age of eighty-five. This aristocrat was famous for his grandiose receptions during which he presented a diamond bracelet to every one of his lady guests and a gold piece to every gentleman. But Giuseppe Tasca doesn't seem to be a good candidate for the title of "the last Leopard". Although his grandson married a Branciforte, the daughter of Prince Trabia and Princess Butera, the nobility of his name only went back to the 1840s. And, above all, the Tascas exploited their agricultural domains with a spirit of enterprise and modernity which explains their exceptional prosperity – nothing in common with the real Leopard, "wooer of death and nothingness", according to the expression of Giorgio Bassani who collected, published and prefaced Lampedusa's two books. Baron Giuseppe di Stefano seems to fit the definition more closely. When he died on April 11, 1988, he had lived for nearly half a century cared for by four pretty nurses in suite 204 (three rooms and a bathroom) of the Hotel des Palmes in Palermo, the traditional lodging of a passing aristocrat. A legend – apparently purely legend – claimed that he had been confined there by the Castelvetrano Mafia, punished for killing a child who happened to be on his land. But Baron di Stefano was simply an eccentric and, although this character trait contributes quite a deal to the quality of a Leopard, it is not enough by itself.

Putti decoration in the
entrance hall of the
Beneventano del Bosco
palace in Siracusa.

The truth is that there is no "last Leopard", because the end of the species was already written into its genetic structure, and the race, already on the way to extinction at the end of the 19th century, was swallowed up in the great cataclysm of World War I, at the same time as the gold standard, the *petits Savoyards*, the Tsars of Russia, and the supremacy of good old Europe. That didn't prevent the Leopards from surviving, but only in an individual manner and often thanks only to surprising adaptations. Fulco di Verdura showed the way. At the beginning of the Jazz Age, Fulco realized that he – like a good many aristocrats – was ruined. As he had taste and an artistic sensibility, he got himself hired by Coco Chanel, designing textiles, ornaments and necklaces; thus he became a jeweler. In 1937 he left Chanel and Paris to work with a jeweler in New York. Two years later, he set up on his own in an office on Fifth Avenue. He was a great success and, with a new fortune, retired in London in 1973 as a true Anglophile Leopard.

Giuseppe Tomasi di Lampedusa saw his Palermo palace destroyed by German bombs in 1943 and, twenty-five years later, that of Santa Margherita di Belice was ruined in an earthquake. Indeed he was no longer owner of the "Sicilian Vatican" of the Filangeris; his uncle, Prince Alessandro Tasca di Cutò, a socialist deputy (how the Leopard had changed it spots!) had sold it after World War I.

The Prince of Lampedusa didn't have to work to live. Discreet, taciturn, looking like "a general in retreat, or something of the sort", according to the description of Giorgio Bassani, he gave himself up totally to his only vice, reading. Towards 1955, apparently in his sixties, he started writing, sometimes at home, sometimes on a table at the Bellini Club, the Casino of the Nobility. Giuseppe Tomasi di Lampedusa died soon afterwards, in the spring of 1957. And shortly, the Leopard, a family remembrance drawn from history, inspired by heraldry, achieved its ultimate metamorphosis.

The Leopard is not a heraldic animal. The arms of the Lampedusa family and consequently of Giulio di Lampedusa which served, it is said, as the model for don Fabrizio Salina, are a leopard rampant or, more precisely, lionised: a leopard in the attitude of a lion rampant. In heraldry the word rampant means standing on the hind legs. "The author, for personal reasons, has not entitled his book Il Leopardo, but Il Gattopardo. To describe his Leopard he has not once used the heraldic term, rampant, but the more approachable and picturesque word, dancing." Lampedusa, advertisement for The Leopard.

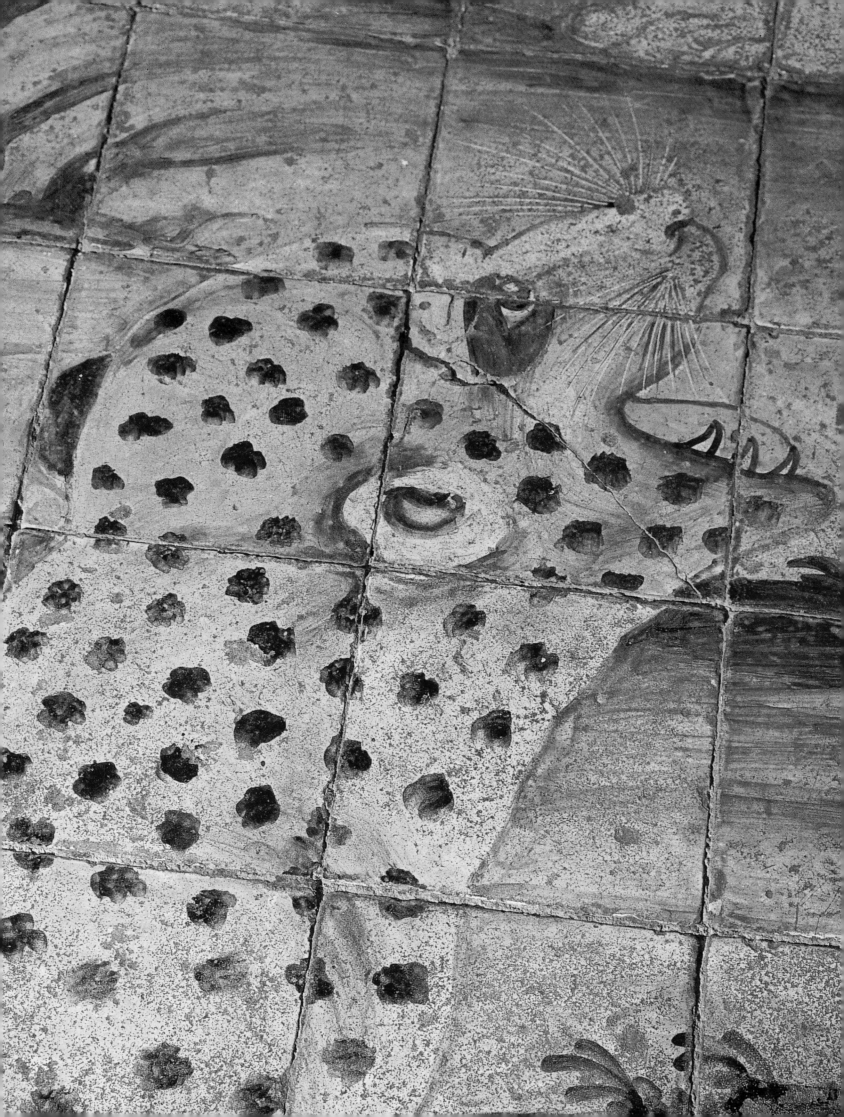

Bibliography

- Bufalino, Gesualdo, *La luce e il lutto*, Palerme, Sellerio, 1988.
- De Roberto, Federico, *Les Princes de Francalanza*, Paris, Stock, 1993.
- Di Verdura, Fulco, *A Sicilian Childhood*, New York, London, 1982.
- Drago, Francesco Palazzolo, *Famiglie nobili siciliane*, Palermo, Arnaldo Forni.
- Dumas, Alexandre, *Le Speronare*, Desjonquères, 1988.
- Du Pays, A.-J., *Guide d'Italie et Sicile*, Hachette, 1877.
- Fernandez, Dominique, *L'École du Sud*, Paris, Grasset, 1991 – *Palerme et la Sicile*, Paris, Stock, 1998 – *Le Voyage d'Italie*, Paris, Plon, 1998 – *Le Radeau de la Gorgone*, Paris, Grasset, 1997.
- Hamel, Pasquale, *Breve storia della società siciliana (1790-1980)*, Palermo, Sellerio.
- Maraini, Dacia, *Bagheria*, Milan, Rizzoli.

- Maupassant, Guy de, *En Sicile*, Brussels, Complexe, 1993.
- Padovani, Marcelle, *Sicile*, Paris, Le Seuil, 1991.
- Pirandello, Luigi, *The old and the young*, London, Chatto and Windus, 1928.
- Requiez, Salvatore, *La ville di Palermo*, Palermo, Flaccovio.
- Sciascia, Leonardo *"Le Conseil d'Égypte"* in *Œvres*, Paris, Denoël, 1980 – *Noir sur noir: un journal de dix années*, 1969-1979, Paris, Maurice Nadeau, 1981 – *Mots croisés*, Paris, Fayard, 1985.
- Serio, Ettore, *La vita quotidiana a Palermo ai tempi del Gattopardo*, Milan, Biblioteca Universale Rizzoli, 1999.
- Tomasi di Lampedusa, Giuseppe, *The Leopard*. London, Harvill, 1961. New York, Pantheon, 1961. *The Siren and Selected Writings. ibid*, 1982.
- Tuzet, Hélène, *Viaggiatori stranieri in Sicilia nel XVIIIe secolo*, Palermo, Sellerio.
- Verga, Giovanni, *Mastro-Don Gesualdo*, Paris, Gallimard, 1991.

Acknowledgements

This book would not have been possible without the help and friendship of all the Sicilians who have received us and who, with kindness and good humour, have opened their palaces and their cupboards to us. We thank them.

We should like to express our gratitude to all those who have advised and welcomed us; to the ladies of the houses who entrusted us with their magnificent objects and helped with the settings:Karine Vanni Calvello di San Vincenzo, Luisa Rocco Camerata Scovazzo, Giulia Paternò di Spedalotto, Signoretta Licata di Baucina, Daniela Camerata Scovazzo and Gustavo Wirz, in Palermo.

We owe the success of our stays in Catania and Siracusa to Giovanna and Pietro Notarbartolo di Salandra, Rosa Anna and Pietro Beneventano del Bosco di Monteclimiti, Laudomia Piccolomini Salmon and Emanuela Notarbartolo di Sciara.

Thank you to Angheli Zalapi and Fanny Canalotti for having guided us through Sicilian society.

Finally, our warm thanks go to Nicolo Norarbartolo di Salandra, our indefatigable and efficient assistant.

Lydia Fasoli sends her kind regards to Christine Moussière, Totò Bergamo, Giuì di Napoli, Giorgio and Gabriella Frasca, Colette Véron.

We thank l'Institut P. Borsellino for its gastronomical advice and for making the pastries *Oscar, Alba, Caflisch*.

Jean-Bernard Naudin thanks Laboratoire Arka for developing the images.

Lydia Fasoli and J.-B. Naudin

The editor thanks Brigitte Del Grande for her valuable help.

Translated and edited by Alexis Gregory

Spedizione del Corpo Garibaldi.

Sirtori Giuseppe capo di stato maggiore
Crespi - Manin - Calvino - Majocchi -
Craxiotti - Borchetta - Bruzzesi - Türr -
primo ajutante di campo di Garibaldi
Cenni - Montanari - Bandi - Stagnetti -
Basso Giovanni, Segretario Generale.
 Comandanti delle Compagnie
Nino Bixio Comand. delle I. Comp.
Orsini II
Stocco III
La Masa IV
Anfossi V
Carini VI
Cairoli VII
Intendenza Acerbi Boni - Maestri - Rodi.
C. medico Ripari Boldrini - Ciulini.